CU00763065

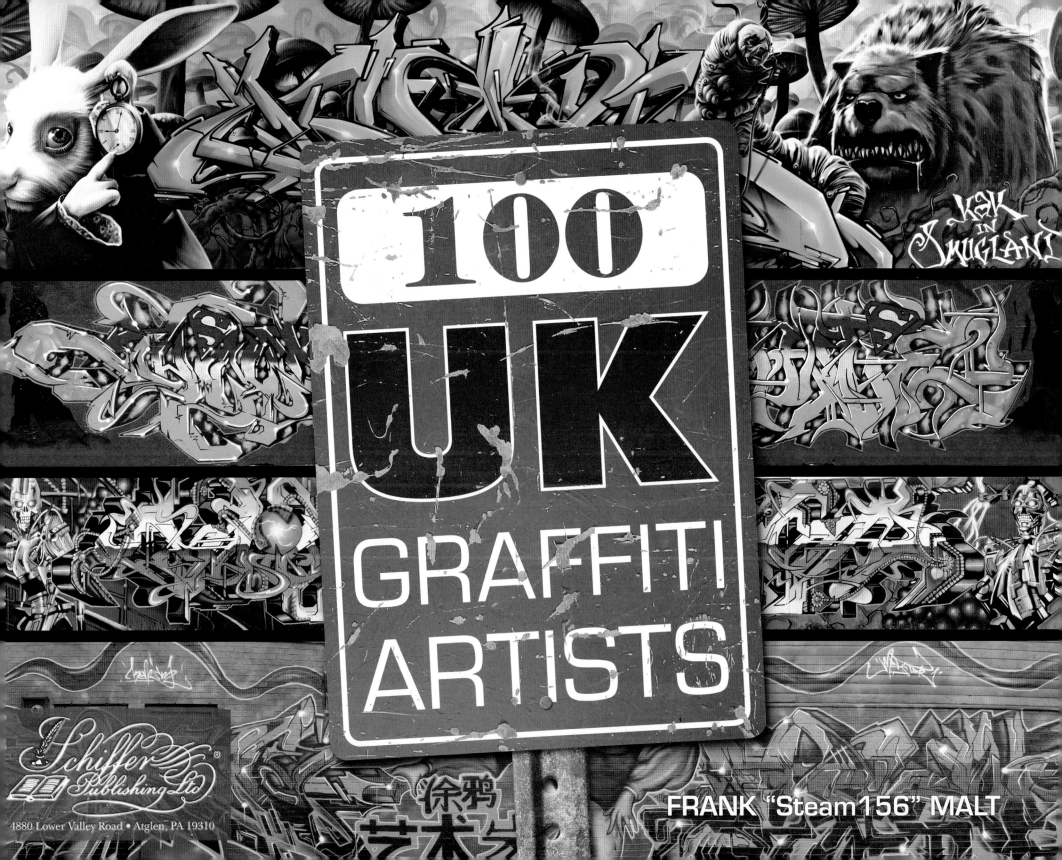

100 UK GRAFFITI ARTISTS

KØK IN SMUGLAND

Schiffer Publishing Ltd
4880 Lower Valley Road • Atglen, PA 19310

FRANK "Steam156" MALT

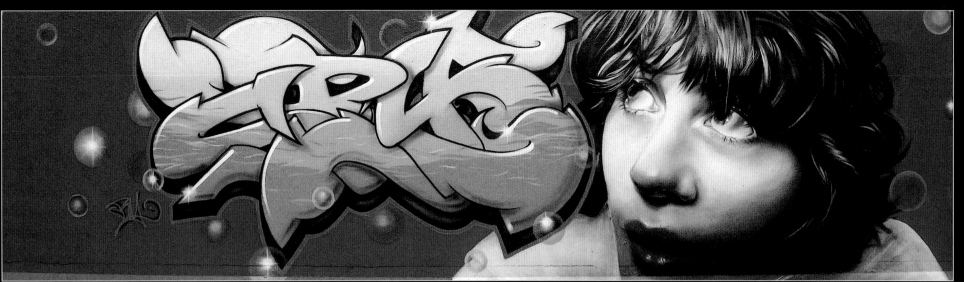

Other Schiffer Books on Related Subjects:

Street Talking: International Graffiti Art, 978-0-7643-4199-1, $45.00

New York City Graffiti: The Destiny Children, 978-0-7643-3720-8, $50.00

Morris Park Crew: The Official History, 978-0-7643-4157-1, $34.99

Copyright © 2012 by Frank Malt

Library of Congress Control Number: 2012944028

All rights reserved. No part of this work may be reproduced or used in any form or by any means—graphic, electronic, or mechanical, including photocopying or information storage and retrieval systems—without written permission from the publisher.
The scanning, uploading and distribution of this book or any part thereof via the Internet or via any other means without the permission of the publisher is illegal and punishable by law. Please purchase only authorised editions and do not participate in or encourage the electronic piracy of copyrighted materials.
"Schiffer," "Schiffer Publishing Ltd. & Design," and the "Design of pen and inkwell" are registered trademarks of Schiffer Publishing Ltd.

Designed by John P. Cheek
Cover design by Justin Watkinson
Type set in Avant Garde Md BT/Minion Pro/ITC Avante Garde Gothic Std

ISBN: 978-0-7643-4196-0
Printed in China

Published by Schiffer Publishing Ltd.
4880 Lower Valley Road
Atglen, PA 19310
Phone: (610) 593-1777; Fax: (610) 593-2002
E-mail: Info@schifferbooks.com

For the largest selection of fine reference books on this and related subjects,
please visit our website at **www.schifferbooks.com.** You may also write for a free catalog.

This book may be purchased from the publisher.
Please try your bookstore first.

We are always looking for people to write books on new and related subjects. If you have an idea for
a book, please contact us at
proposals@schifferbooks.com

Schiffer Books are available at special discounts for bulk purchases for sales promotions or premiums. Special editions, including personalised covers, corporate imprints, and excerpts can be created in large quantities for special needs. For more information contact the publisher.

In Europe, Schiffer books are distributed by
Bushwood Books
6 Marksbury Ave.
Kew Gardens
Surrey TW9 4JF England
Phone: 44 (0) 20 8392 8585; Fax: 44 (0) 20 8392 9876
E-mail: info@bushwoodbooks.co.uk

Dedications and Mentions

I would like to dedicate this book to my Nan, Honora Violet Long, who has supported both me and my passion for graffiti for most of my life. Sadly, my Nan passed away while I was working on this book. Rest in peace, Nan.

Also, a special thanks to all the amazing artists that are featured in this book. Without their help and support, this book would have never happened. A special thanks to Drax WD, Sami Montague, and also Lee102 for their fantastic words.

Not forgetting: Dave Logic; Joe@LDN; Time; Cane101; Zomby; Elk; Blaze; Band; Met; Bert23; Toby Willsmer; Semik; Sami Montague; Martin Jones; Colt45; Diet; Dank; Demon; Eine; Eska; Owed; Rench; Roid; Pure Evil; Rask; Rize; TML Stars; Ser; Inkie; Sian; Artful Dodger; Pride TCA; Cazbee; Jump2; Peter Pedrero; Rio2; Fuel; Busk; Demane; Parlee; Catch; Regret; Baps; Dsyer; Tox; Noir; Severe; Mr Met; 2kold; Foam; Rich; Rage; Demo; Mode2; Chok; Sterling; Jano; Gold Peg; Hash; Mask; Four; Fugi; Fume; GFunk; Kosa; Mobstr; Neka; Omerta; Panik; Paris; Cryse; System; Snub23; Towns; Bref; Keep; Popz100; Shun; State of art; Juice126; Eskimo; Dazer; Pure; RE; Dek; Insa; Cast; Manik; Mean; Mint; Ebzke; Elate; Envy; React; Rebus; Replete; Petro; Pheks; Seks; Sick; D-Face; Dicer; Zukie; Coma; Crime; 10Foot; Agent; Prize; Rels; Julio Abajo; Akit; AktOne; Anik; Anoe; Auto; Bleach; Boms; BRK; Cheo; Spat; Spya; Stet; Stika; Stik man; Sune; Taco; Teach; Toaster; Toxic; Type; Vamp; Zenof; Zeus; Siege; Crept; Felz; Rate; Jason; Riot68; HowAboutNo; 1timo1; Romany WG; Brighton Rocks; Neas; WalkAndy; John19701970's; Buddz909; Diskyof; Mist One; Tuff Tim; Melanie Hill; Lee Bofkin; Ed Dempsi; Jet; Letty Lyons; Char; Euroh; Dreph; Will Robson-Scott; Mess, from around the wizzle's; Akes; Skip; Mono; Deac; Kapton1; Siner; Rascal; Skyhigh; Eureka; Skeema; Fluid; Hoakser; Wicca; Mer; Blavoe; Karm; News; Seyer; Flaver; Reoh; Glimmertwin; Dylek; Twomest; and King Robbo, get well soon mate. And anyone who I forgot.

Drome2 – RIP
Infoe – RIP
Dier – RIP
Shine159 – RIP

Websites

www.aerosolplanet.com

www.londongraffititours.com

Also:
www.artcrimes.com
www.artofthestate.co.uk
www.chromeandblack.com
www.globalstreetart.com
www.graff-city.com

www.graffoto.co.uk
www.hurtyoubad.com
www.ldngraffiti.com
www.willsmer.com

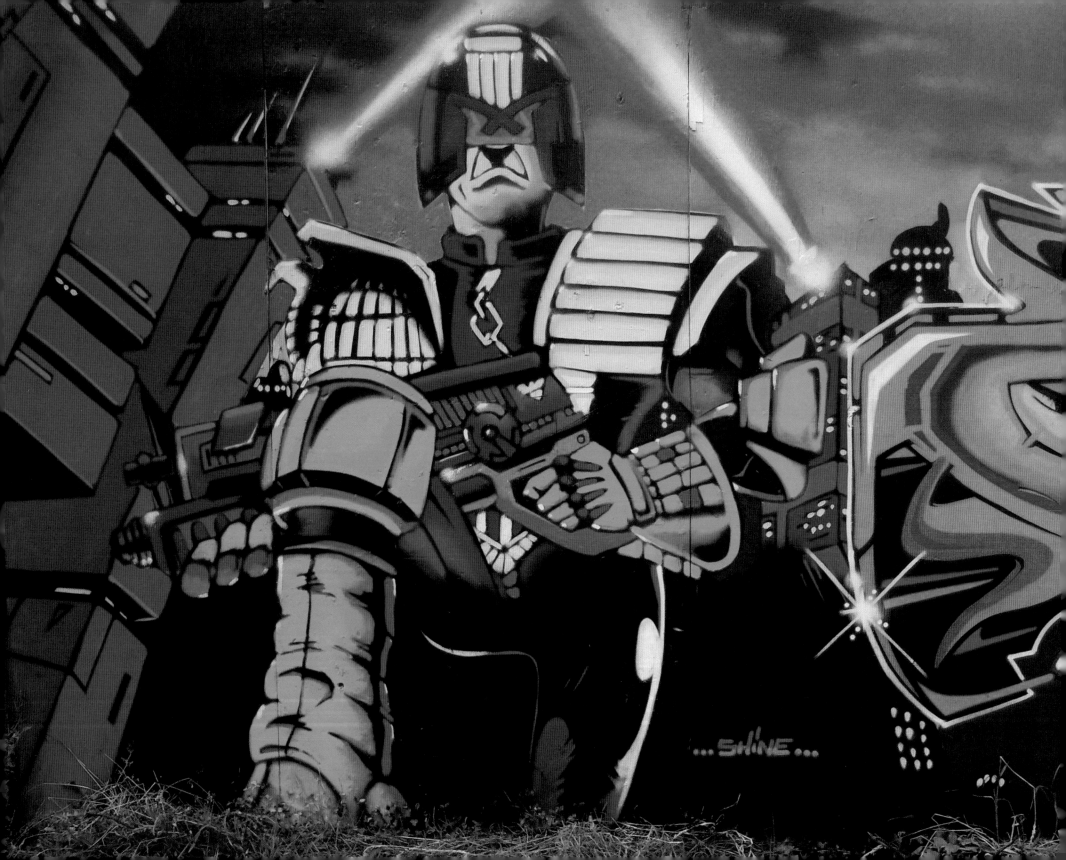

...SHINE...

CONTENTS

FOREWORD by Drax 6
Steam156: Modern-day Documenter 8

THE ARTISTS

Alert	12	Dilk	66	Mear	118	Shye131	170	
Amuk	14	Dime one	68	Merc	120	Skam	172	
Andy Seize	16	Don	70	Meros	122	Skire	174	
Ante	18	Doze	72	Mighty Mo	124	Skore	176	
Aroe	20	Drax	74	Nylon	126	Smug	180	
Astek	24	Ebee	78	Odisie	128	Snatch	182	
Blam	26	Ekto	80	Part2ism	130	Snoe	184	
Bonzai	28	Estum	82	PIC	132	Snug	186	
Brave one	30	Frame	84	Ponk	134	Sokem	190	
Carl	32	Gary	86	Pref	136	Solo One	192	
Cept	34	Gnasher	88	Prime	138	Stylo	194	
Choci Roc	36	Goldie	90	Probs	140	Sweet Toof	196	
Chu	38	Hemper	92	Proud 2	142	Tek33	198	
Chum101	40	Hush	94	Quest	144	Title	200	
Corze	42	Ink Fetish	96	Rebus	146	Tizer	202	
Crane	44	Insane	98	Relay	148	Trans1	204	
Crok	46	Jadell	100	Robbo	150	Upstart	206	
Crome	48	Jiroe	102	Rocket01	152	Urge	208	
Cruel103	50	Keen Roc	104	Rowdy	154	Vibes	210	
Cry	54	Kelzo	106	Sepr	156	Vodker	212	
Dane	56	Kemef Inc	108	Shades	158	Wisher	214	
Dasr	58	Kilo	110	SHEONE	160	Xenz	216	
Demo	60	Lovepusher	112	Shine	162	YesB	218	
Dep	62	Mac1	114	Shok1	166	Zadok	220	
Ders	64	Mash	116	Shucks One	168	Zaki Dee 163	222	

FOREWORD

What is Style and what Does Graffiti Mean to Us?

Ask a bunch of graffiti writers anywhere in the world what graffiti means to them. Ask them what "having style" means and then ask them to describe their own style. I guarantee that after you've listened to seven or eight sets of answers, you'll be more confused and further from any definitive or clarifying answers than you were when you started.

Personally, what graffiti means to me is hard to explain. I started writing in the mid 1980s so it's been with me for a long time now. I don't really notice that it's there most of the time these days, it just follows me around like some kind of stalker. Sometimes, when the mood suits me, I slow down and let it catch up. Then, once again, I'm a writer and many of my favorite things start to happen.

Style

Style should be a reflection of the artist it represents. Anyone that's engaged in a form of artistic representation after an amount of time develops their own style. This is true of footballers, dancers, musicians, and all forms of artists. Reaching that point in your artistic development is an achievement in itself because it shows that you have gone beyond the point of learning and are now producing. Producing what it is that you are capable of. At this point in the style stakes, people can see what you are actually capable of doing. You are no longer hindered by a serious lack of technique or by simply being inexperienced and not having the know-how to advance your style game.

My Style

I think it's honest. I think it reflects someone who isn't really an artist at all, someone who has zero God-given artistic ability or natural artistic talent. I think it's the style of a graffiti writer that simply wishes he didn't have to do pieces at all and one who would be happier just writing his name. My style, when it works properly, I believe it's a victory for a vivid imagination over a lack of technical brilliance and any natural artistry. My style is me, it's what I'm capable of. Sometimes I'm happy with the results, other times I cringe and think *Christ! How embarrassing*. My style is a blunt portrayal of my abilities or limitations within the graff game. You may or may not like the results when I

slap a chunk of my identity on a wall. Taste differs, but the highest compliment you can pay me is recognizing that something is by me. I used to write my name everywhere because I wanted to be noticed. Now I write it in selected places with a little more flair, hoping that somebody will recognise me. If you've ever done that, I thank you.

I know I said that graffiti is like a stalker to me these days, but the truth is when I first embraced this thing/movement/sub-culture it was me that lurked in the dark corners watching and trying to understand; it was me that did all the chasing. I was the stalker. I so much wanted to be part of whatever it was that I jumped through hoops to placate its every nuance and notion. Eventually, like a cowboy on a wild horse, I think I tamed it and we became one. We became the rampant narcissistic, self promoting entity, and look-at-me-ism that calls itself Drax. I say "we" because, though when I throw off my writer's cloak I am simply me, when it's on, I am more than me, I am we. Sorry, but sometimes when I talk about graffiti writing my thought processes become disjointed and confused to the point where I'm not even sure whether it's me talking anymore or not. I think what I'm trying to say is: Graffiti means many different things to me but sometimes I can't separate myself enough from it to be able to tell you what they are.

Ask a bunch of UK graffiti writers the three questions I've attempted to answer above and I'm guessing it'll take you three, four, or maybe even less sets of answers to reach the point of a "arghhhh! OK, enough!" meltdown. Us graffiti writers, in essence we're a contradiction. We're destroyers that create stuff but also the creators of nice stuff that destroy things. We're the nice man from the street that fucks up the place and we're the fucked up man from the street that makes the place look nice. We're the way out there guys that give the place edge and sometimes we're simply the guys that are way out there on the edge. We can be glorious and sometimes we can be pretty damn pathetic. We are often the most soulless of vessels drifting self-indulgently in a sea of apathy, but sometimes we can also be the person who's capable of bringing light and hope to some of the darkest recesses and holes known to man. I started writing in 1985 and since then, as I've travelled across the country, I've met all the above manifestations of the UK graffiti writer. In truth, at one point I've probably

been all of them, too. Many others would tell you the same story. Graffiti writing is not a moment, a time, or a place. It's a journey.

From Plymouth to Inverness and from Derry to Brighton, since approximately 1982, when graff first came to these shores, we've been drifting in and out of one guise or another. Pioneers like Shades, Skam, and 3D set the ball rolling as they brought a slice of New York to the streets of the UK. Then legendary writers such as Artful Dodger and Zaki from the Trailblazers crew fine tuned the details on the boards at London's Covent Garden at a time when most of Europe was looking in that direction for inspiration.

London's Mode2 headed across the Channel to Paris in the mid 80s, taking some London swagger with him. From there, along with Bando and Shoe from Amsterdam, they set the benchmark by which most European graff is still defined. A little while later, events like Bridlington (in 1987) showcased some of the UK's finest talent to the world, talent such as Goldie (Wolverhampton) and Inkie (Bristol). As the 80s closed the train writers of London did what they could to emulate the rolling art gallery that was then the New York subway system. Writers like Prime, Carl ST, Merc ACR, and Robbo put in shifts that pushed graffiti endeavours to the limits. Across the country fine scenes were flourishing from Manchester to Bristol, Colchester to Glasgow, Nottingham to Birmingham, and beyond. Many writers from different backgrounds and walks of life came from these scenes, each bringing his or her own little touch of individualism with them. In the early 1990s, the acid house rave scene brought fluorescence to much of the country's wall spaces. The styles of writers like Part 2 (York), Mear (London), Solo One (Leicester), and Snatch PFB (London) are a testament to that era.

Then, in approximately 1994/5, we actually started getting good paint. Artists raised on a diet of sub-standard brands like Homestyle, Japlac, and Dupli-Color were suddenly fat with a deluge of fresh paint brands from Germany and beyond. The art went to a whole new level. Artists like Alert (Nottingham), Kelzo (Manchester), Seize WD (London), and Skore TRC (Kent) pushed the UK scene higher up the international style ladder. Then, as the 90s subsided, the whole world suddenly woke up to the delights of UK graffiti, only now it had been re-branded as "Street Art."

Now, along with the spray painting talents of artists like Tek33, Rowdy, Wisher, and Love Pusher, we were also introduced to art by those exhibiting the joys of wheat-pasting, stencilling, the extensive use of emulsion paints, and even art by fire extinguisher. Graffiti/Street Art was now a whole new animal. It had become mainstream. Once the plaything of a selective few, something you needed to be in the know to know about, it was now something that everybody knew. Now there isn't a bar, hotel foyer, or nightclub in any town in the UK that doesn't have art on its walls that gives a nod to the UK writing scene.

Now it's 2012 and whether all these developments are a good or a bad thing, truthfully I couldn't answer that question either without leading you and myself down another cul-de-sac of contradiction, self doubt, and confusion. The UK graffiti writing scene means many different things to many different people. It's a scene that is and has always been a kaleidoscope of styles, directions, attitudes, and opinions. These are a few of its finest practitioners. Please do not take them lightly.

Drax. WD. PFB. KOA. GVB. AOK
Since 1985.
On Flickr & Facebook as Drax WD.

STEAM156
Modern-day Documenter

To most with an interest in writing, "Steam 156" is a name that is well known, either through his graffiti, or more likely through his tireless documentation of graffiti; this comes as little surprise when we consider that he has been at it for more than a quarter of a century. Steam156 is a genuinely passionate collector of graffiti; he serves to preserve what the buff or the elements will certainly destroy and to share his knowledge. It is difficult to imagine Steam's passion fading or energy for graffiti running out.

Steam156 explains, "I have always been in love with graffiti. I remember as a child taping every program on TV that might feature graffiti; for example, all of the old New York City crime shows. I have never stopped documenting graffiti art in the 26 years I have been involved." Steam156, a pretty humble guy, says that he never classified himself as an amazing photographer, "I was mainly a click and shoot guy with a basic digital camera." Sometimes pointing and shooting is all it takes.

Born in the late 1960s in London, Steam156's initial interest in graffiti started in 1984, an awakening fuelled by the *Buffalo Gals* video, *Wild Style, Body Rock,* and *Breakin',* etc. At the time, he was living in Brighton; he was kicked out of school and unemployed. Eventually, Steam156 was offered a move to London. Having got up a fair deal in Brighton and made a name for himself, London was a shock. Of this Steam156 comments, "I could not believe how big graff was there. I had to start all over again, trying to get up as much as I could. I was living in South East London and knew nobody. So, I started off by tagging the local bus routes. As soon as it got dark, I'd head out with my markers and paint, walking for miles and hours each night. During the day I would hit the insides of the buses." Eventually bumping into other writers, Steam156 soon began visiting the local British Rail yard. Never really one to paint elaborate pieces, he purely enjoyed getting up.

So began his hunt for graffiti…. Landing a job delivering office supplies around London, he spotted graffiti all day long. He would note down the best and return on the weekend. He recalls early trips to Westbourne Park and pieces by the Chrome Angelz, T-Kid painting the TDK billboard, the Post Office HOF, and so on. Soon his weekends were spent hungrily hunting graffiti. Through thick and thin, he continued. Out of this he grew his photo collection, this led to many connections with writers worldwide, mainly through the magazines *IGT* and *Hip Hop Connection*, which Steam contributed to. It got to the point where writers from around the globe would drop in unannounced. Steam156 also got in touch with both James Prigoff and Henry Chalfant, forming lasting friendships with both.

All the while, Steam156 continued to be active and began doing commissions, particularly with other writers such as Mear. This lead to work that was on TV shows and generated a lot of press coverage for him. He helped organise graffiti art shows and create *Graphotism* magazine.

A keen traveller, graffiti has taken Steam156 far from home; from his early Parisian adventures to times in NYC and experiences with Hex in LA, Steam has explored many places in between. The places were, of course, filled with characters and Steam was lucky to spend time with legends such as Dondi, Seen, Iz the Wiz, TATS crew, and Quik. Travel is something that Steam156 pursues with passion to this day.

More recently, Steam156 has not slowed: he started the website Aerosolplanet.com, had several shows of his photos, runs graffiti tours, and has produced a series of DVDs. My feeling is that Steam156 will probably go on forever, busy preserving what will definitely be destroyed; so good on him and long may he continue!

–Steam156 & Sami Montague

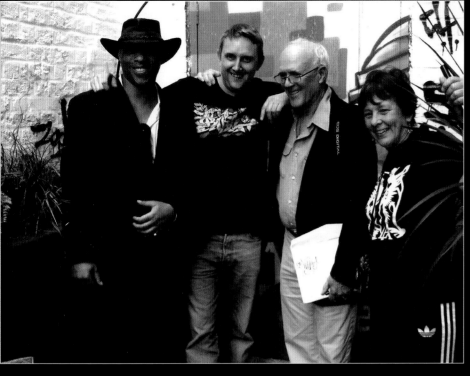

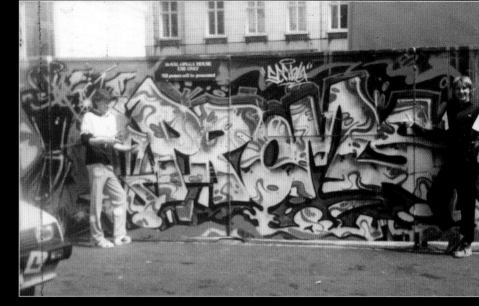

Wizard and Steam156, Covent Gardens, London 1985

Blade, Steam156, Henry Chalfant, and Martha Cooper at the *Subway Art* 25th anniversary book launch, London 2009

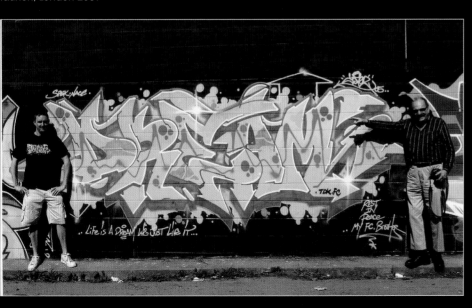

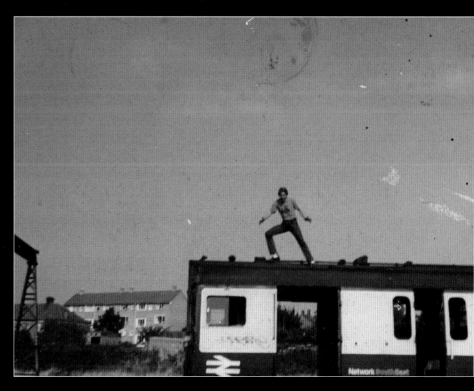

Steam156 and James Prigoff, San Francisco 2009

Grove Park, London 1986

THE ARTISTS

Alert

Artist = Alert
Location = Nottingham
Painting since = 1985
Crews = HA (Heavy Artillery), ILC (In Living Colour)
Quote = Graffiti to me is a way of life! It's that place I can go and relax from the everyday hustle and grind of adulthood, a sort of therapy session of self expression, an outlet for emotions and escapism. Graffiti is my unshakable addiction bordering on an illness. From the moment I wake up in the morning to the time I go to sleep, I'm thinking about graffiti! Integrity is everything. Stay true to yourself.
Website = www.alert1.co.uk

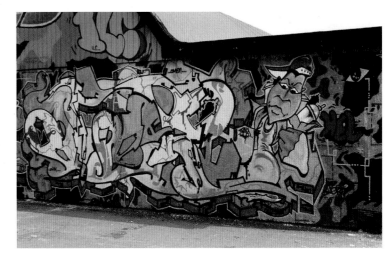

Fumes, Nottingham 1996, photo by Alert

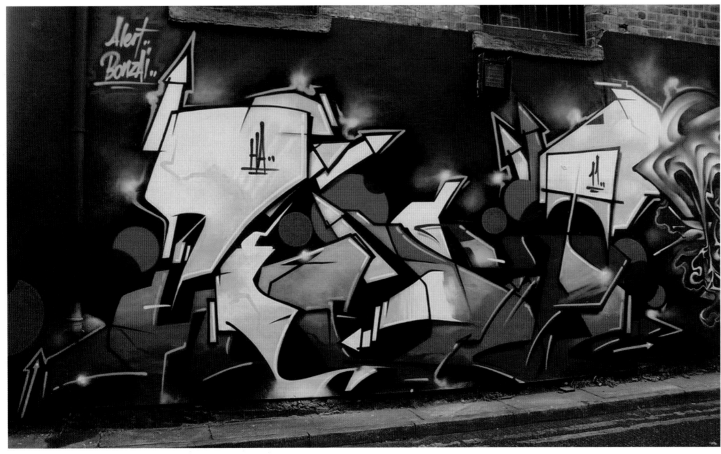

Nottingham 2011, photo by Alert

12

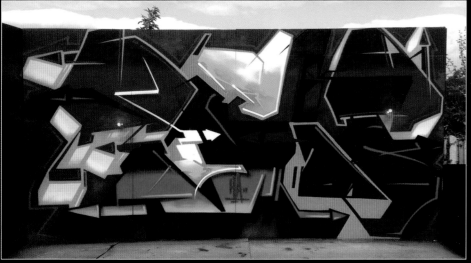

Shadyville, Nottingham 2011, photo by Alert

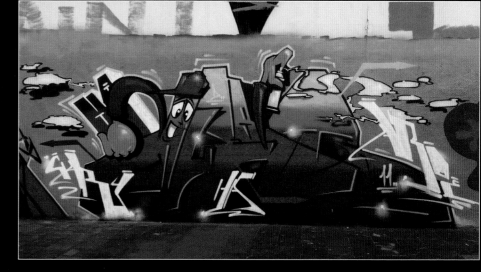

Holland 2011, photo by Alert

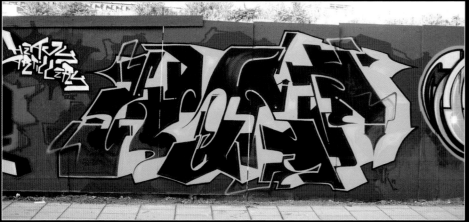

Brighton 2008, photo by Alert

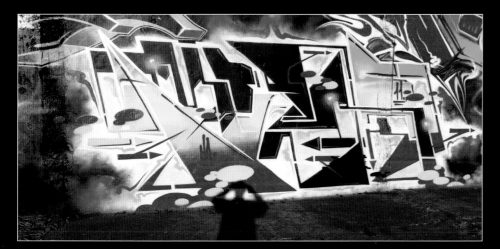

Sheffield 2011, photo by Alert

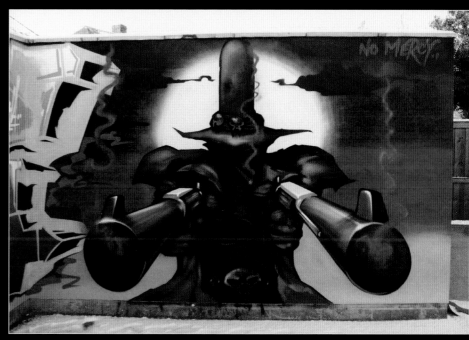

No Mercy, Nottingham 2009, photo by Alert

13

Amuk

Artist = Amuk
Location = Kent
Painting since = 2003
Crews = KYS (Know Your Self), LTD (Long Term Damage)
Quote = My style, like the planet's tectonic plates, is continuously shifting and forming new shapes. It just moves slowly, always striving for perfection but never quite getting there. That's what keeps me going, the urge to progress and push my letters.

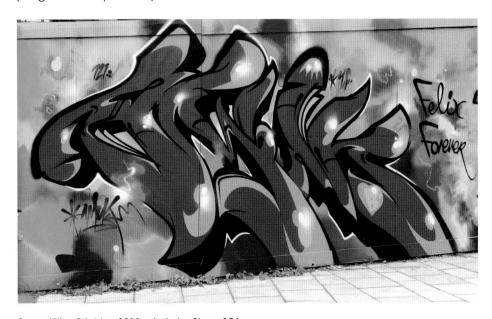

Scrap Killer, Brighton 2011, photo by Steam156

Meeting of Styles: London 2011, photo by Steam156

Going Big, Newcastle 2008, photo by Amuk

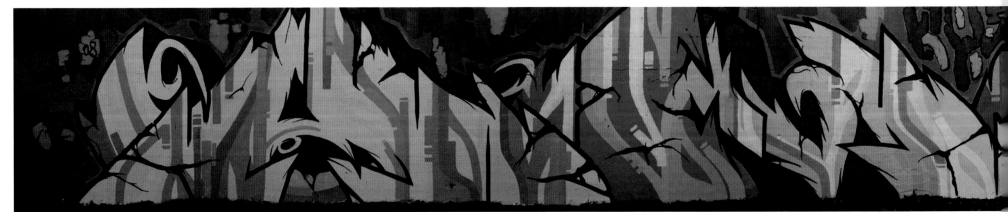

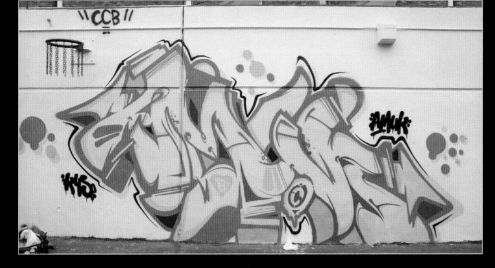

Yellow Peril, London 2011, photo by Steam156

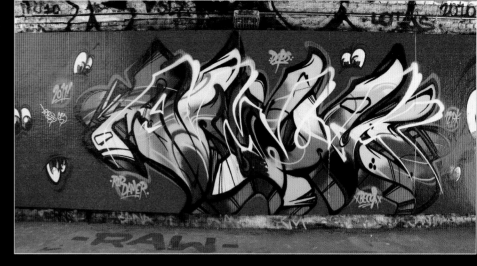

Eye See You, London 2011, photo by Steam156

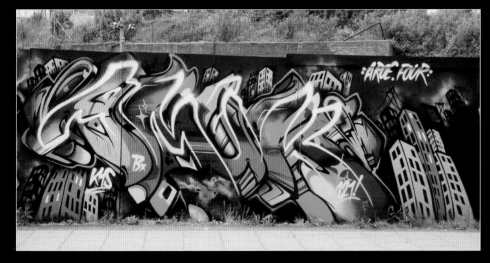

Graf City, Brighton 2011, photo by Steam156

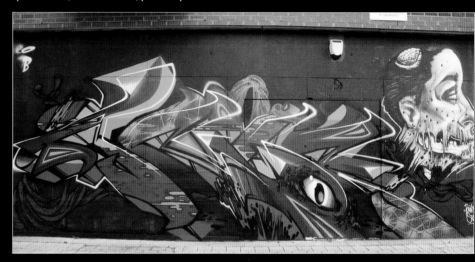

Zombie Instant Death, Meeting of Styles: London 2011, photo by Steam156

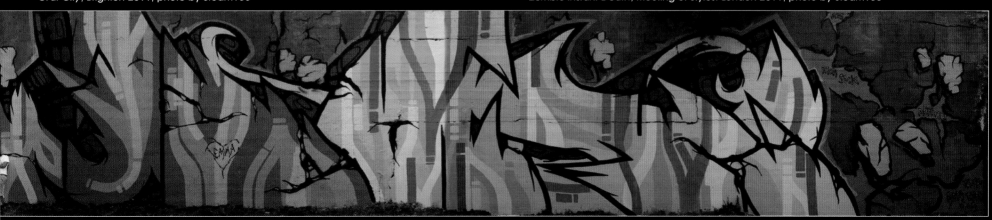

Andy Seize

Artist = Andy Seize
Location = London
Painting since = 1986
Crews = WD (World Domination), TME (The Mad Ethnicz), KOA AUZ (Kiss Our Ass)
Quote = Style and originality are very important. Letter styles should have: a good flow, colour, shape, and proportion. These things mean everything to me.
Website = www.andyseize.co.uk

London 2011,
photo by Tyla Arabas

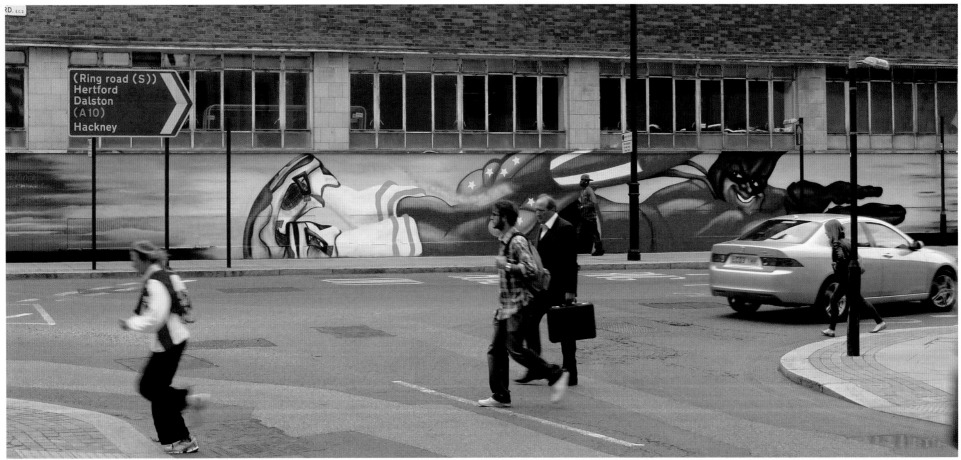

London 2009, photo by Steam156

16

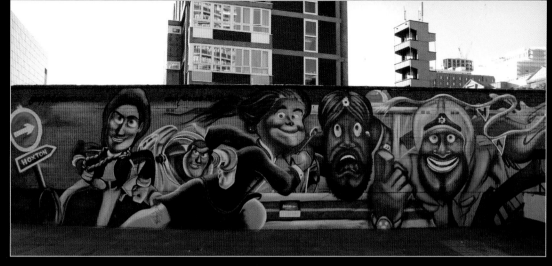

London 2011, photo by Steam156

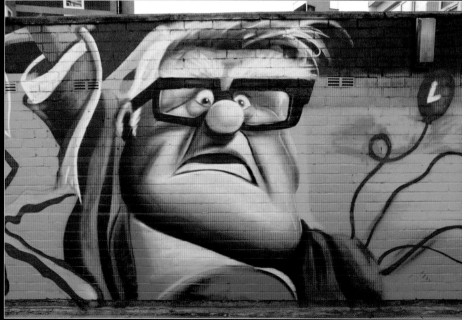

London 2011 (detail), photo by Steam156

Ante

Artist = Ante
Location = South London
Painting since = 1997
Crews = TUS (The Usual Suspects), LTD (Live the Dream)
Quote = In my eyes, having a good style is one of the main things about writing. Firstly, if you haven't developed your own style then go back to the drawing board. Obviously, everyone's style will have influences—it's the nature of writing. I feel writers should be able to see a piece and then know who it's by just by looking at the style.

A good style, well that is more a matter of opinion. What some may say is a good style, others will say is not. I think as long as you can rock your own style and continue to look to develop it, then that's winning in my eyes.
Website = www.Flickr.com/theusualsuspects

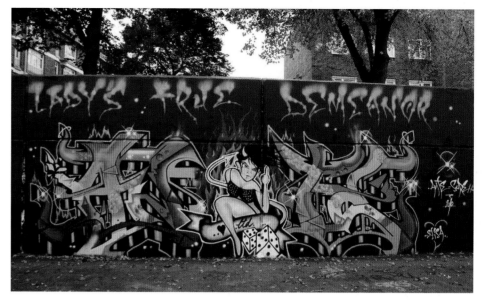

London 2010, photo by Steam156

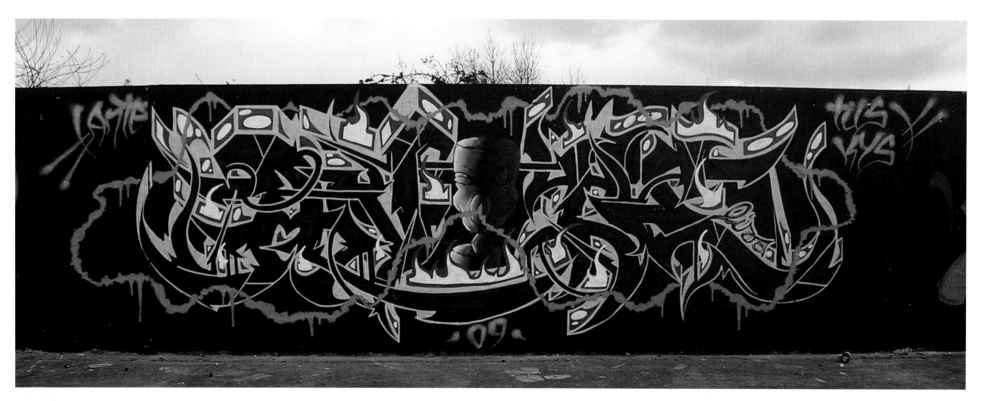

Essex 2009, photo by Ante

18

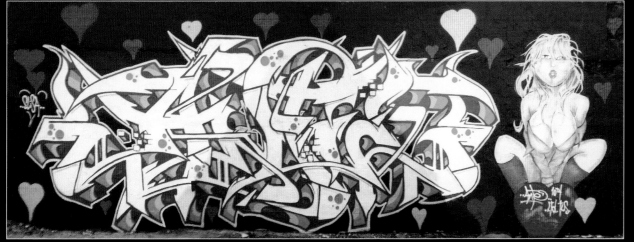

Kent 2010, photo by Ante

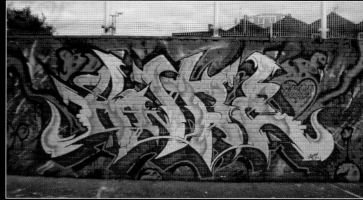

London 2011, photo by Ante

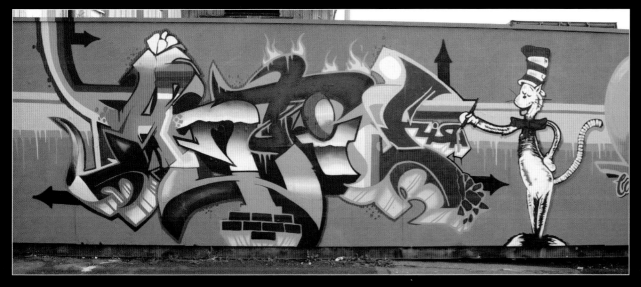

Kent 2011, photo by Ante

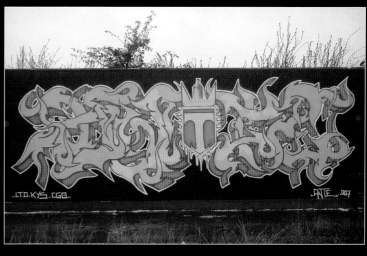

Essex 2007, photo by Steam156

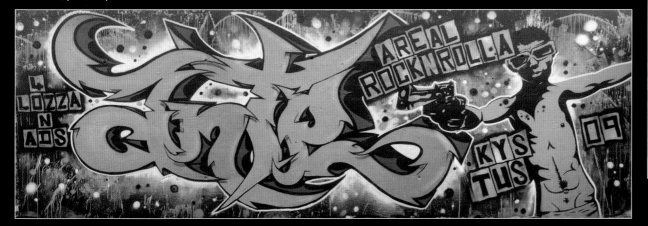

London 2009, photo by Ante

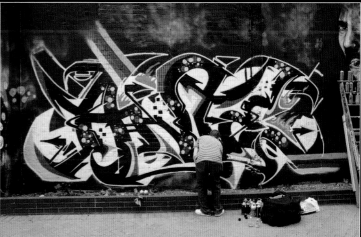

Meeting of Styles: London 2010, photo by Steam156

Aroe

Artist = Aroe
Location = Brighton
Painting since = 1984
Crews = HA (Heavy Artillery), MSK (Mad Society Kingz)
Quote = Graffiti is the best and worst thing that has ever happened to me. It's given me tremendous highs and demoralizing lows. It is the single constant in my chaotic life. I would never be without it, as it gives me an extension to my persona that both helps and hinders me in equal measure.
Website = www.heavyartillerycrew.com

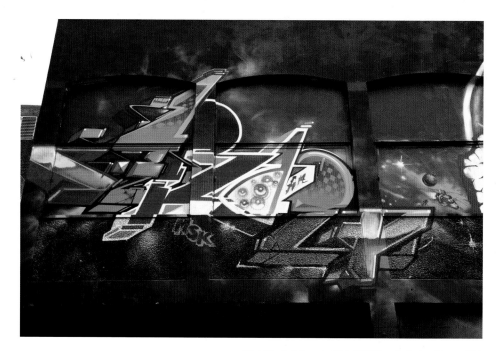

See No Evil Event: Bristol 2011, photo by Steam156

Portsmouth 2010,
photo by Steam156

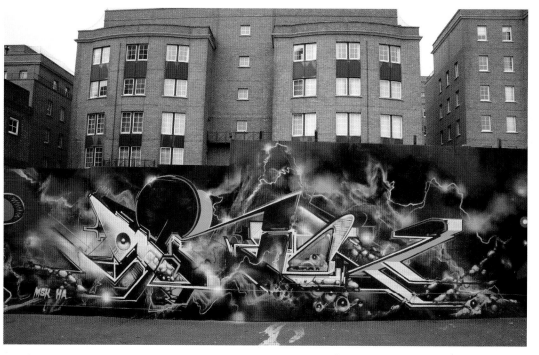

Ice Grill, Brighton 2009, photo by Steam156

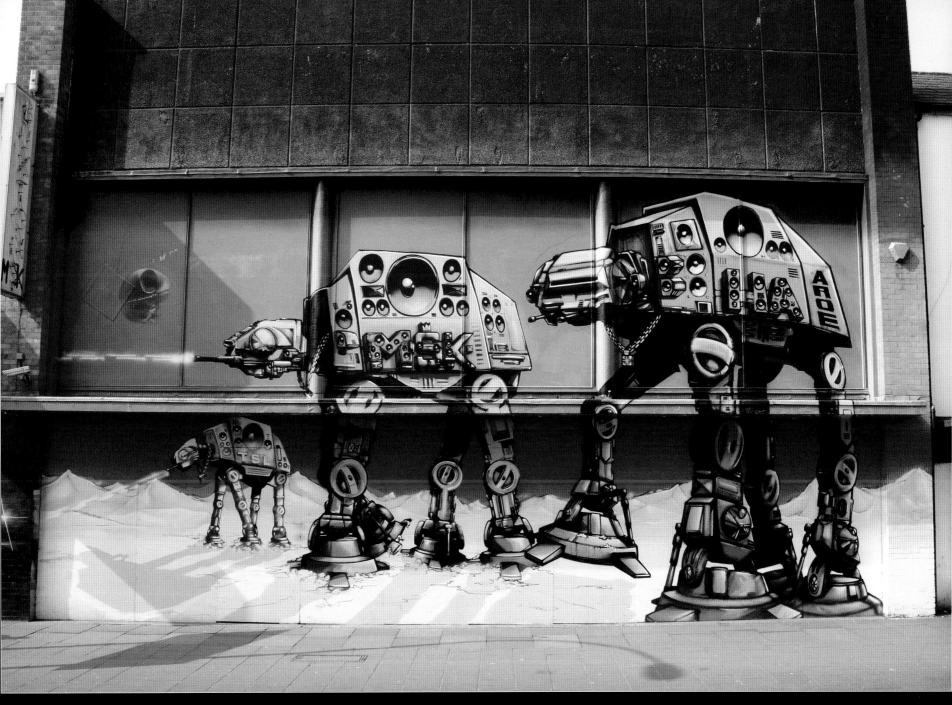

Making Suckers Kneel, Brighton 2010, photo by Steam156

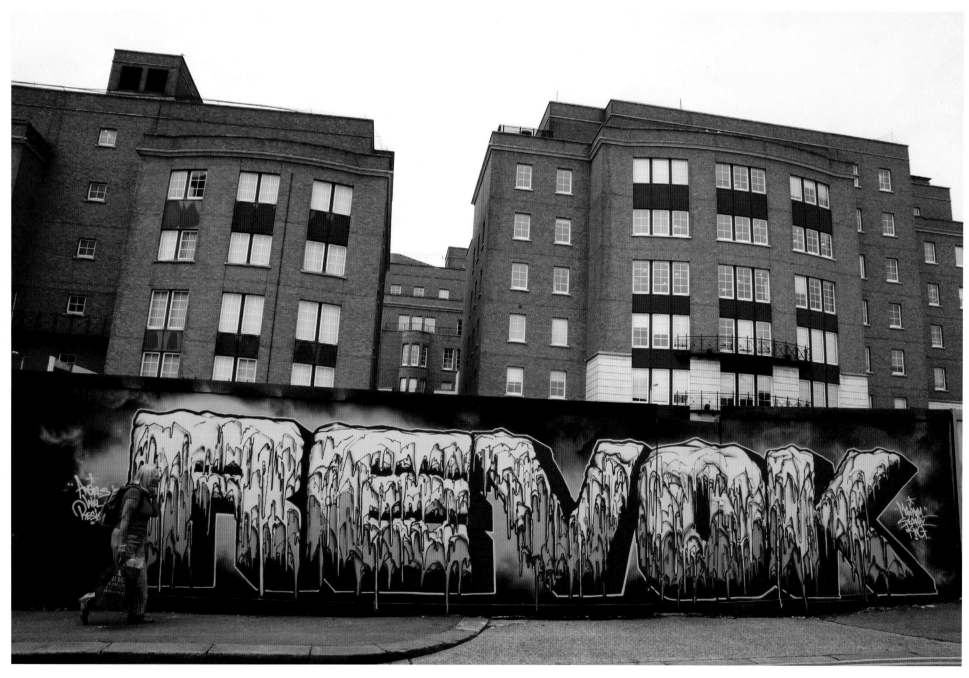

Revok, Brighton 2009, photo by Steam156

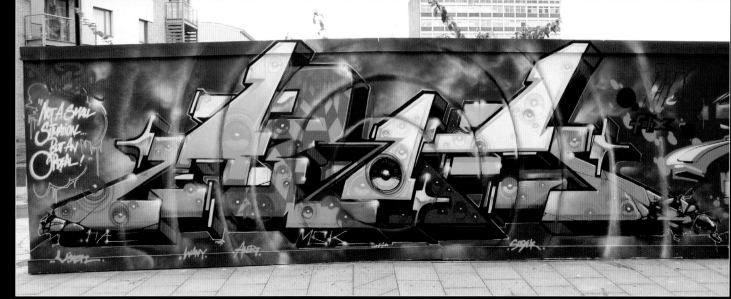

Sonic Booms, Brighton 2011,
photo by Steam156

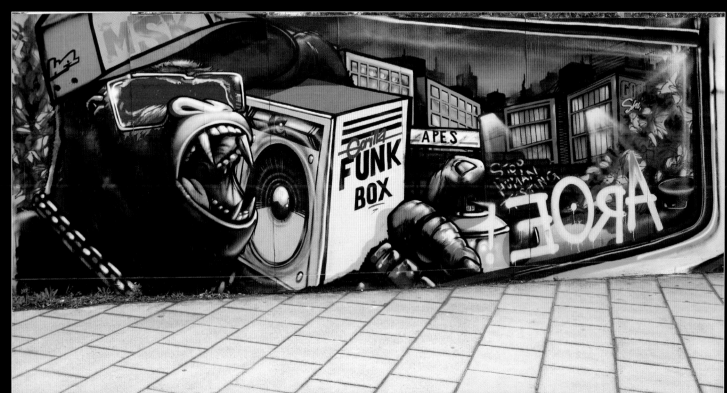

Heavyweight Primate, Brighton 2011,
photo by Steam156

Astek

Artist = Astek
Location = South London
Painting since = 1986
Crews = TNB (The Nasty Boys), KD (Kings Destroy)
Quote = I would describe my style as burner style. I strive to achieve very wild complex pieces. I switch from lots of colour to no colour in my style to complement my fierce and dark styles.
My style is always very worked on, very polished; I always aim for perfection.
Website = www.astekz.com

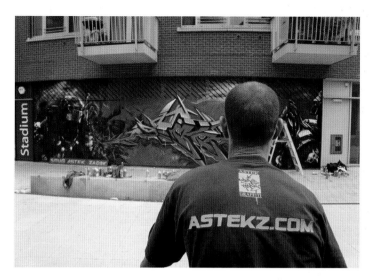

Meeting of Styles: London 2010, photo by Steam156

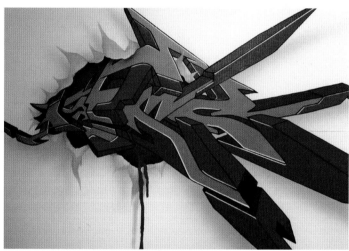

Best Gallery Show: London 2006, photo by Steam156

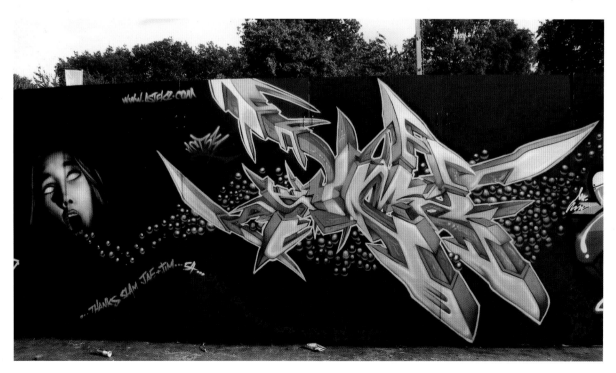

Write 4 Gold: London 2006, photo by Steam156

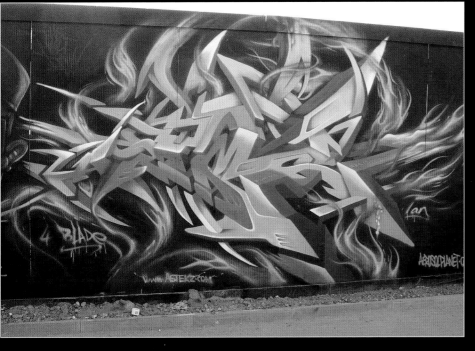

Sleeping Giants Jam: Brighton 2006, photo by Steam156

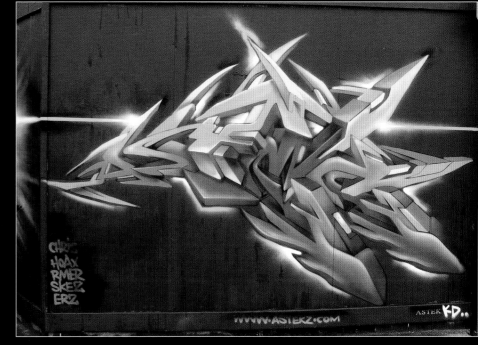

Meeting of Styles: London 2009, photo by Steam156

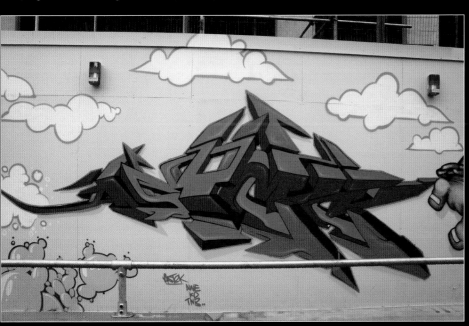

London 2010, photo by Steam156

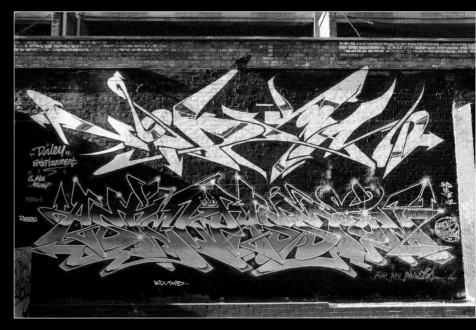

Astek/Vodker, Meeting of Styles: London 2011, photo by Steam156

Blam

Artist = Blam
Location = Kent
Painting since = 2002
Crews = none
Quote = I'd describe it as photorealistic with a twist. I like to try and use images and make them my own rather than make them identical—either using different colours or placing them in a different context.
Website = www.blam.org.uk

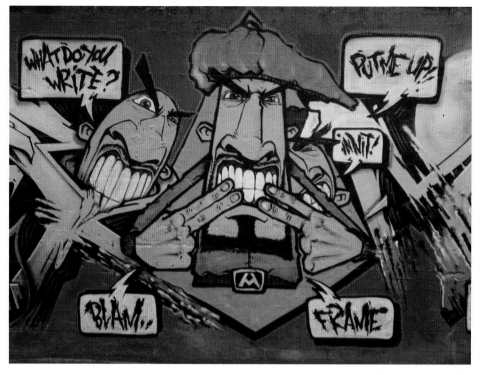

Frame/Blam, London 2011, photo by Blam

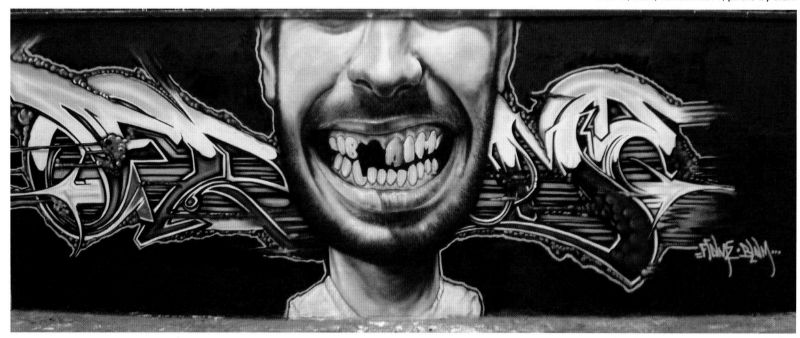

Frame/Blam, London 2011, photo by Blam

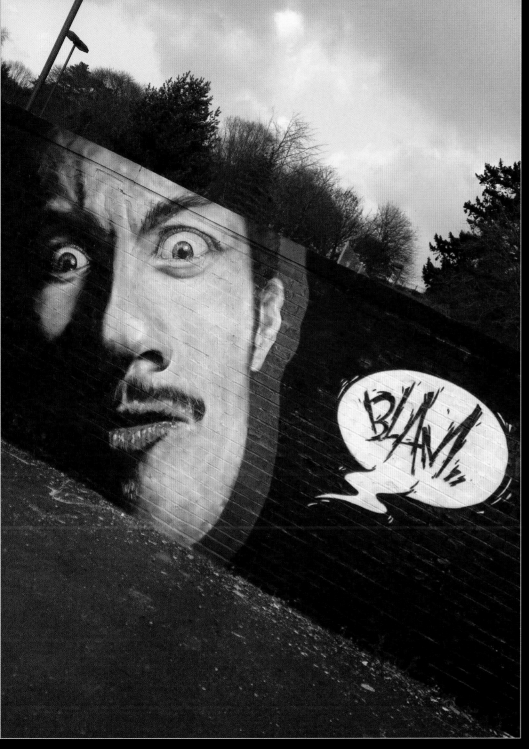

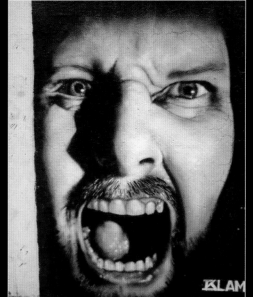

London 2009, photo by Blam

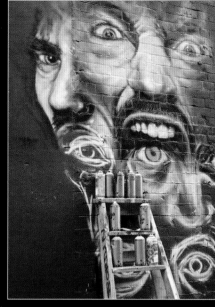

Meeting of Styles: London 2010, photo by Steam156

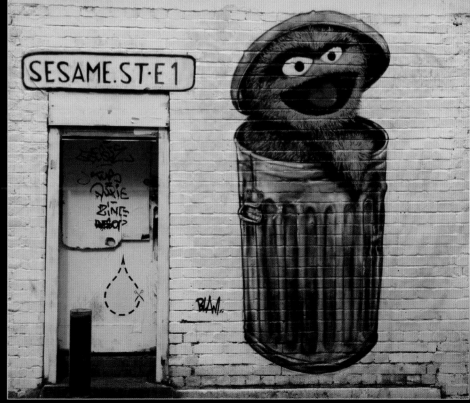

Devon 2010, photo by Blam

London 2011, photo by Steam156

Bonzai

Artist = Bonzai
Location = London
Painting since = 1989
Crews = ILW (Infamous Last Words)
Quote = I first became involved in graffiti when the first wave of hip-hop hit the UK shores in the mid 80s. I have been living in London for the past 10 years; since moving to London I have wanted to push myself and see where I could take the art form. At the turn of 2010, I totally switched up my style and set myself a target of painting as many pieces as possible in a totally new style. Meeting and painting with like minded artists, mixed with not being afraid to try new ideas and unusual colour schemes, I found my niche. I'm constantly pushing myself and my work to new levels and strive to make every piece more complex, colourful—a progression from the last.
Website = www.bonzaione.com

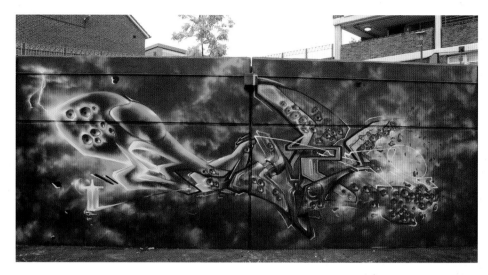

London 2010, photo by Steam156

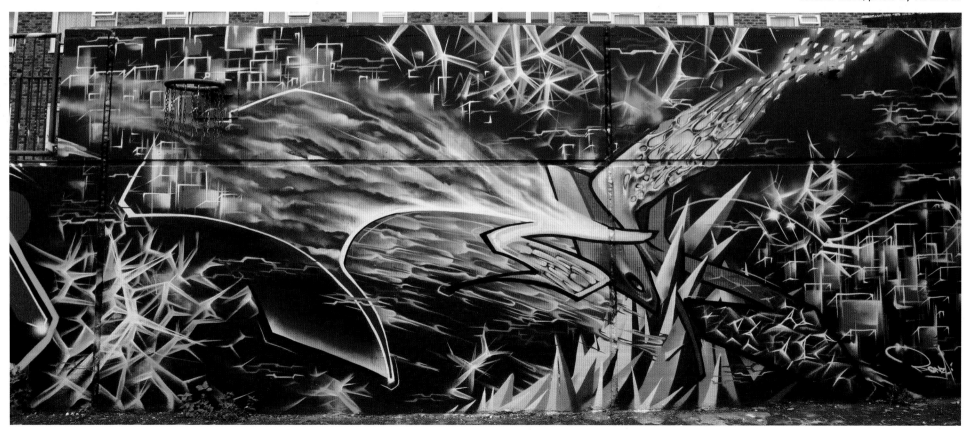

London 2011, photo by Steam156

28

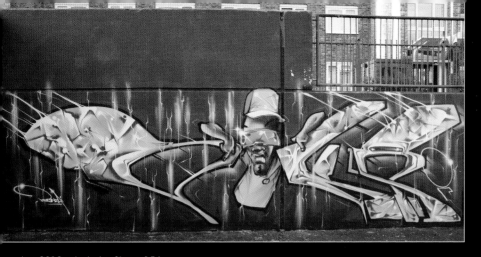

London 2010, photo by Steam156

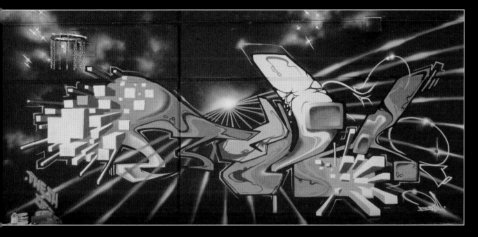

London 2010, photo by Steam156

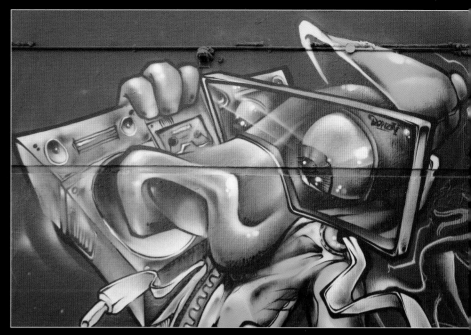

London 2011, photo by Steam156

Bonzai/Vibes, London 2010, photo by Steam156

Brave one

Artist = Brave one
Location = Essex
Painting since = 1988
Crews = TUS (The Usual Suspects)
Quote = Style is something you develop over years, sometimes decades! Everyone has a style, an approach. Little traits and habits in the way they paint—little subtleties in design and technique.

I like to think that my letter style, whilst being unique, also has elements of all the best things I saw other artists do whilst growing up! Artists like URGE, SHOK, ASTEK, SEIZE, K-LINE, and of course REAKT. These guys set standards in the 80s which you can still judge style and validity by today.
Website = www.braveone.co.uk

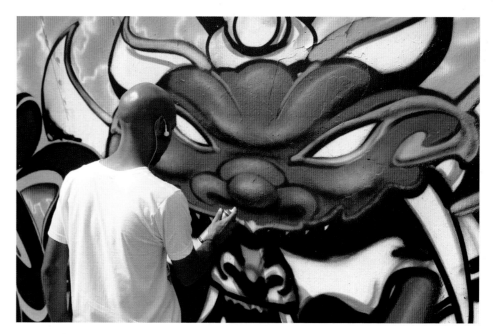

Lakeside Old School Jam: Essex 2011, photo by Steam156

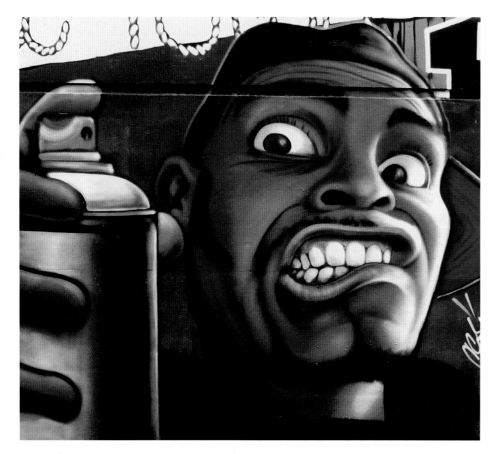

London 2007, photo by Brave one

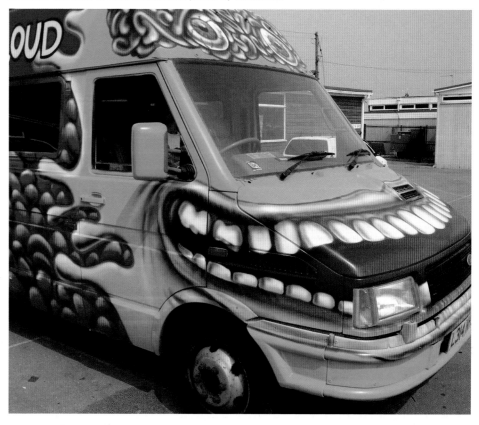

Bum in the Mud Festival: Essex 2007, photo by Brave one

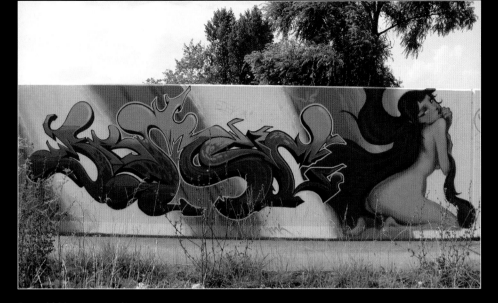

Essex 2009, photo by Steam156

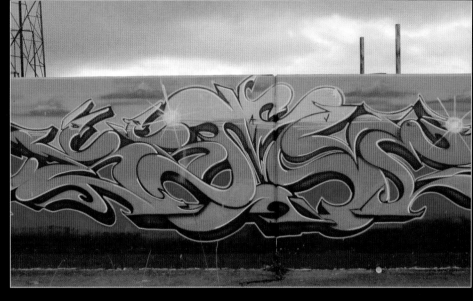

Essex 2009, photo by Steam156

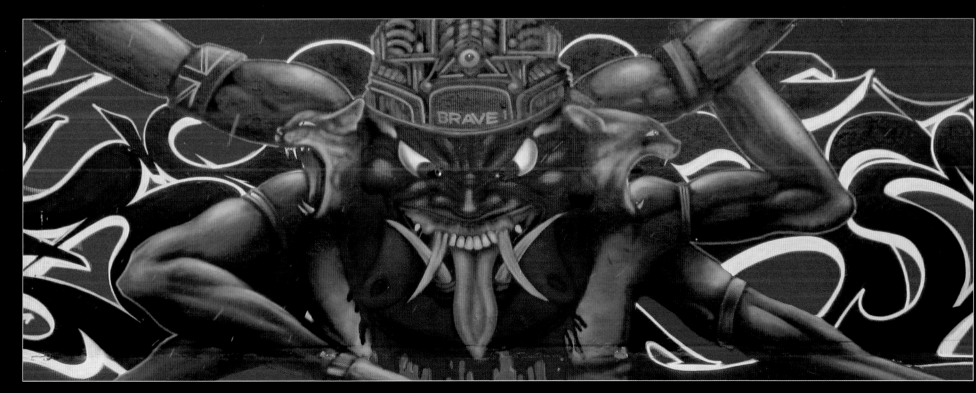

Essex 2009, photo by Steam156

Carl

Artist = Carl
Location = North London
Painting since = 1983/84
Crews = STP (So Tough Posse), MOM (Moments of Madness)
Quote = I always think that style is something you stumble upon by luck and hard work—highlighting the small things into something that becomes personal, like a tag. I do think style is important, as it's your signature and your mark in a particular area.

Meeting of Styles: London 2010, photo by Steam156

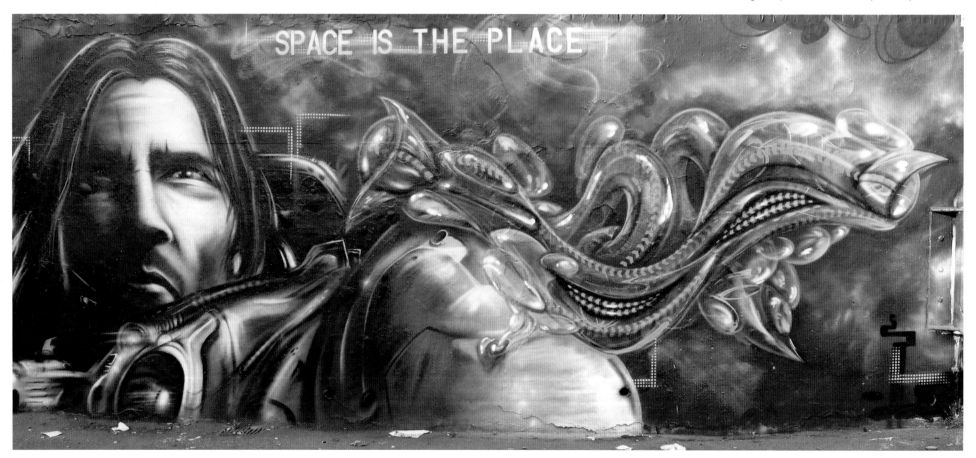

Space Is the Place (character by Trans1), London 2010, photo by Carl

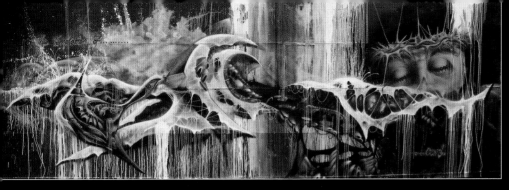

The Temptation of Carl, Cambridge 2011, photo by Carl

Carl vs Carl, Cambridge 2011, photo by Carl

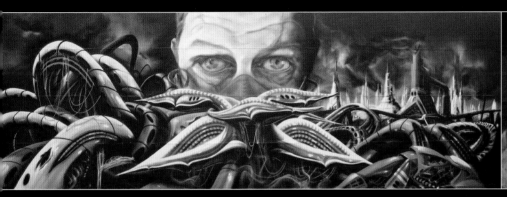

In the Wastelands of Carl's Mind, Cambridge 2010, photo by Carl

Got Me Pipe but Not Ready to Find My Slippers!, Cambridge 2011, photo by Carl

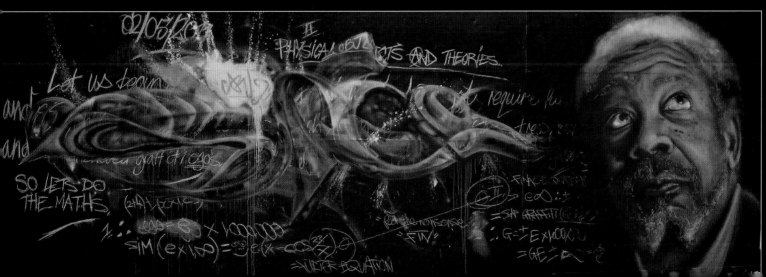

So, Who Messed Up My
Blackboard of Thought?,
Cambridge 2011, photo by Carl

Cept

Artist = Cept
Location = London
Painting since = 1986
Crews = TRP (The Rolling People, Tottenham Rockit Patrol, The Rebel Panzas)
Quote = I would describe my style as: Cold rock stuff from a funk galaxy cartoon planet at the edge of the psychedelic universe, turn left, down the alley, over the tracks and it's roughly in that bit by the shops.
Website = www.spradio.com

Cept/Eine, London 2003, photo by Cept

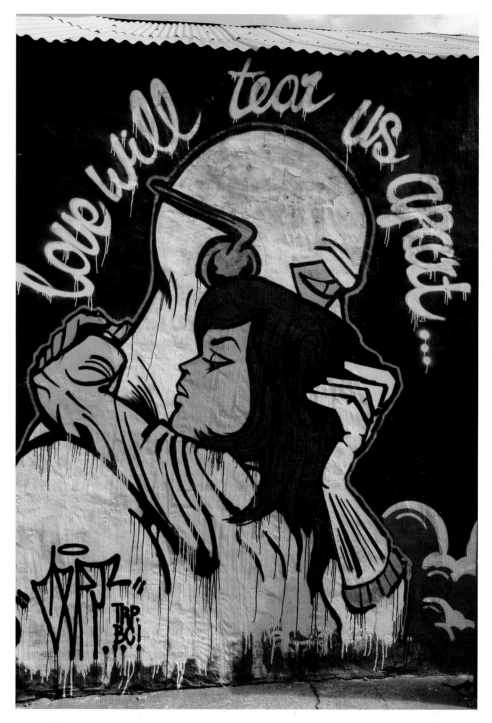

London 2010, photo by Steam156

London 2010, photo by Steam156

London 2010, photo by Cept

London 2010, photo by Steam156

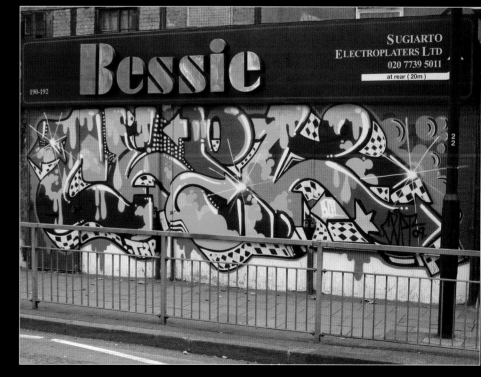

London 2009, photo by Cept

Choci Roc

Artist = Choci Roc
Location = North London
Painting since = 1983
Crews = AWE (All World Experts), WRH (We Rock Hard), Rocstars
Quote = Firstly, the word graffiti means nothing to me. B-boy culture is where it's at for me—writing, breaking, MCing, DJing. These are the basic elements that mean a lot to me. The punk ethic of doing it for yourself is what the origins of b-boy culture mirrored.
Website = www.teamrobbo.org

Shy147 for Duro, London 2011, photo by Choci Roc

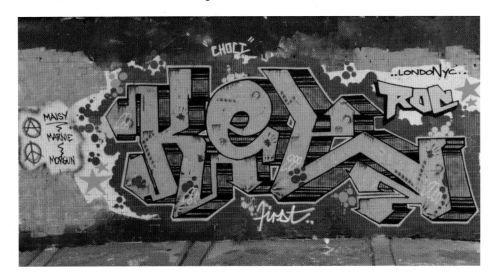

Kel First, London 2010, photo by Choci Roc

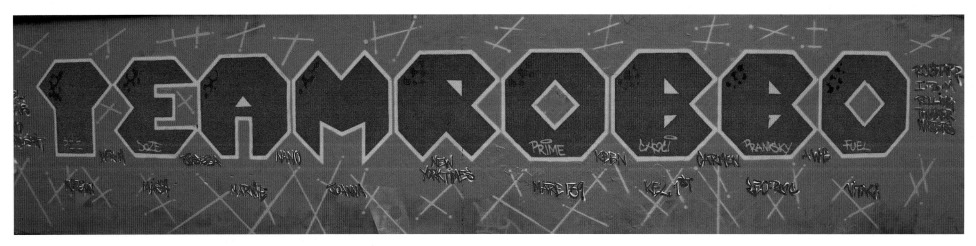

London 2011, photo by Choci Roc

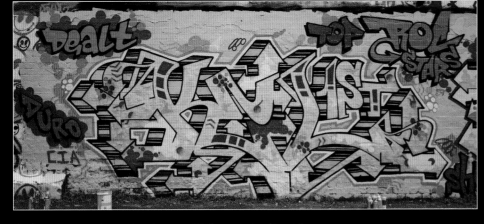

Kel 1st, Choci Roc/Keen Roc, London 2010, photo by Choci Roc

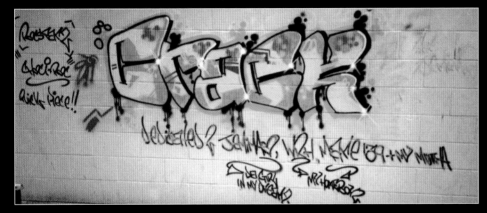

Crack, London 1986, photo by Choci Roc

London 2011, character by Astek, photo by Choci Roc

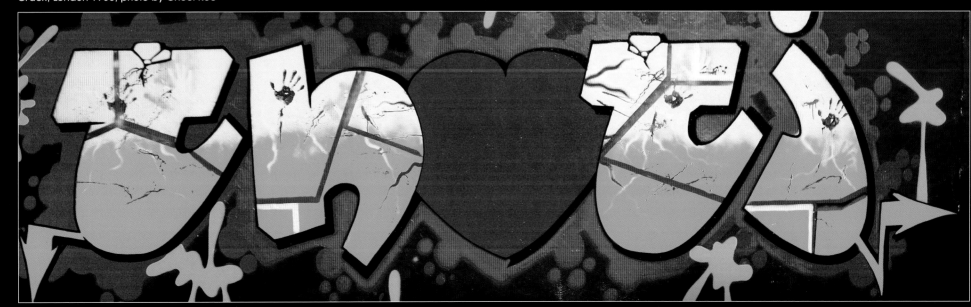

London 2010, photo by Choci Roc

Chu

Artist = Chu
Location = Walsall
Painting since = 1983
Crews = Ikonoklast
Quote = Graffiti has always meant: to apply paint to a public surface without permission. In my opinion, it can still be defined as graffiti if permission has been given, against the wishes of most of the media. Even though its origin is from the Italian word meaning inscribe, there is a romantic notion that implies it began on the walls of caves, for early humans to communicate en masse. There are as many different types of graffiti as there are graffiti artists; graffiti nowadays defines a technique, not simply the act.

The story of graffiti has been altered by the notion that it can be any piece of visual art that ensconces to be derived from a graffiti ethic, application, or with imagery normally borne of aerosol murals. Commercialism has taken over the graffiti community: everyone is out to make some fast coin, from painting anything similar to other successful artists, or aligning with desperate attempts to house "collected works" in galleries in the hope that free drinks will entice visitors to the launch party to part with their (hard) earned cash. A very different graffiti world to one which set out to oppose commercialism, but employ methods from the realm of advertising to broadcast personal ideals or messages to the outside that things aren't quite what they seem. Gallery owners, early adopters of artwork, and some photographers, claim a stake in the graffiti community as if it wouldn't be possible without their support.

Graffiti belongs to the graffiti writers, the only solace for expression that empowers an otherwise unheard voice. Anything less isn't graffiti, it's just art.
Website = www.schudio.co.uk/blog

Berlin 2010, photo by Chu

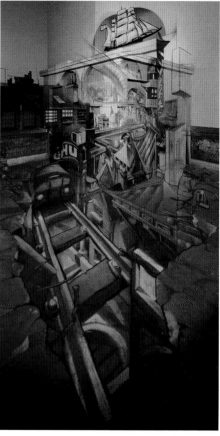

London 2010, photo by Chu

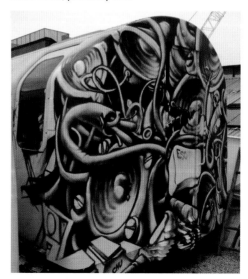

London 2008, photo by Chu

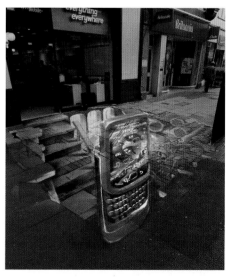

Everything Everywhere, Manchester 2011, photo by Chu

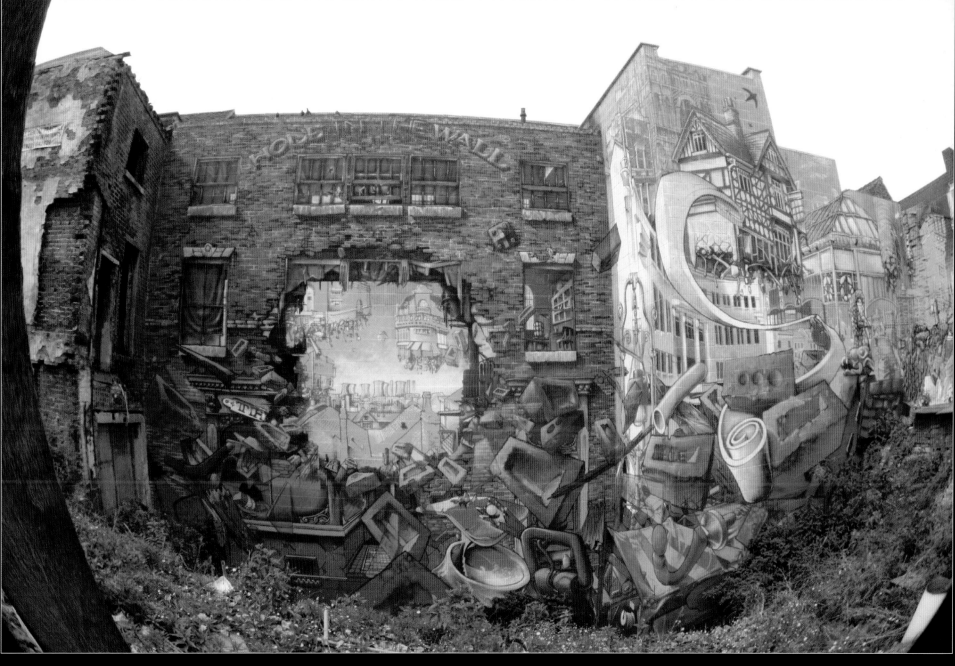

Hole in the Wall, Walsall, photo by Chu

Chum101

Artist = Chum101
Location = Brighton
Painting since = 1985
Crews = TO (The Others), AZ (Astro Zombies)
Quote = For want of a better term, and off the top of my head, I'd describe my style as Nextcentric Cartoon Perversions of Letterform Psychedelia, haha! I have a lot of obsessions from outside of graffiti that bleed into my approach. I'm currently really into historical engravings and woodcuts. Pursuing ambitions within tattooing is also a big influence, in terms of imagery from the history of that tradition.

Splash Art Jam: Surrey 2011, photo by Steam156

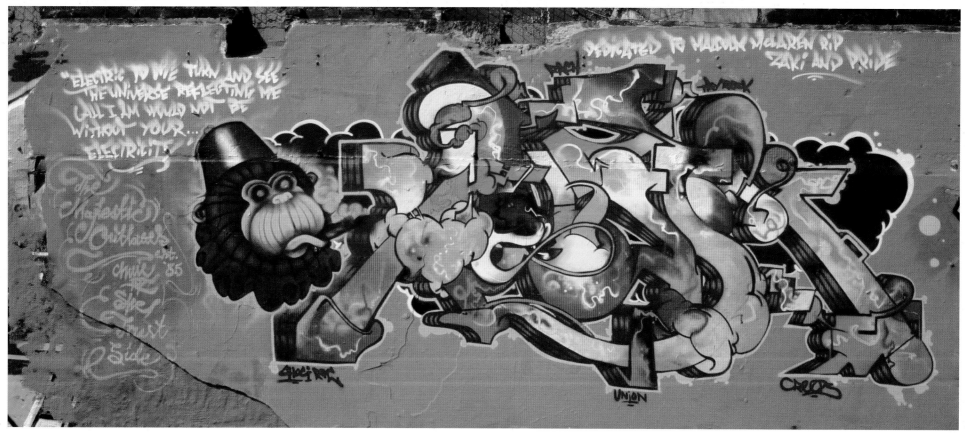

Electrorock, Brighton 2010, photo by Datachump

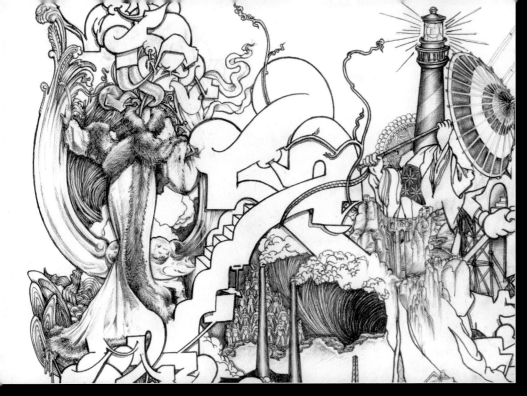

Nextcentricity, ink on paper (left hand detail), photo by Chum101

Nextcentricity, ink on paper (middle detail) 2011, photo by Chum101

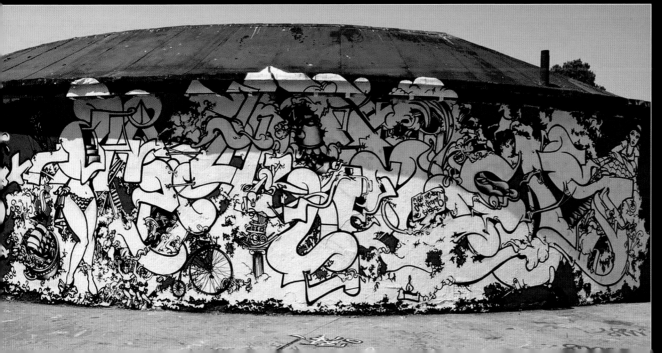

The Level Headed Mental Wealth Service, Brighton 2011, photo by Datachump

41

Corze

Artist = Corze
Location = West London
Painting since = 1985
Crews = SBS (Subway Saints)
Quote = Chunky funky letters with extreme fills. Always evolving and trying to be original.

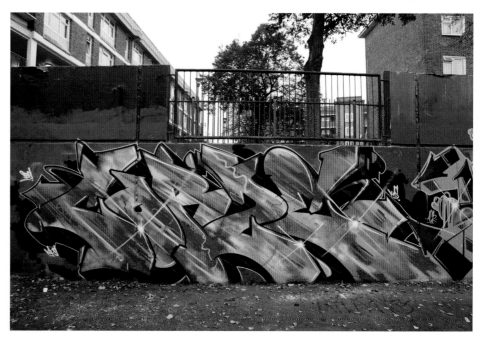

London 2011, photo by Steam156

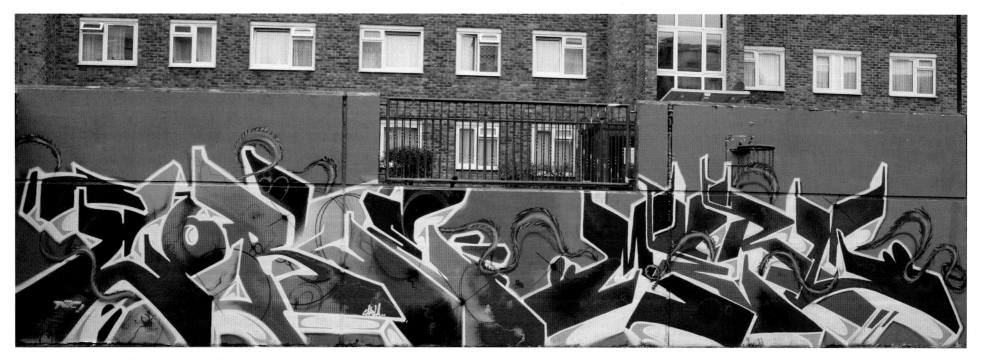

Corze/Merc, London 2010, photo by Steam156

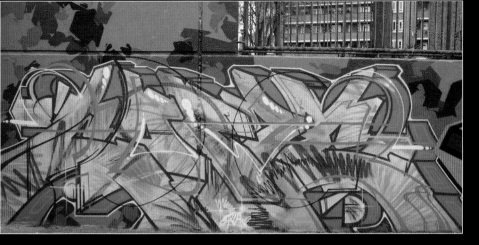

London 2011, photo by Steam156

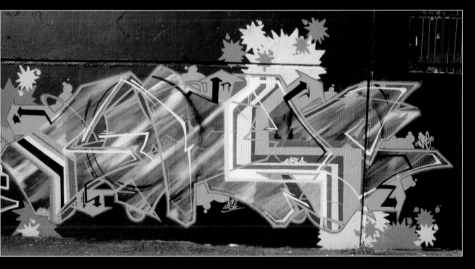

London 2011, photo by Steam156

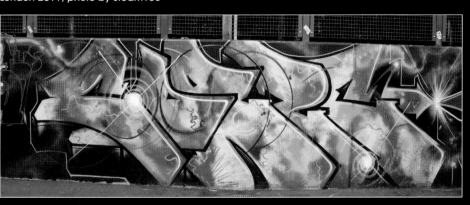

London 2011, photo by Steam156

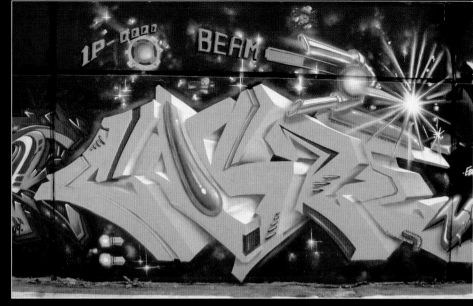

London 2009, photo by Steam156

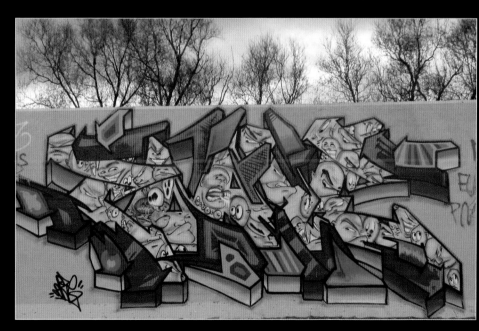

Essex 2009, photo by Steam156

43

Crane

Artist = Crane
Location = East London
Painting since = 1983
Crews = DPC (Da Perfect Crime)
Quote = It's never stopped being about getting my name out there, but these days I don't really think of it like that. It's more about being able to get out paint with good people and have a laugh, share experiences, and strengthen bonds. The fact that I can put life on hold for a few hours is a welcome bonus, too.

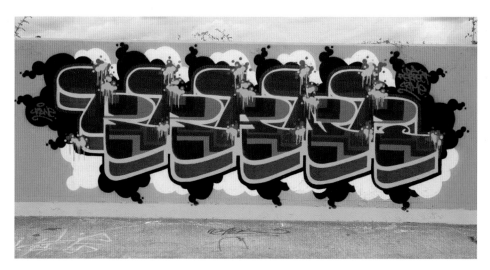

Essex 2010, photo by Steam156

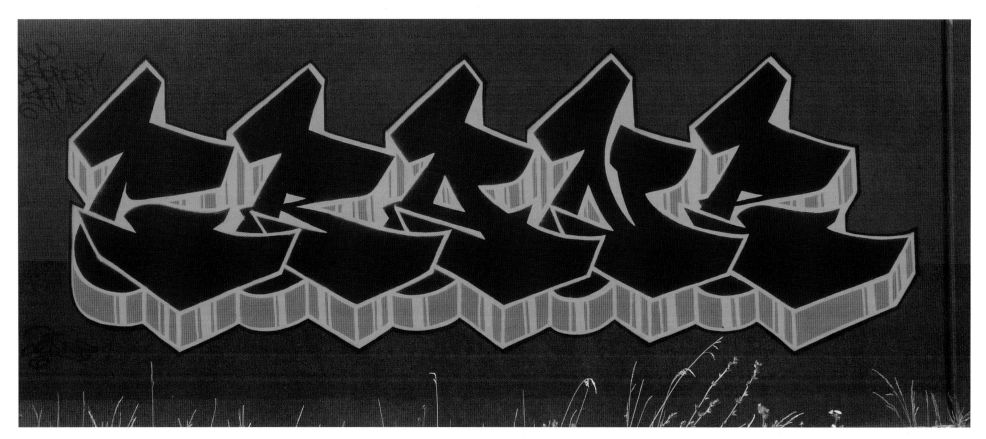

Essex 2009, photo by Steam156

44

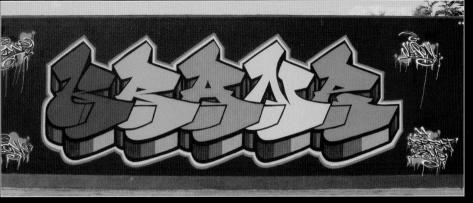
Essex 2009, photo by Steam156

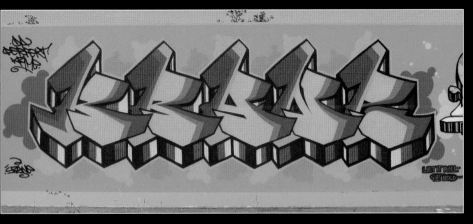
Essex 2009, photo by Steam156

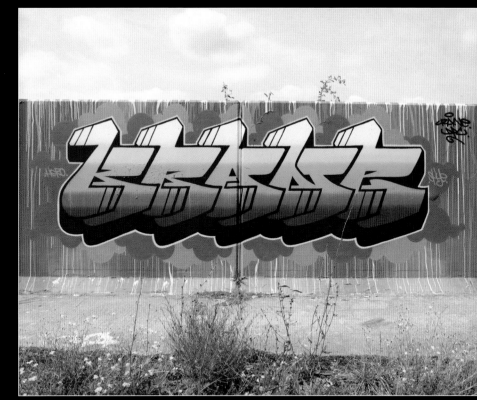
Essex 2011, photo by Steam156

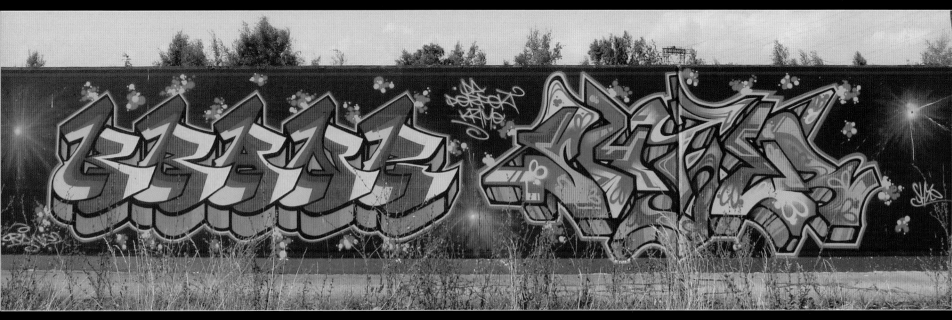
Crane/Shye131, Essex 2009, photo by Steam156

45

Crok

Artist = Crok
Location = London
Painting since = 1985
Crews = TBF (The Buff Fails), TRC (The Religious Cult)
Quote = My style—predatory, cold-blooded, biologically complex beneath, streamlined on the surface.
Website = www.thebufffails.blogspot.com

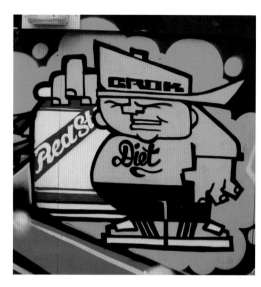

London 2011, photo by Steam156

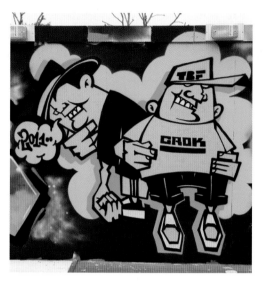

London 2011, photo by Steam156

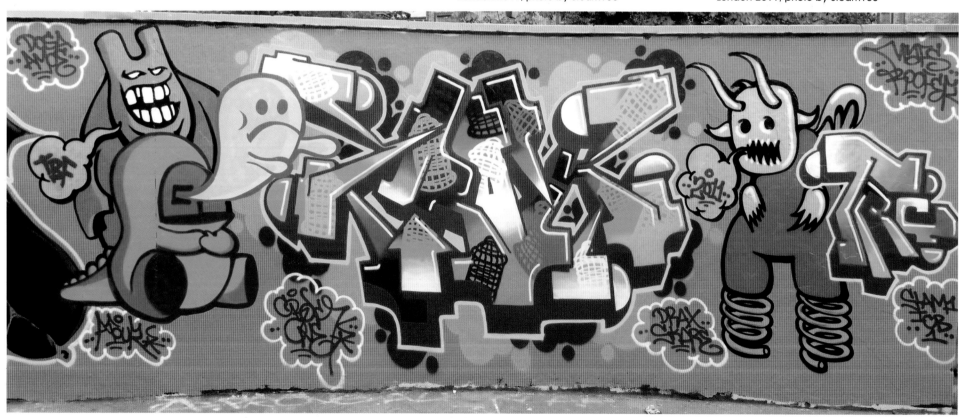

London 2011, photo by Crok

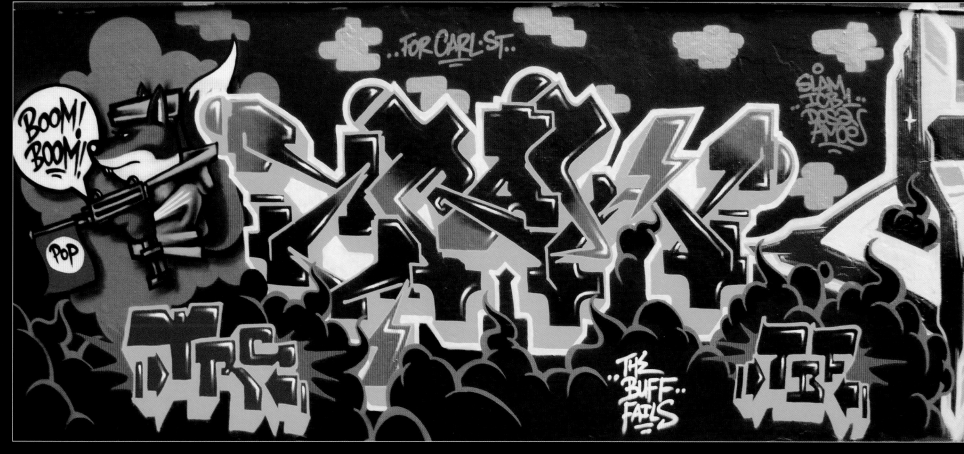

London 2011, photo by Crok

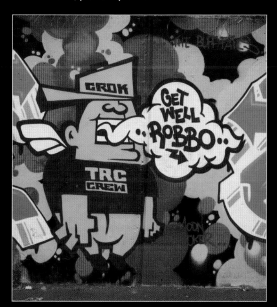

London 2011, photo by Steam156

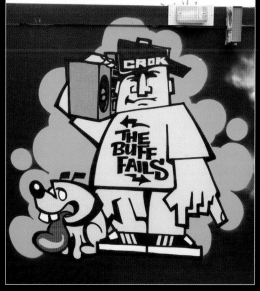

London 2011, photo by Steam156

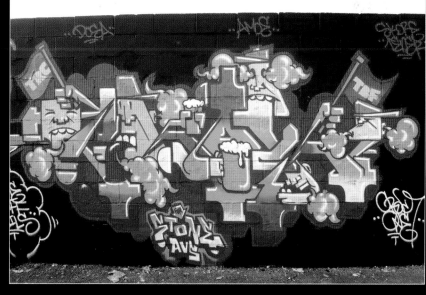

London 2011, photo by Crok

Crome

Artist = Crome
Location = West London
Painting since = 1998
Crews = RT (Represent)
Quote = My style—static and OCD neat (aka—a bit boring), but hopefully improving.

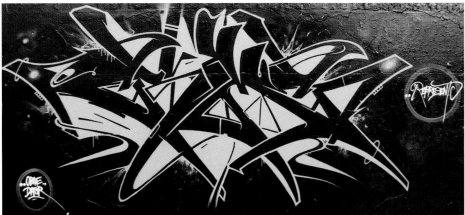

London 2009, photo by Crome

Meeting of Styles: London 2011, photo by Steam156

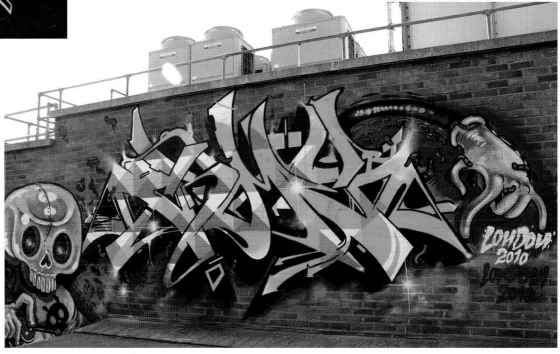

London 2010, photo by Crome

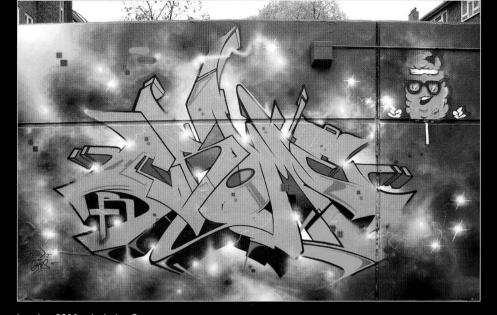

London 2011, photo by Crome

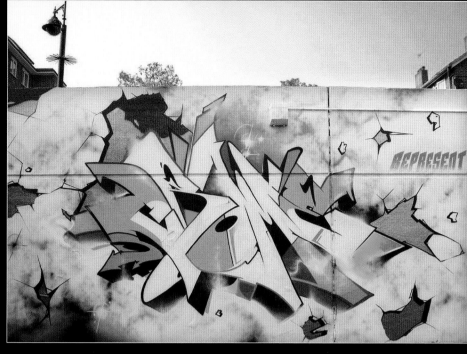

London 2011, photo by Crome

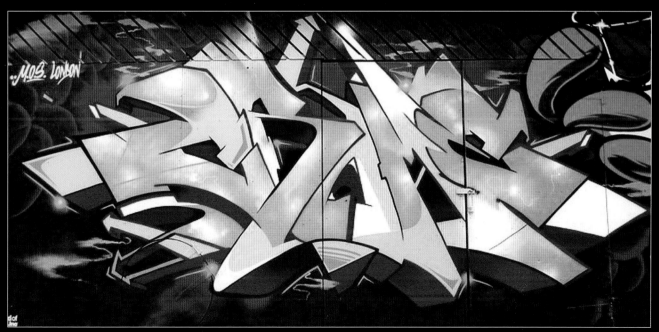

Meeting of Styles: London 2011, photo by Crome

London 2011, photo by Crome

Cruel103

Artist = Cruel103
Location = Manchester
Painting since = 1985
Crews = AMP (After Midnight Psychos), BYB (Bad Yard Boyz)
Quote = Graffiti means to me—the never ending quest to get up and get over. Graffiti makes the whole world my playground. Graffiti is the truth that strikes after midnight and knocks your senses for six, and it goes on and on till the break of dawn. I write therefore I am. Graffiti is not my hobby, it's my life.

Nottingham 2011, photo by Cruel103

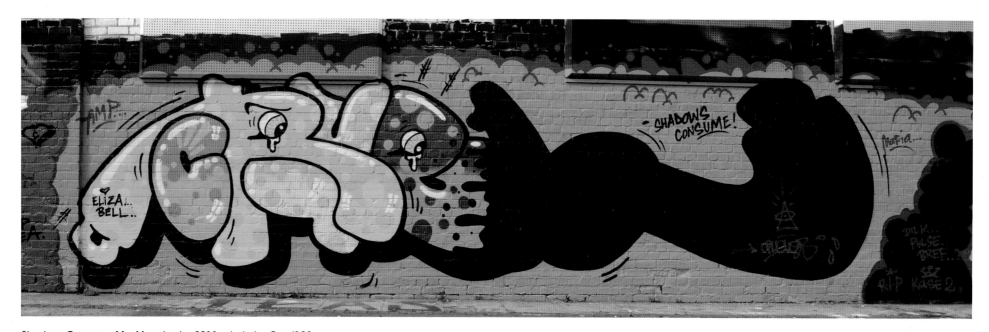

Shadows Consume Me, Manchester 2011, photo by Cruel103

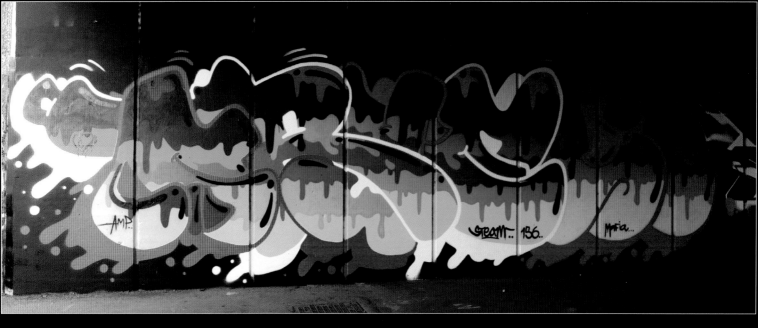

Aerosolplanet Jam: Tamworth 2011, photo by Steam156

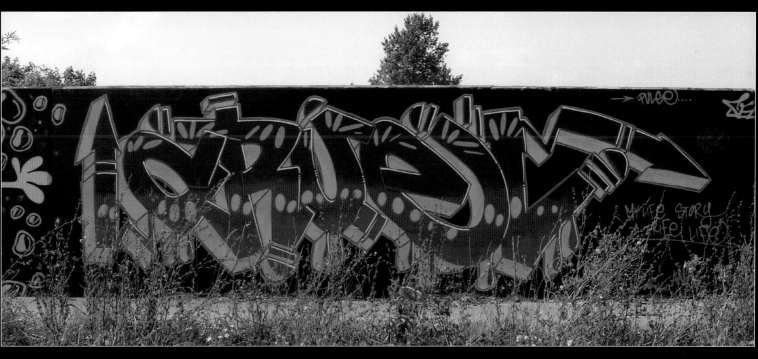

Essex 2010, photo by Steam156

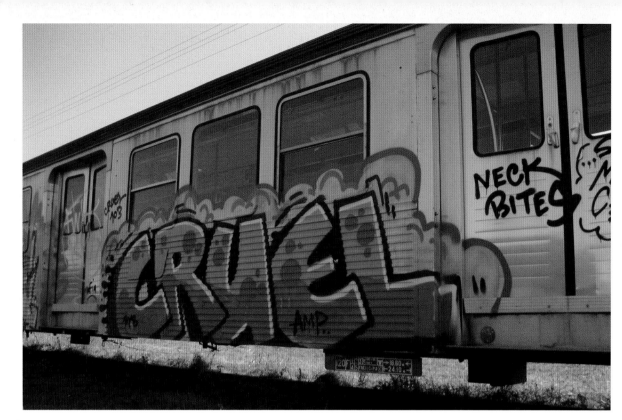

Transylvania 2011, photo by Cruel103

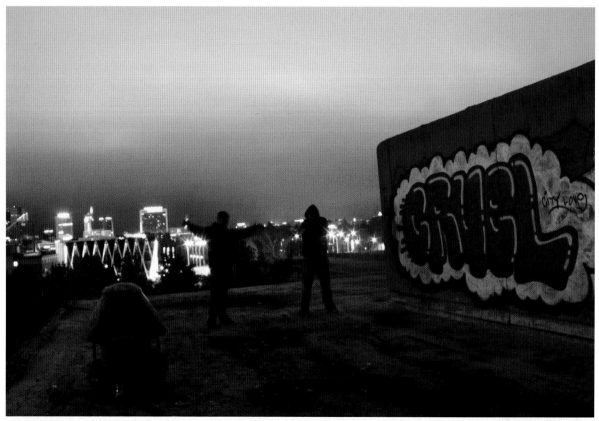

Estonia 2011, photo by Cruel103

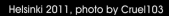
Helsinki 2011, photo by Cruel103

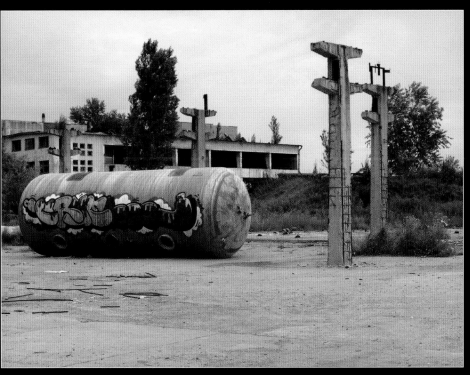

Bucharest sausage, Bucharest 2011, photo by Cruel103

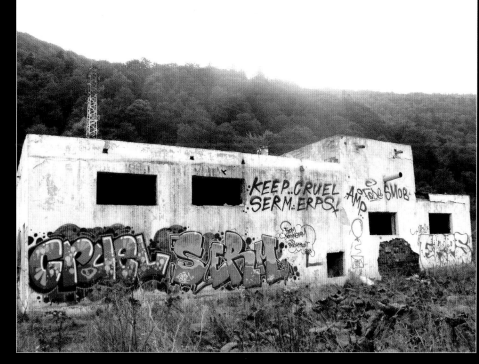

Cruel/Serm, Carpathian mountains 2011, photo by Cruel103

Cry

Artist = Cry
Location = Essex
Painting since = 1990
Crews = none
Quote = Graffiti has become my life as much as sleeping or eating. I see walls in my dreams, wake up and try to write down the concept. I lost touch with graffiti a while back for various reasons and spent a long time denying that part of myself. When I came back into it, the first thing I did was shed the restraints of that old skin and I feel I've been metamorphosing ever since. I've grown more and more into myself and it's the thing that makes me, "me." Life never gets in the way anymore, unless I choose to allow it to, and no one will ever be able to take it from me. Graff honestly is the most important thing to me. The friends I've made, the places I've been, I feel blessed. In a perfect world I'd be a graffiti tourist, going around the world, sleeping on floors and painting every waking moment. Then spending the evening toasting the day's effort, toasting the weather for not being British, and toasting just about any thing we can.

Girls on Top Jam: London 2011, photo by Steam156

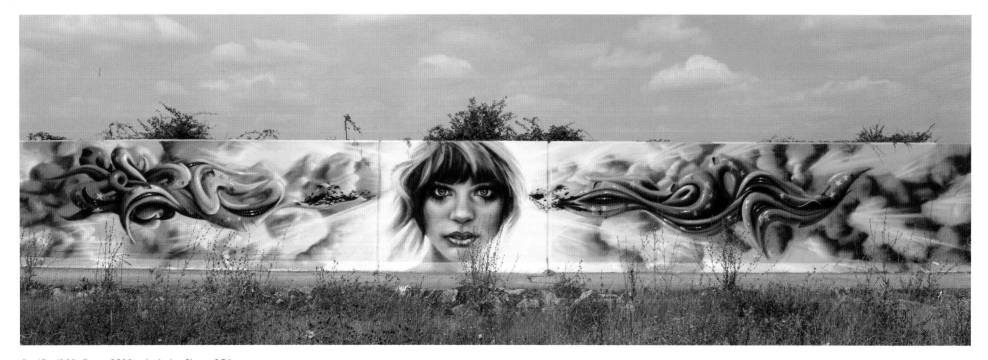

Cry/Carl131, Essex 2011, photo by Steam156

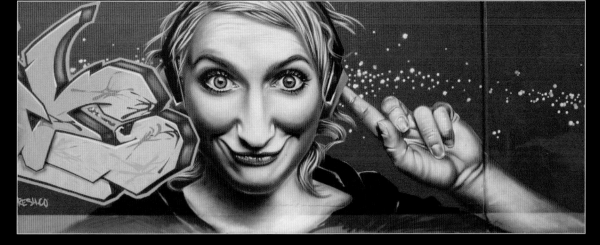

Essex 2011, photo by Steam156

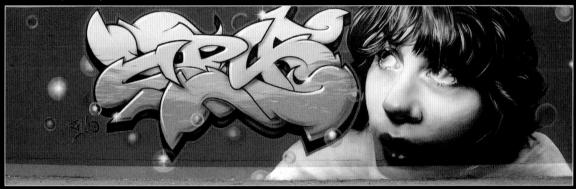

Essex 2010, photo by Cry

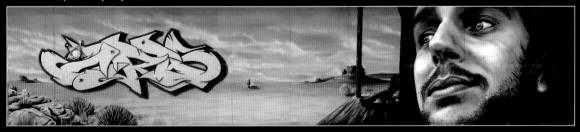

Wildwest, Cambridge 2011, photo by Cry

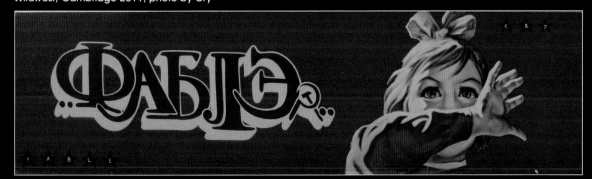

World Wide Foot, Essex 2009, photo by Cry

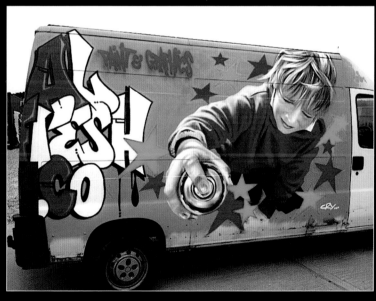

Cry/Kilo, Cambridge 2011, photo by Cry

55

Dane

Artist = Dane
Location = South London
Painting since = 1987
Crews = VOP (VISIT OTHER PLANETS)
Quote = Graffiti is like an imaginary friend for life; just when you think you've grown out of it, it urges you to do something. Sometimes you can't resist.
Website = www.mrdane.co.uk

London 2008,
photo by Dane

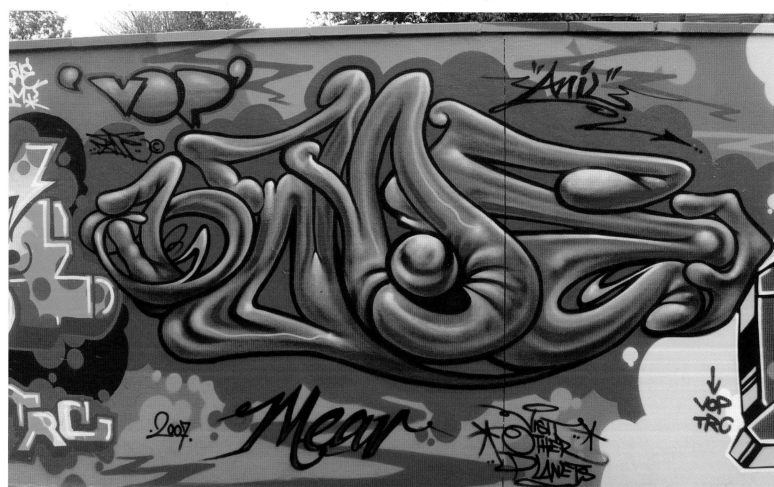

London 2007,
photo by Dane

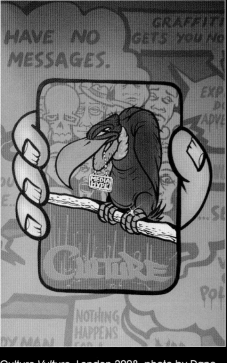

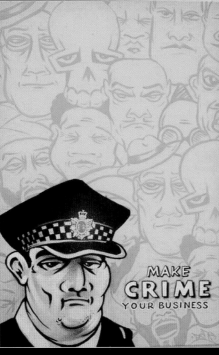

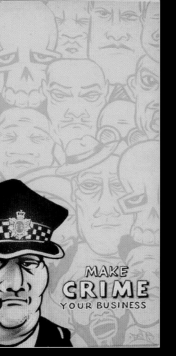

Culture Vulture, London 2008, photo by Dane

Make Crime Your Business, London 2008, photo by Steam156

Luton 2007, photo by Dane

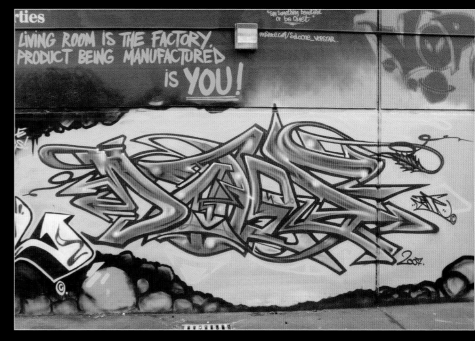

Love and Hate, London 2007, photo by Dane

London 2007, photo by Dane

Dasr

Artist = Dasr
Location = North West London
Painting since = 1994
Crews = Rarekind / Parklifers
Quote = Style is the main source of a good healthy graffiti career. If you don't have a style, your paintings can end up in a pile of photos that all look the same. You need people to see one letter or even the first bar to you letters and know it's you; you have to be distinct. I've tried in my career to work on my own style and not compromise my letters. They have served me well. I'll treat them with the same respect.
Website = www.rarekindlondon.com

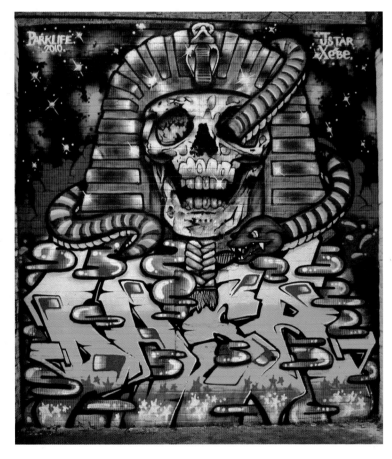

London 2010, photo by Dasr

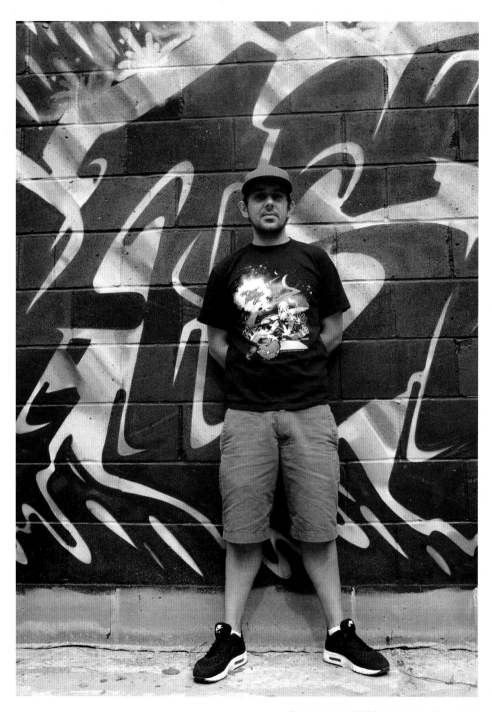

Dasr, London 2010, photo by Steam156

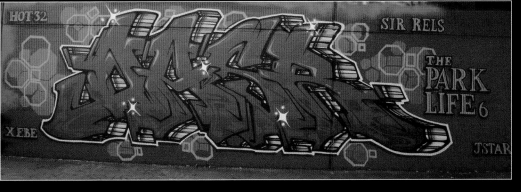

London 2010, photo by Steam156

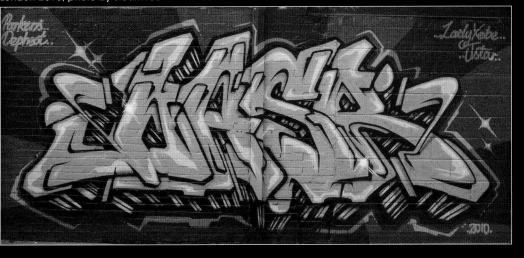

London 2010, photo by Steam156

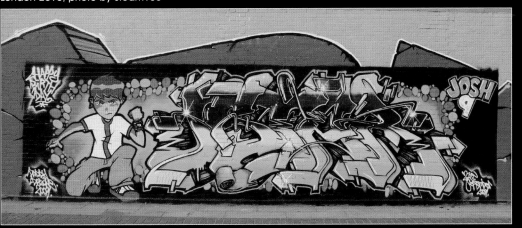

Jstar, London 2009, photo by Steam156

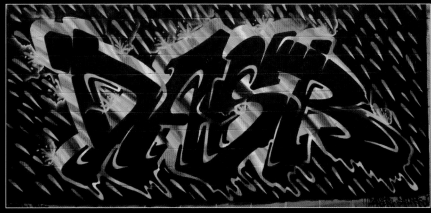

40 *Colour Disco*, London 2010, photo by Dasr

London 2010, photo by Steam156

Demo

Artist = Demo
Location = London
Painting since = 1996
Crews = LSD (Live Spray Die)
Quote = Graffiti means a life saver for me. I do it for the love, every week I go out to paint—a week without painting is like a week without food, can't have it.

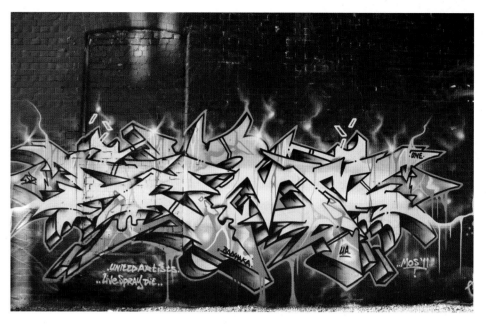

Meeting of Styles: London 2011, photo by Steam156

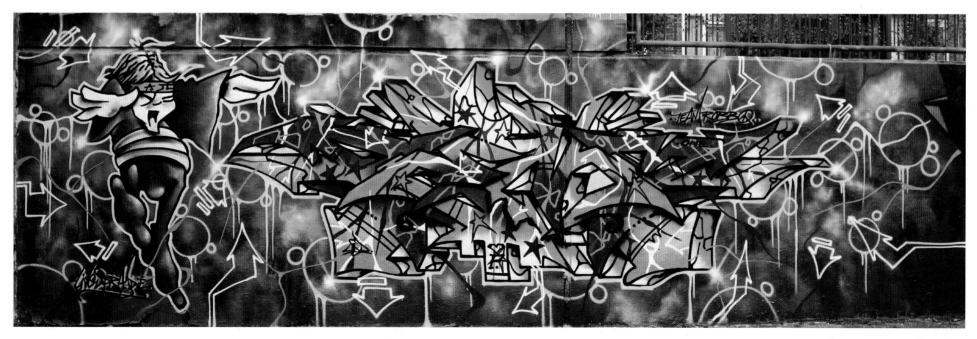

London 2011, photo by Steam156

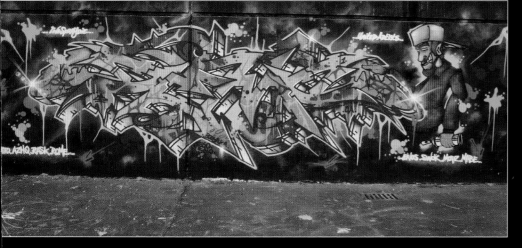

London 2011, photo by Steam156

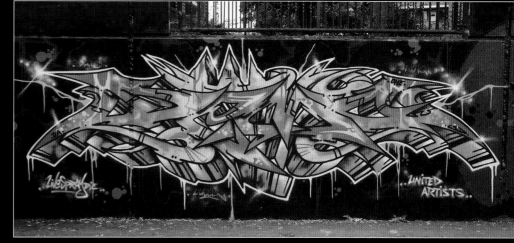

London 2011, photo by Steam156

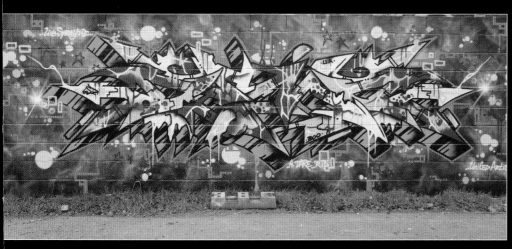

London 2011, photo by Steam156

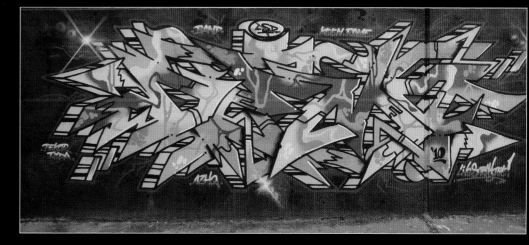

London 2010, photo by Steam156

Dep

Artist = Dep
Location = South London
Painting since = late 80s
Crews = none
Quote = I always find it hard to describe my style. It's a bit of a mix with loads of different influences from 80s skateboards graphics, graphic design, and cartoons.
Website = www.paintshopstudio.com

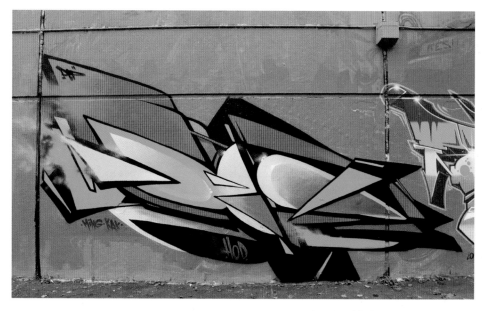

London 2011, photo by Steam156

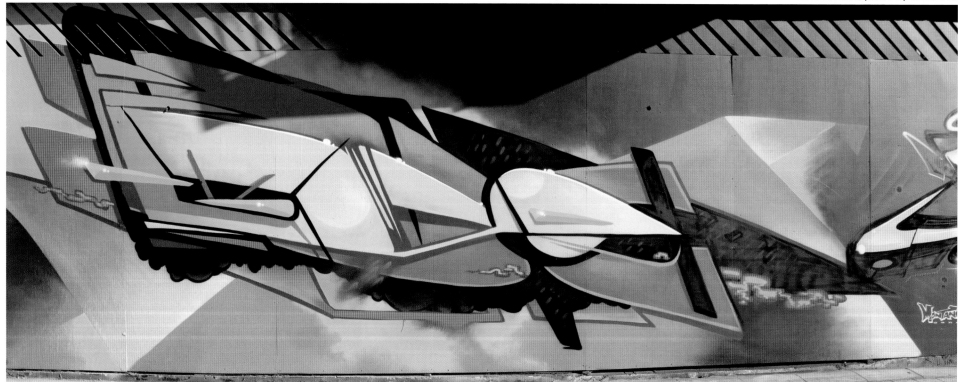

Meeting of Styles: London 2011, photo by Steam156

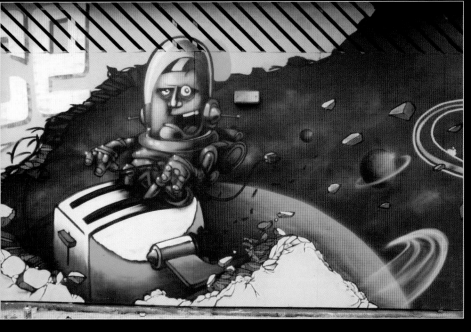

Meeting of Styles: London 2010, photo by Steam156

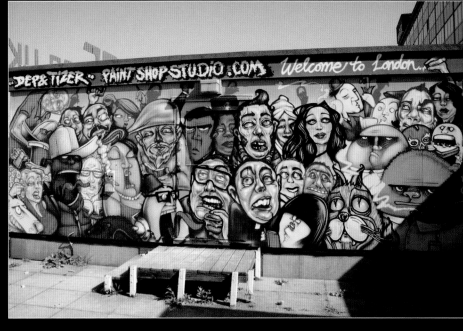

Dep/Tizer, London 2011, photo by Steam156

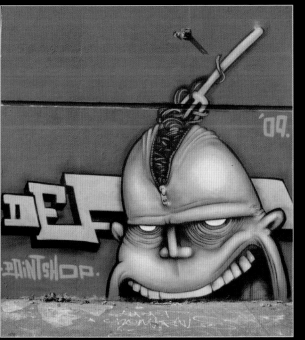

London 2009, photo by Steam156

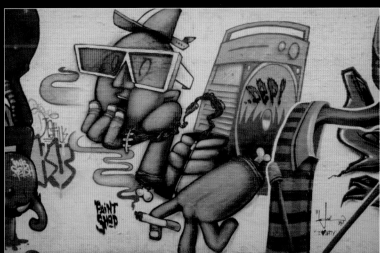

London 2011, photo by Steam156

London 2011, photo by Steam156

Ders

Artist = Ders
Location = London
Painting since = 2000
Crews = RT (Represent)
Quote = I don't really paint from proper sketches. I know people who have the whole thing worked out on paper, colours and all, and just copy that onto the wall. I'll have bits of letters on separate pieces of paper and use those as a guide when I paint. I don't really know, I like good letters but I rely on Meker, who I paint with, to come up with the colours.

Meeting of Styles: London 2011, photo by Steam156

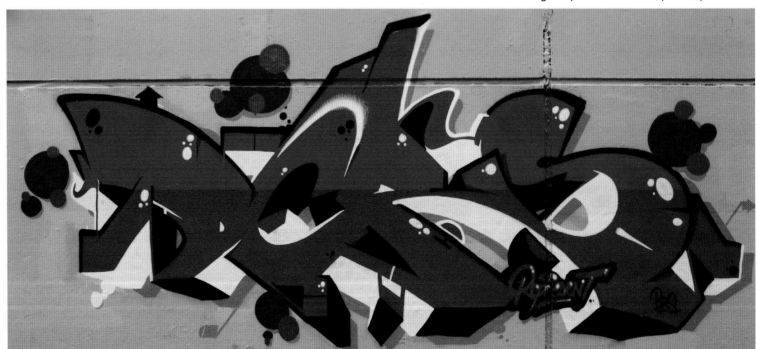

London 2011,
photo by Steam156

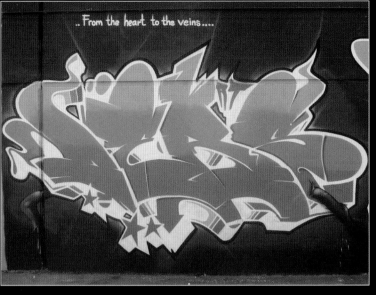

.. From the heart to the veins....

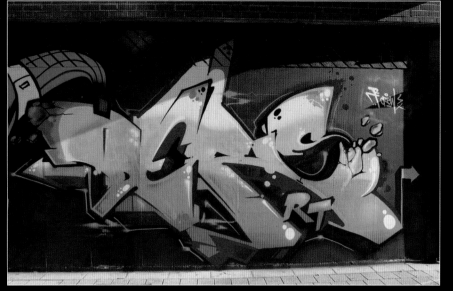

Far left:
London 2009, photo by
Steam156

Left:
Meeting of Styles:
London 2011, photo by
Steam156

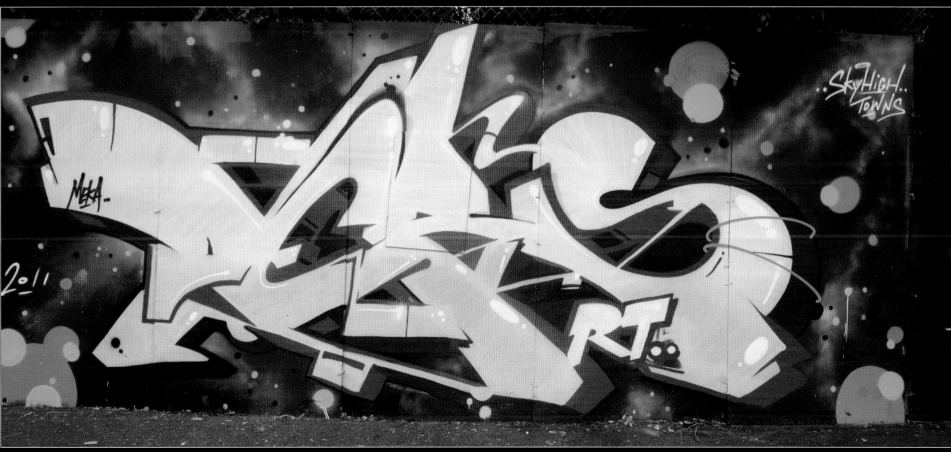

Dilk

Artist = Dilk
Location = Nottingham
Painting since = 1986
Crews = Anti Drip, FHJ (Fucking Hell John)
Quote = My style changes a little every time I paint. I would say my style moves with the times; my fills and backgrounds are well thought about and planned. They might look chaotic but the outline is always clean and precise—this is what pulls the piece together.
Website = www.dilk1.com

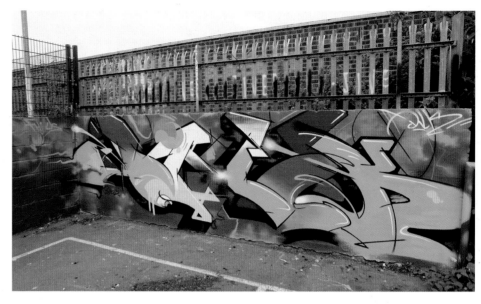

Nottingham 2011, photo by Dilk

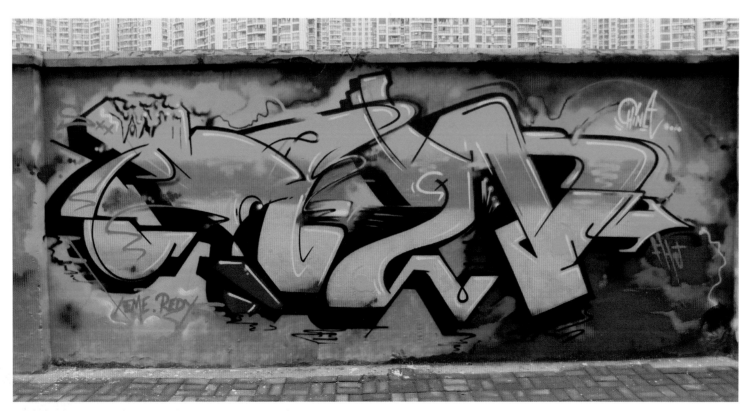

Shanghai 2010,
photo by Dilk

66

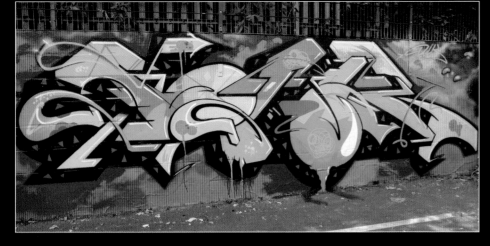

Nottingham 2008, photo by Dilk

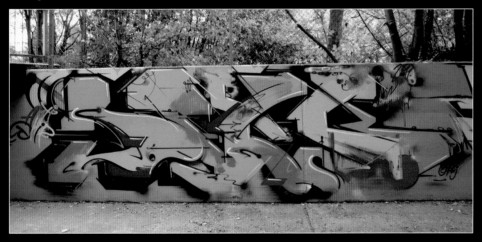

Leicester 2011, photo by Dilk

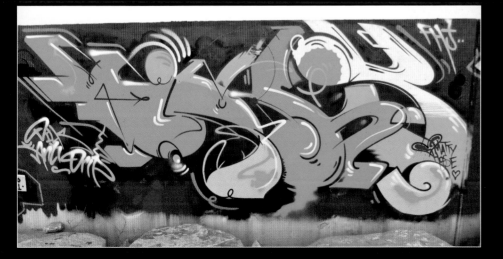

Barcelona 2010, photo by Dilk

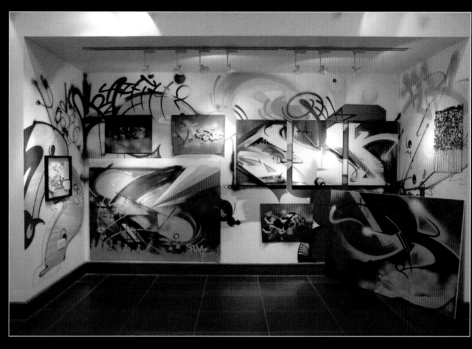

New Court Gallery: Nottingham 2011, photo by Dilk

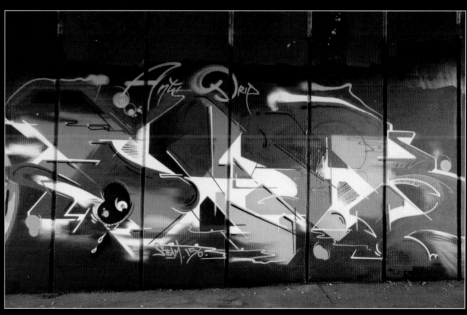

Aerosolplanet Jam: 2011, photo by Steam156

Dime one

Artist = Dime one
Location = North Wales
Painting since = 1987
Crews = CS (Cream Soda), FBA (Fast Breakin Artists)
Quote = I think it's really important to develop something that is true to yourself. It's something that defines your pieces, and other writers should be able to look and see pretty much straight away who has painted the piece—even if you can't read it straight away.
Website = www.facebook.com/pages/dime-one-northwales-graffiti-art-murals

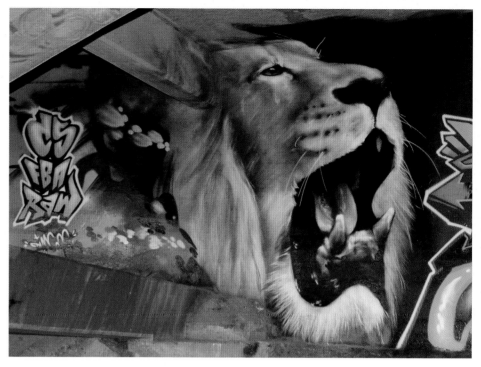

Wales 2011, photo by Dime one

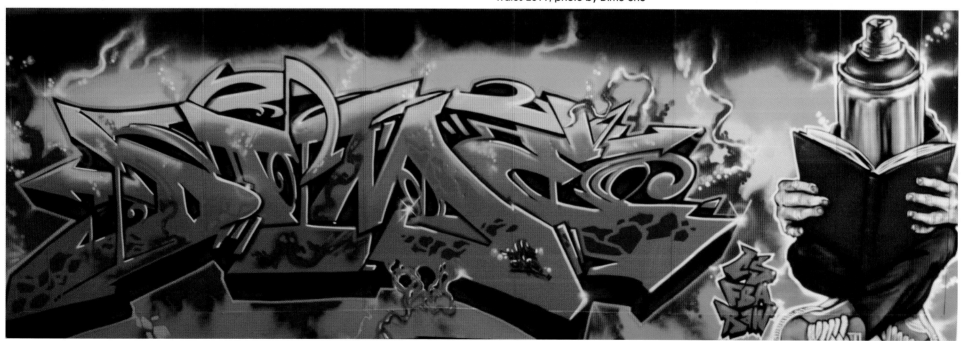

Thinking Can, Wales 2011, photo by Dime one

68

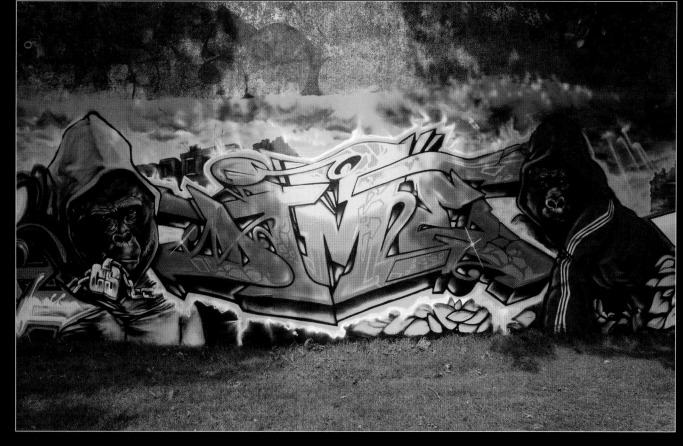

Gorillas, Wales 2011, photo by Dime one

Wales 2011, photo by Dime one

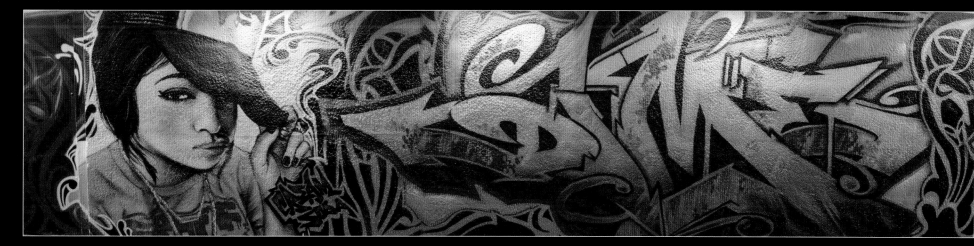

Wales 2010, photo by Dime one

Don

Artist = Don
Location = South West London
Painting since = 1985
Crews = SBS (Subway Saints), UA (United Artists)
Quote = I don't go as far to say it saved my life, because in the same breath it nearly cost mine—also could have put me in a place where I certainly could not have survived. So that was a wake up call—it does mean everything to me. It gave me a focus for sure. Like the great author of this book, who would also share the same experiences, it helped one to be organised, design/ideas, paint, photograph, document, social—a routine in my/our early years. You have to be on the ball, some more than others—and I would like to say on behalf of all of us, STEEL is never safe.
Website = www.pauldonsmith.com

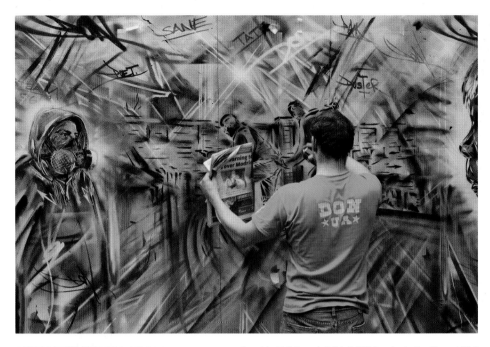

See No Evil Event: Bristol 2011, photo by Steam156

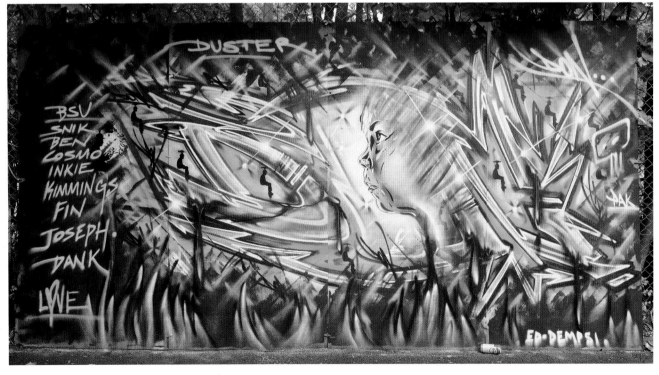

Splash Art Jam: Surrey 2011,
photo by Steam156

70

London 2009, photo by Steam156

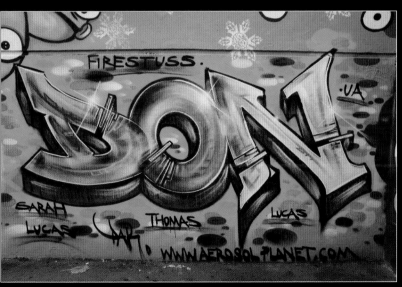

London 2010, photo by Steam156

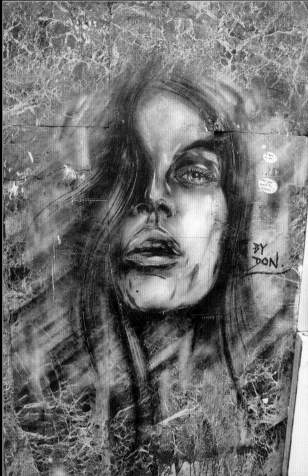

Id Cover Girl, London 2011, photo by Steam156

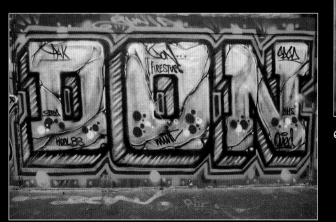

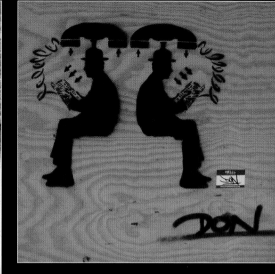

Phone Tapping, London 2011, photo by Steam156

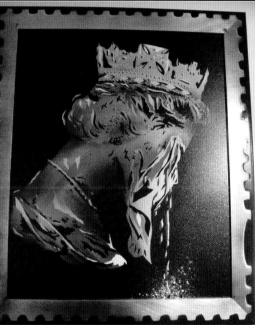

Queens Tears, London 2008, photo by Steam156

Doze

Artist = Doze
Location = North London
Painting since = 1985
Crews = WRH (We Rock Hard), PFB (Plenty Fresh Burners), UA (United Artists), Team Robbo
Quote = Graffiti has consumed almost half of my life. It's fair to say that I don't live and breathe it as I once did, but pretty much everyone I know now is through the graf scene. I've met some great people through painting, and nowadays when I get the time to piece, it's more of a social event. I don't paint illegally anymore and I really miss that—it's the thing about graf that separates us from the street art fraternity. I have nothing but respect for the writers that continue to get up: bombing, doing dubs and track sides, and of course hitting steel. Without these people the whole landscape of the scene would change dramatically and that's something that I'd hate to see.
Website = www.teamrobbo.org

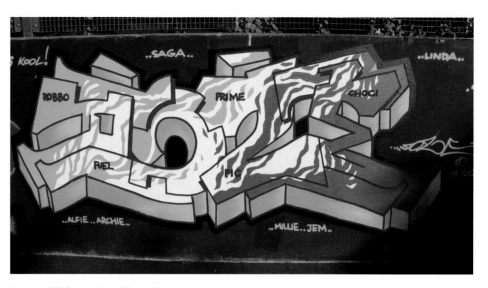

London 2010, photo by Steam156

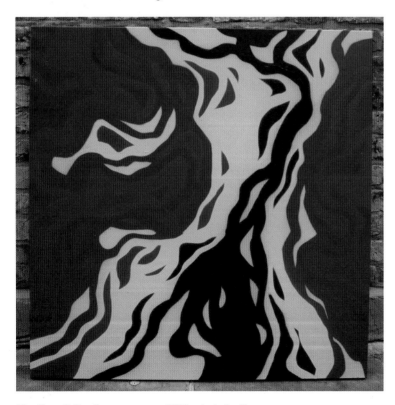

The Cure & the Cause, canvas 2011, photo by Doze

Intimissimi, canvas 2011, photo by Doze

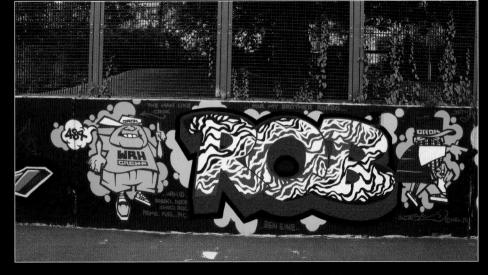

Rob by Doze (characters by Crok), London 2011, photo by Steam156

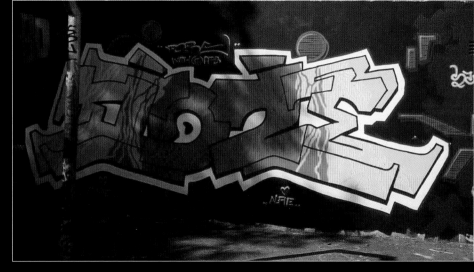

Unity Event: London 1992, photo by Steam156

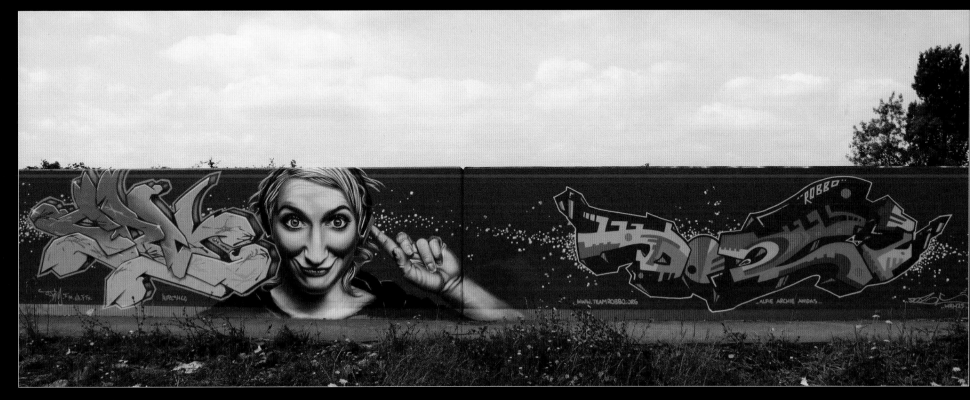

Doze/Cry, Essex 2011, photo by Steam156

Drax

Artist = Drax
Location = London
Painting since = 1985
Crews = WD (WORLDOMINATION), PFB
Quote = Writing graffiti for me represents:
The ability to lose yourself and find
yourself in equal measure.

Style is a reflection of the inner artistic-you.
Well honest style is anyway.
In the land of a million talented imitators
the not so talented individualist can be King.

For me, three ingredients make a writer somebody who is top-notch in
the style game: (1) God given artistic talent, (2) imagination, and (3)
technique.

Natural artistic talent is a gift. Give a young child a pen and tell him to look
at you and draw your face. If the results surprise you then he or she has it.
Having this gift elevates many graffiti writers to a higher level of excellence.

Imagination: Takes an artist out of his comfort zone and advances his art
beyond the sphere of plagiarism.

Technique: Gives his hands the ability to recreate what his eye can see or
what his mind can conjure.

Any graffiti writer endowed with a healthy portion of each of these
ingredients is well on the way to "having style" or even being termed "a
King of style." Alas, for many of us mere mortals, we simply march on, bitterly
thumbing the weaker hand of cards that life has dealt us. Personally, in the
three-factor quest, I would claim to have an abundance of imagination,
acceptable technique, and not a single crumb of natural artistic talent.
Devoid of the third ingredient, it took me a long time to reach a level I
considered competent. Experience and longevity helped me to eventually
attain a decent technical level, and when that didn't suffice I could rely
on a vivid imagination to bail me out. You wouldn't be the first person to
describe my colour schemes as mad or different and you wouldn't be the
last to do so whilst failing to notice that the zany fill ins had bamboozled
you into not noticing what an utter mess the letters were.

Angeles City, Papanga, Philippines 2011, photo by Drax

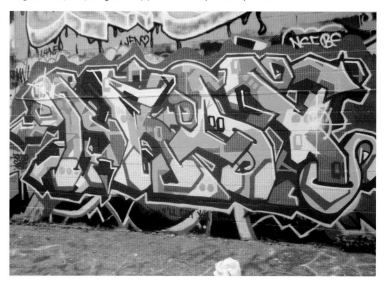

Baltimore, Maryland 2009, photo by Drax

I will not claim to be a "King of style," or even to be someone deemed to
have style, but by just going for it I have acquired something I am proud
to call my style and if you've seen five or six of my pieces, then I would be
honored if you recognised the authorship the next time you see something
by me.
Website = www.flickr.com/photos/draxwd

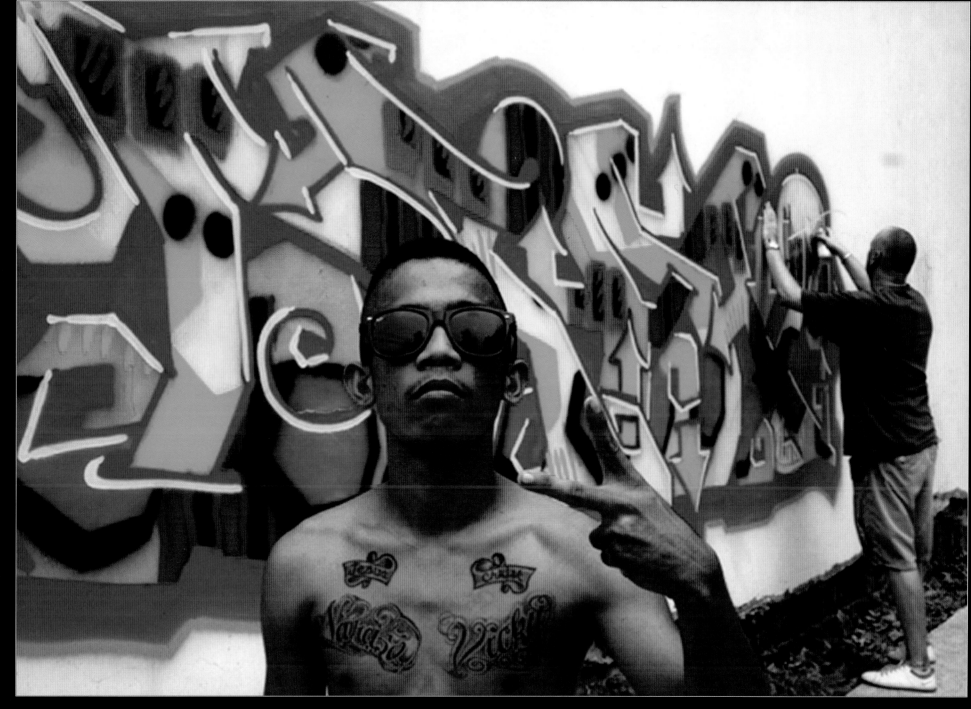

Salvador Estates, Manila, Philippines, 2009, photo by Oliver Manilla

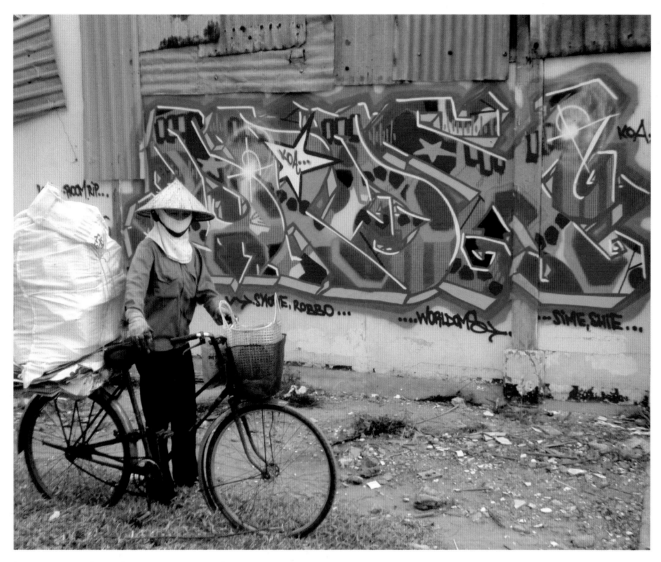

District 3, Ho Chi Minh City, Vietnam, 2008, photo by Drax

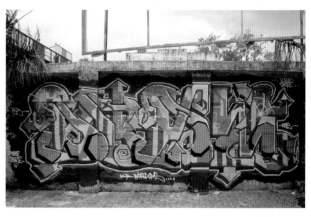

Dharavi slum, Mumbai, India, 2009, photo by Drax

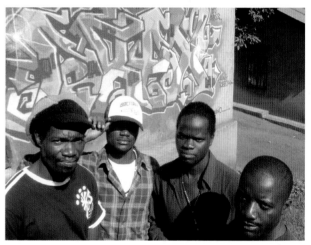

Mulago Township, Kampala, Uganda, 2010, photo by Drax

Villa Crespo, Buenos Aires, Argentina, 2011, photo by Drax

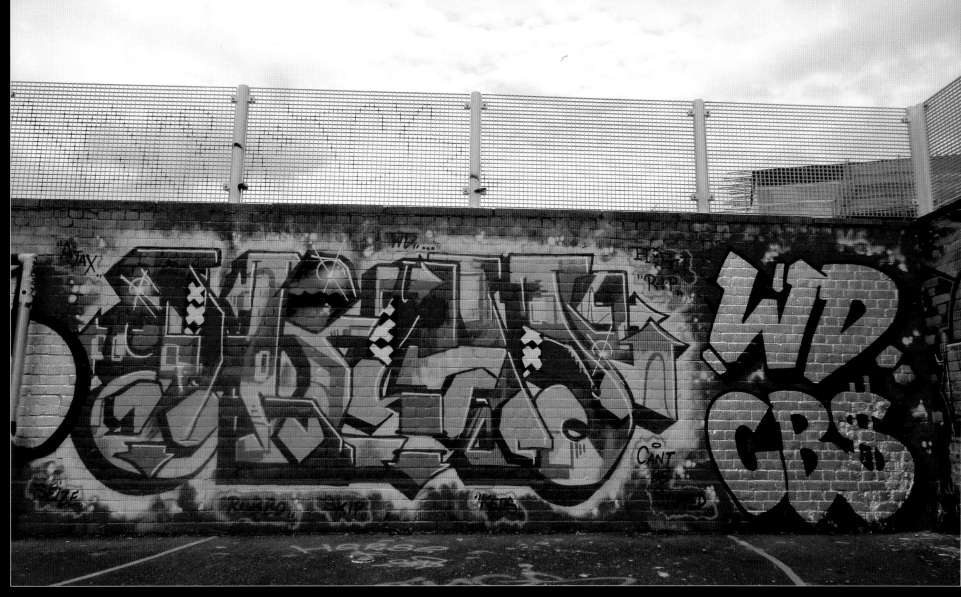

RIP High, London 2011, photo by Drax

Ebee

Artist = Ebee
Location = South London
Painting since = 1985
Crews = none
Quote = Real graffiti is on the trains. It's about bombing and getting up. My illegal days are well gone. Graffiti to me these days is about meeting good friends and doing big fat productions and burners. Sometimes if I go by myself it's about perfecting styles I already have or trying new techniques. It's a lifestyle I've lived for a very long time. I'll never give it up!

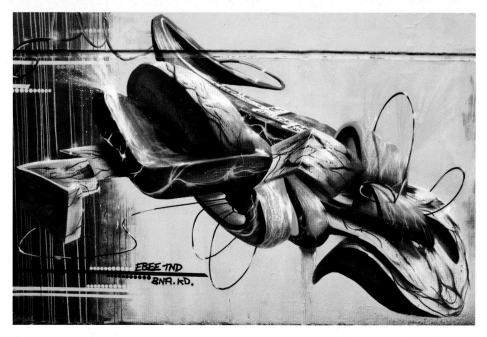

Splash, London 2010, photo by Steam156

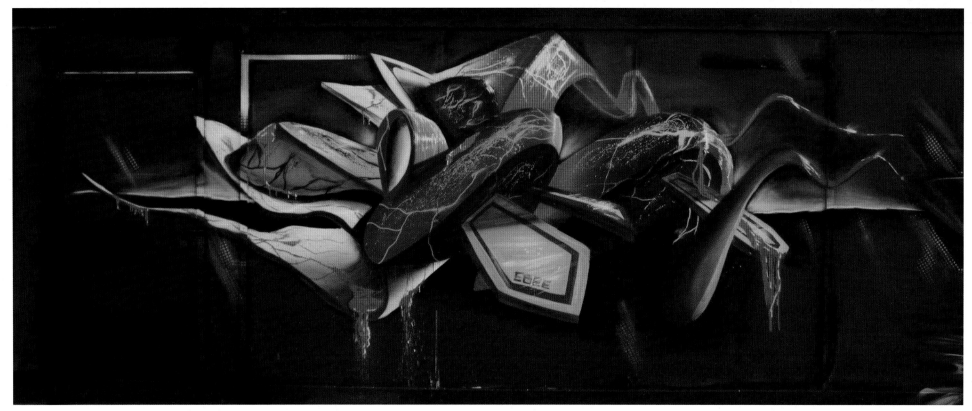

Portsmouth 2010, photo by Steam156

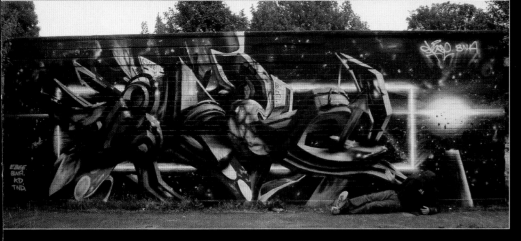

London 2010, photo by Ebee

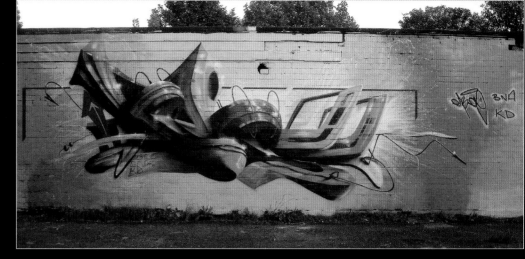

London 2010, photo by Ebee

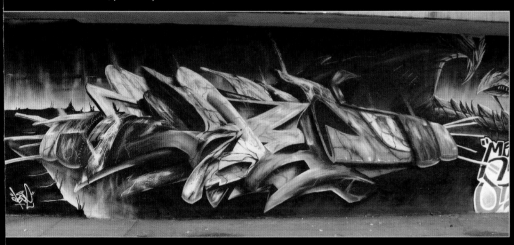

Meeting of Styles: Germany 2010, photo by Ebee

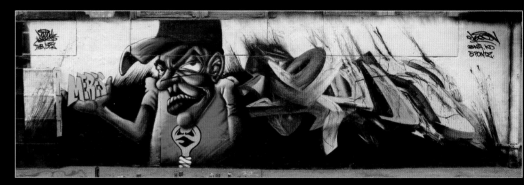

Ebee/Meres, 5 Pointz, New York 2011, photo by Ebee

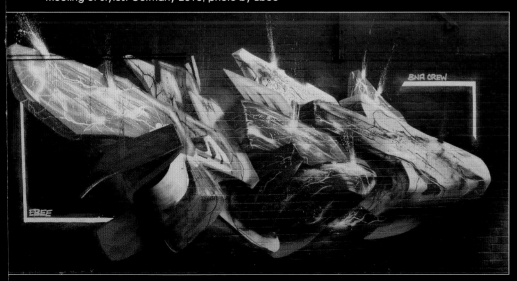

London 2011, photo by Ebee

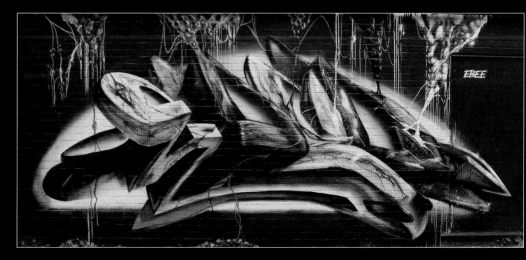

London 2011, photo by Ebee

Ekto

Artist = Ekto
Location = Essex
Painting since = 2005
Crews = SOF (Souls on Fire)
Quote = My style is probably best described as "me"—my thoughts, feelings, personality—it's all there. I believe a person's art is a self portrait: each person has a different way of negotiating it from themselves to their respective medium, technically. I try to keep a good overall shape, normally an upside down diamond with sharp "cut you if you come too close" letters; its a way of getting across a message in your art. From the feedback I get, it seems as if I'm near the mark.
Website = www.ekto.co.uk

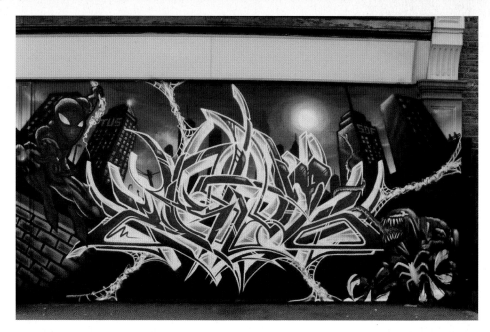

Essex 2009, photo by Ekto

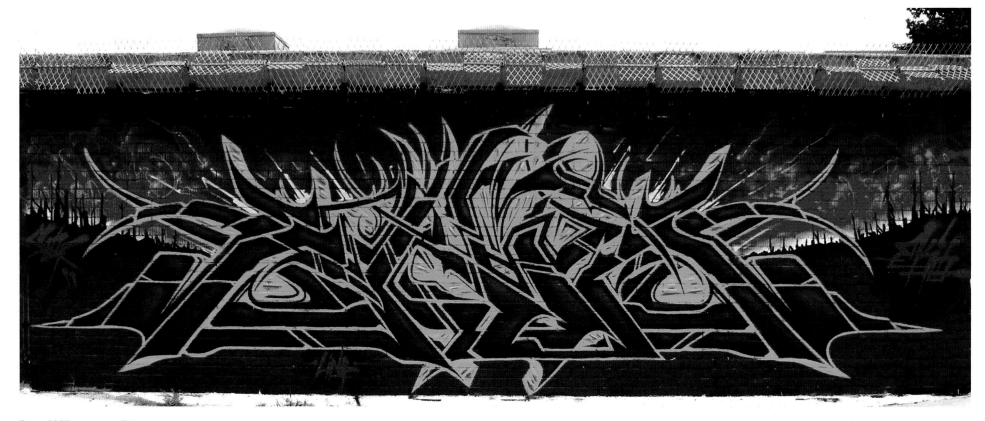

Essex 2007, photo by Ekto

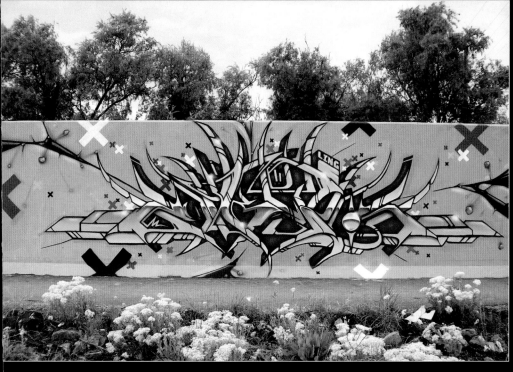

Essex 2010, photo by Ekto

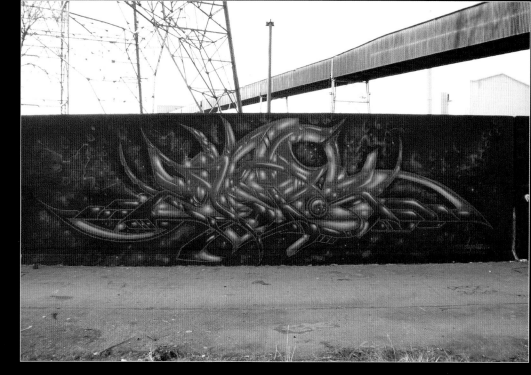

Essex 2010, photo by Ekto

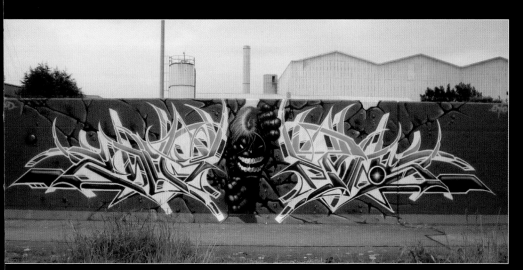

Essex 2009, photo by Ekto

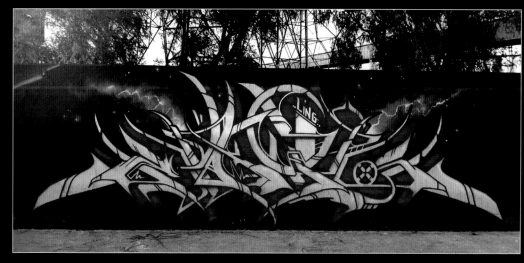

Essex 2011, photo by Ekto

Estum

Artist = Estum
Location = Glasgow
Painting since = 2002
Crews = ER (Easyriders)
Quote = I'm not really sure how to describe my style. I usually ask other people what they make of it. I'd probably put my stuff towards the organic and psychedelic end of the graffiti spectrum. I got a bit bored with the formula of putting letters beside each other in a row, so I build up my pieces with letters, symbols, and shapes—whatever really comes out when I'm painting. I feel this allows me to free up my style, although I'm still very much at the beginning of developing it to be honest.
Website = www.flickr.com/estum

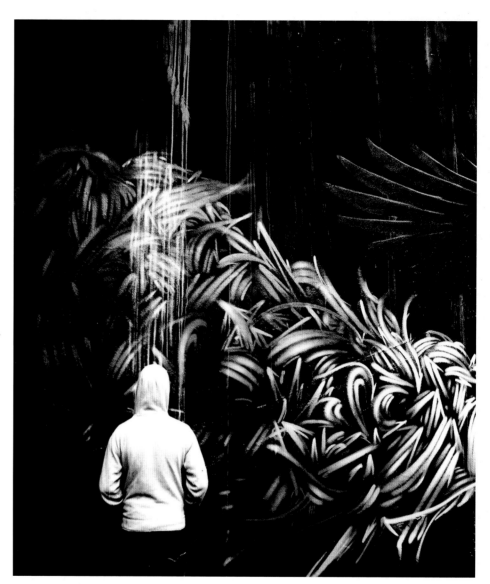

Glasgow 2009, photo by Estum

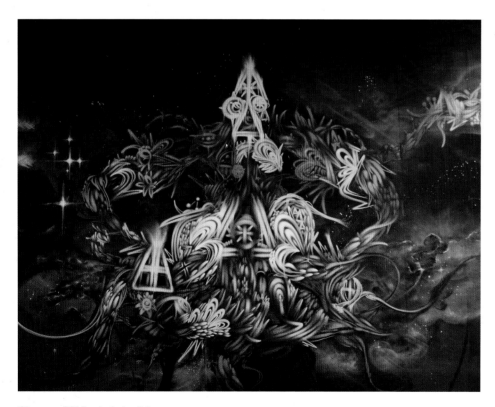

Glasgow 2010, photo by Estum

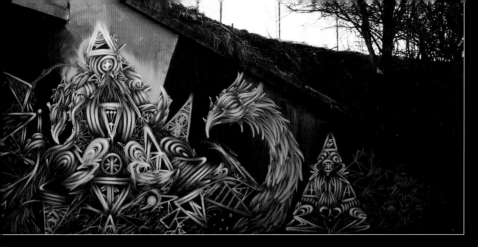

Glasgow 2011, photo by Estum

Glasgow 2011, photo by Estum

Glasgow 2010, photo by Estum

Glasgow 2010, photo by Estum

London 2011,
photo by Estum

Frame

Artist = Frame
Location = Essex
Painting since = 1985
Crews = Third Decade Allstars
Quote = I'm constantly switching my style up—this is due to an extremely low boredom threshold, so therefore I try to test myself and not just paint something I know I can pull. It also depends on how I'm feeling at the time and who I am painting with. Currently I've gotten a little lazy and looser and rarely do outlines beforehand. Everything is freestyle at the wall, which I kind of like, as it's a gamble and you're never quite sure of the outcome. So, to give a name to my style I would say Loosely Layered Dark and Moody.
Website = www.framerase.co.uk

Frame

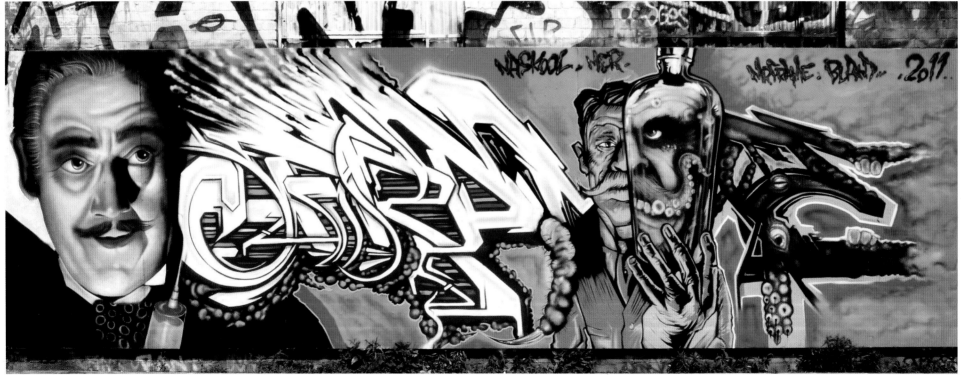

Frame/Naskool/Blam, London 2011, photo by Frame

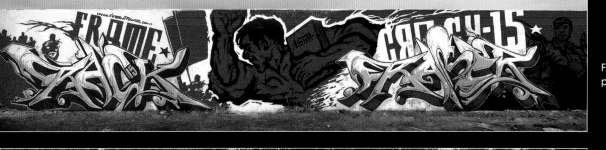

Frame/Crack15, Essex 2006
photo by Frame

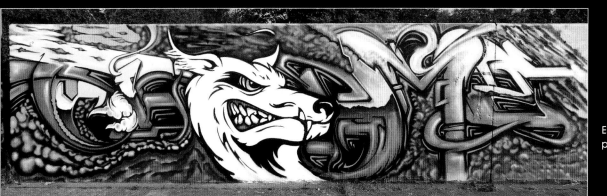

Essex 2011,
photo by Frame

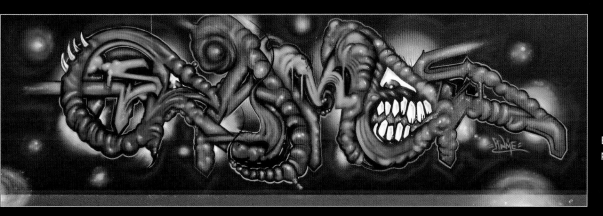

Essex 2011,
photo by Frame

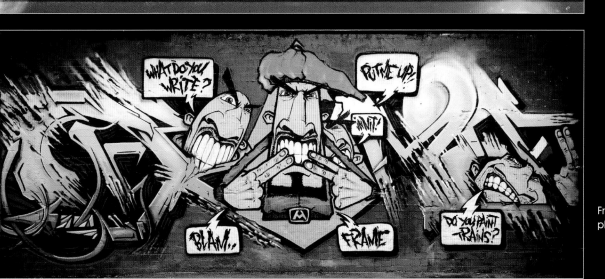

Frame/Blam, London 2011,
photo by Frame

Gary

Artist = Gary
Location = Brighton
Painting since = 1998
Crews = HA (Heavy Artillery), MSK (Mad Society Kingz)
Quote = Graffiti means a lot to me. It's my best pal and arch nemesis at the same time.
Website = www.heavyartillerycrew.com

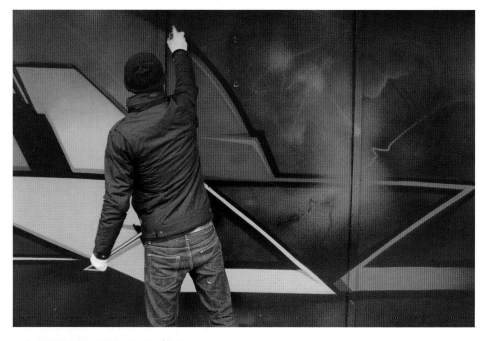

Portsmouth 2011, photo by Steam156

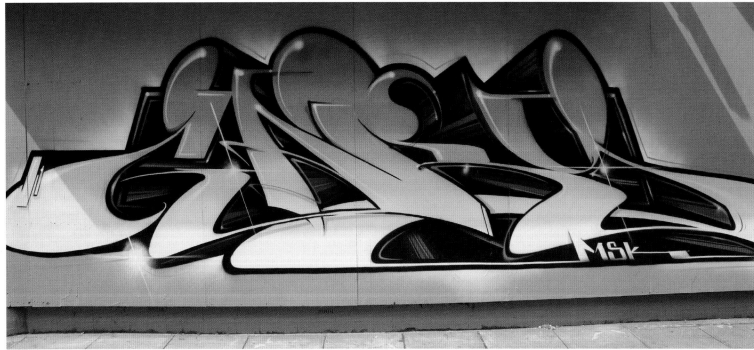

Brighton 2011, photo by Steam156

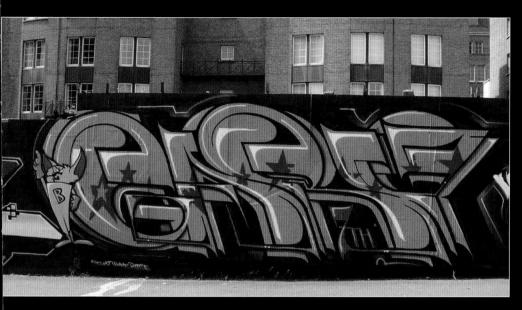

Brighton 2009, photo by Steam156

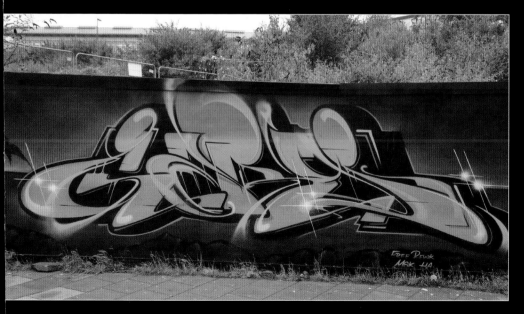

Brighton 2011, photo by Steam156

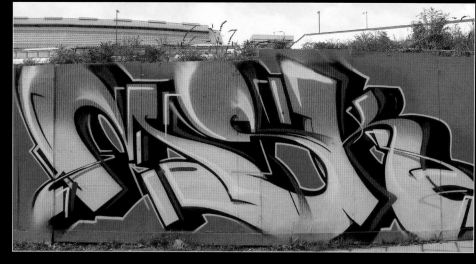

Brighton 2009, photo by Steam156

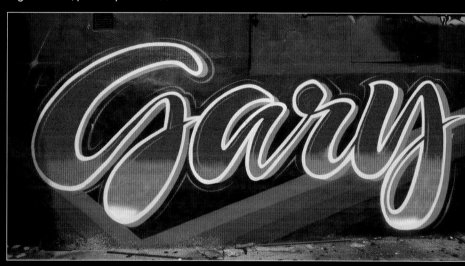

Brighton 2010, photo by Steam156

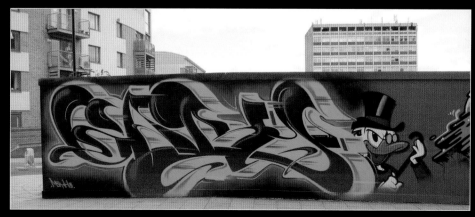

Brighton 2010, photo by Steam156

Gnasher

Artist = Gnasher
Location = Essex
Painting since = 1987
Crews = LDS (Legendary Status)
Quote = My style, download-images-from-the-internet-and-copy-them-ism ha ha...no it's probably photorealism, well nearly photorealism. I do try and choose my characters that have a cool set of "gnashers" and go to town on the mouth and drool. For awhile I was creating characters in Photoshop®, but they turned into disturbing weird eyeless demons. It was a little glimpse into my psyche.... When I was doing some collaborations, I asked if I could put some meat hooks through their letters. I got some strange looks...so I started painting Batman and everyone forgot about it.
Website = www.gnashermurals.com

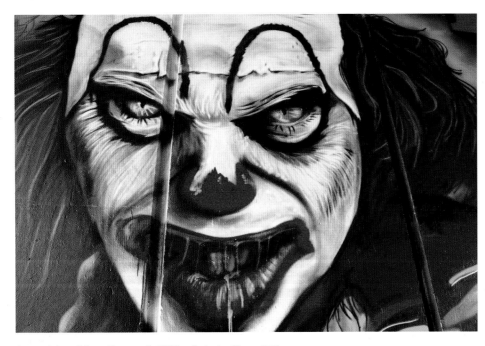

Aerosolplanet Jam: Tamworth 2011, photo by Steam156

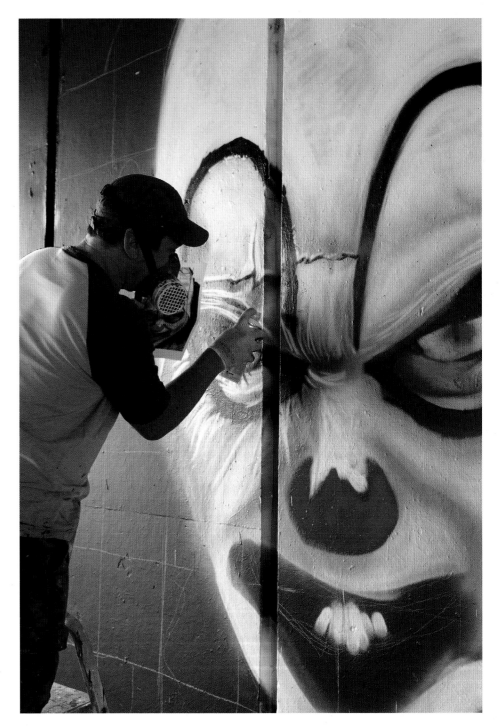

Aerosolplanet Jam: Tamworth 2011, photo by Steam156

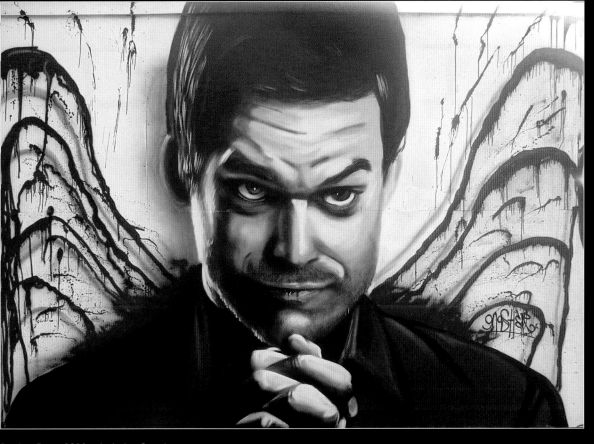

Dexter, Essex 2011, photo by Gnasher

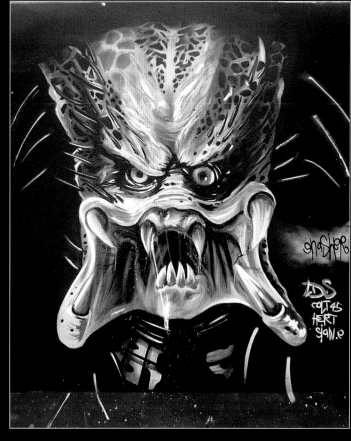

Predator, Essex 2011, photo by Gnasher

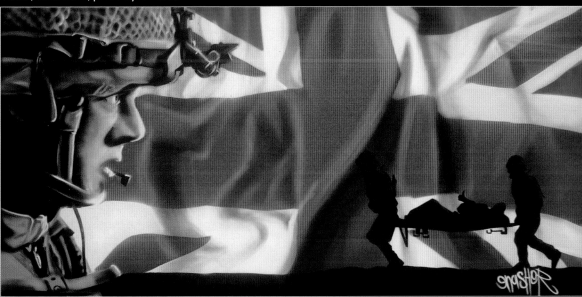

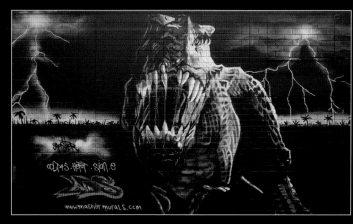

T-Rex, London 2011, photo by Gnasher

Goldie

Artist = Goldie
Location = London
Painting since = birth
Crews = TATS Cru
Quote = It's a way of life, a form of expression, and a great opportunity to share and voice opinions through aerosols.
Website = www.eddielock.co.uk

Fuck Off Portrait, 2008, photo by Goldie

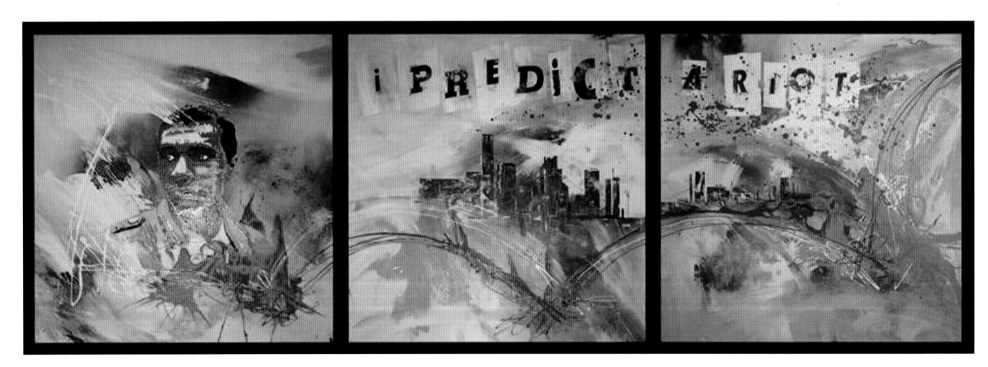

I Predict a Riot, 2008, photo by Goldie

90

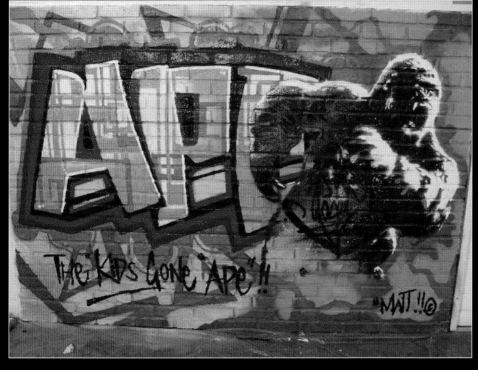

The Kids Gone Ape, 2009, photo by Steam156

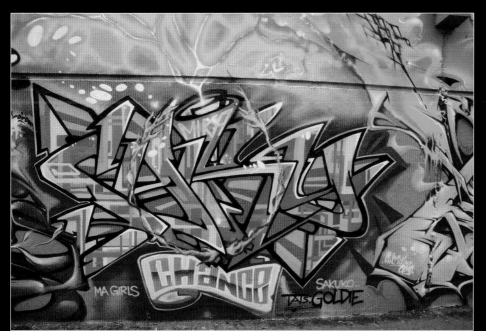

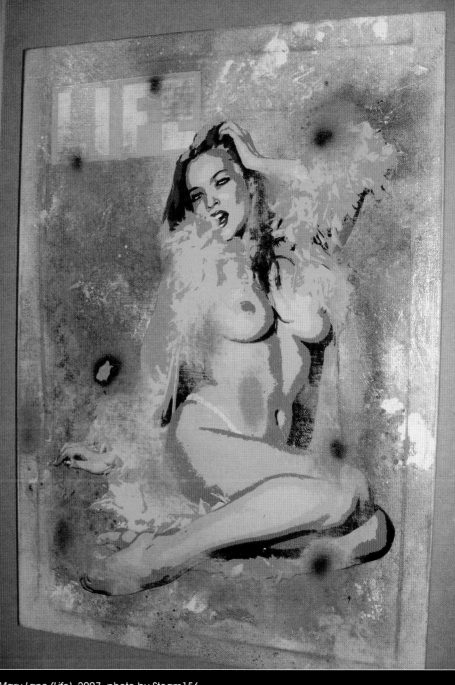

Mary Lane (Life), 2007, photo by Steam156

Hemper

Artist = Hemper
Location = London
Painting since = 1991
Crews = ASK (After Skool Klub), DMT (Doing My Thing)
Quote = I'm always trying different things but I guess I paint more or less traditional wild style letters. People have said my pieces have a lot of movement in them, and I think in some ways that reflects my personality—often dissatisfied and always searching for something new. I guess you could call me restless.

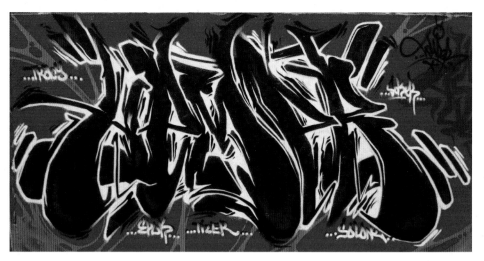

London 2010, photo by Hemper

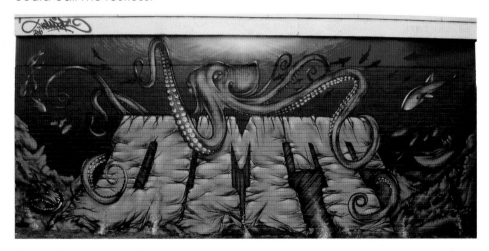

Corsham 2010, photo by Hemper

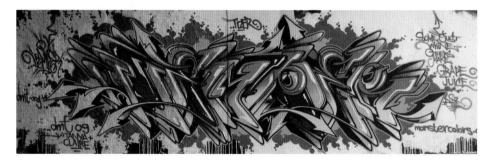

Bristol 2009, photo by Hemper

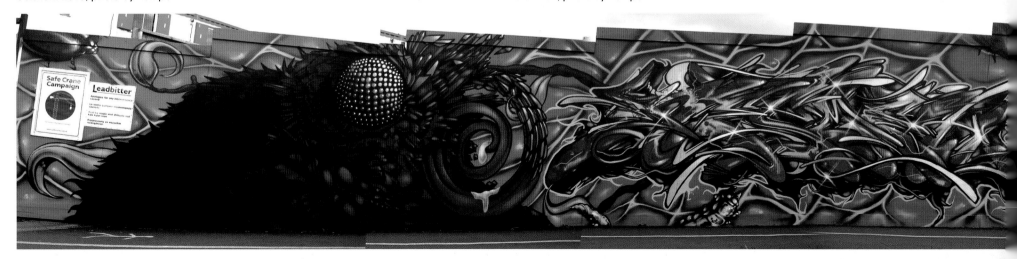

FLX/Hemper/Soker/Feek

92

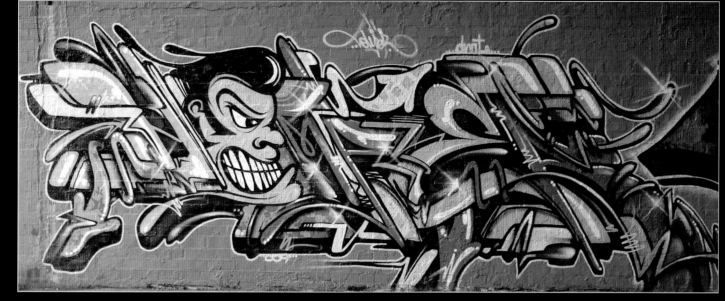

Bristol 2009, photo by Hemper

Bristol 2011, photo by Hemper

Bristol 2011, photo by Hemper

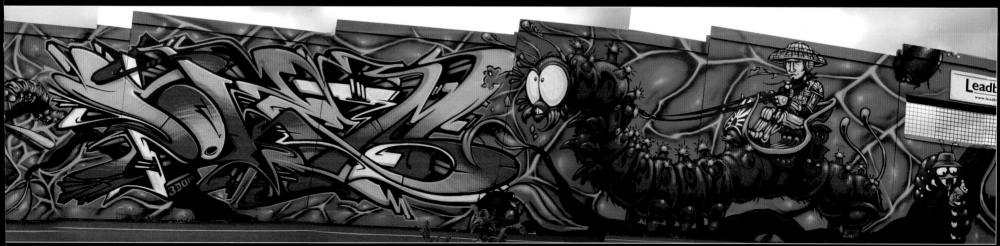

Hush

Artist = Hush
Location = Cambridge
Painting since = 1984
Crews = FTN (Fed the Nonsense), REM (Red Eye Mob)
Quote = Style is a fundamental aspect of graffiti, it's what sets a person apart from the crowd. The development of a unique personal style is one of the biggest motivations for me.
Website = www.flickr.com/photos/og_hush/

Splash Art Jam: 2011, photo by Steam156

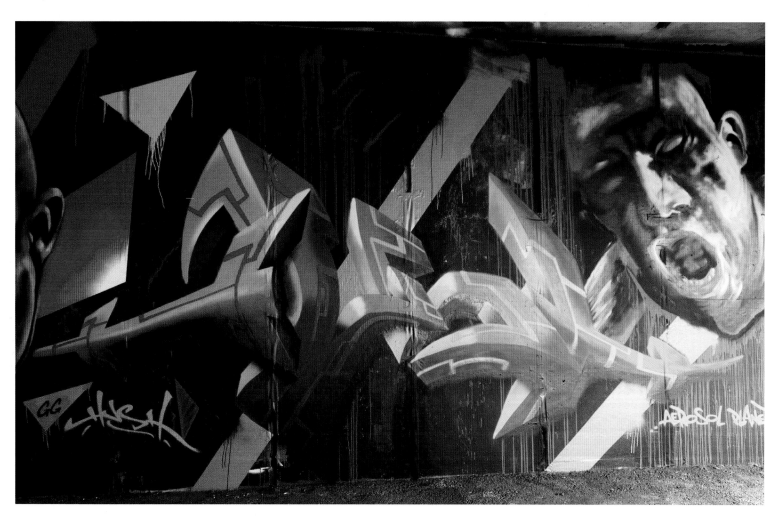

Aerosolplanet Jam: 2011, photo by Steam156

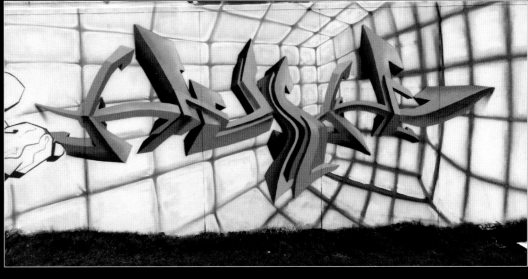

Peterborough 2011, photo by Hush

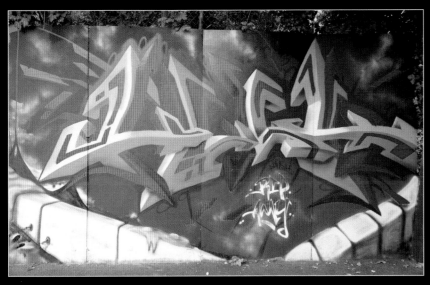

Splash Art Jam: 2011, photo by Steam156

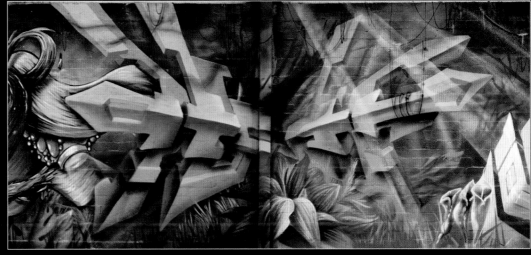

Nottingham 2011, photo by Hush

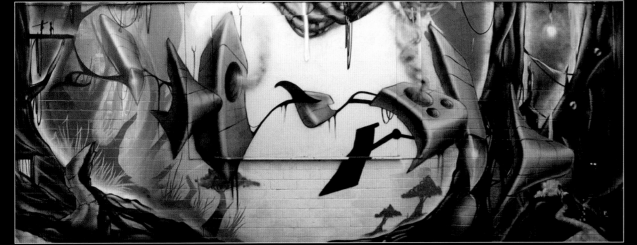

Nottingham 2011,
photo by Hush

95

Ink Fetish

Artist = Ink Fetish
Location = North London
Painting since = 2002
Crews = 40HK (Forty Hit Kombo)
Quote = My style—a surreal visual fusion of American subculture and Japanese pop iconography.
Website = www.inkfetish.co.uk

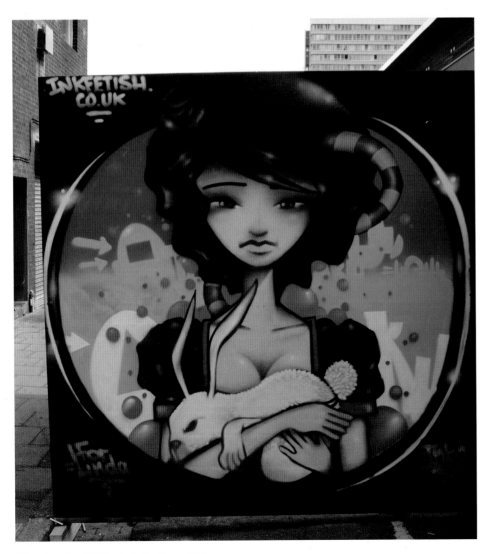

Alice, London 2010, photo by Steam156

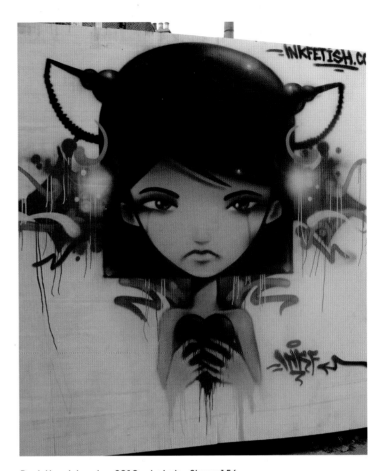

Dark Heart, London 2010, photo by Steam156

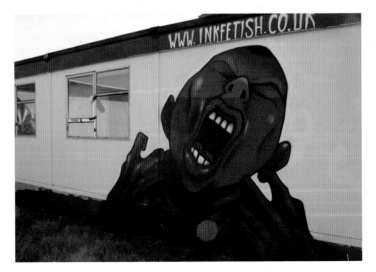

Screamer, London 2011, photo by Steam156

Meeting of Styles: 2010, photo by Steam156

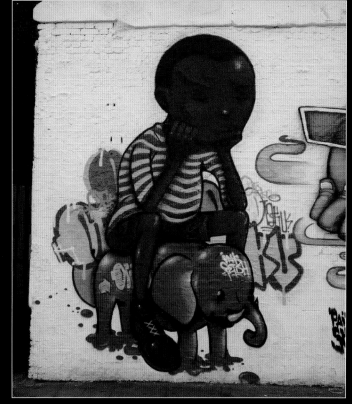

Memory Support, London 2011, photo by Steam156

The Mad Hatter, Meeting of Styles: London 2011, photo by Steam156

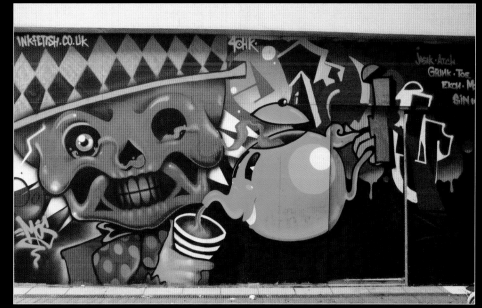

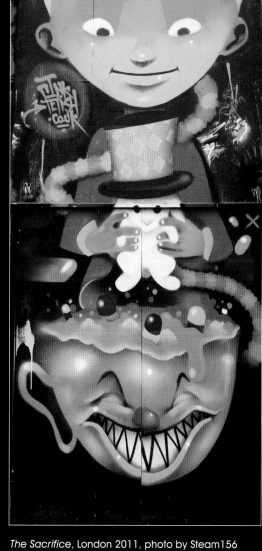

The Sacrifice, London 2011, photo by Steam156

Insane

Artist = Insane
Location = East London
Painting since = 1985–1990 and 2010 to present
Crews = NLZ (No Limitz)
Quote = I'm style-less! Certain writers you can spot their work without them having to sign it and they pride themselves on this (some having spent years honing their skills). I guess I'm still finding my feet. I like to try out as many different things as I can and if along the way I stumble across something I love, then great; and if I don't, then that's also great. The most important thing for me is to enjoy myself.

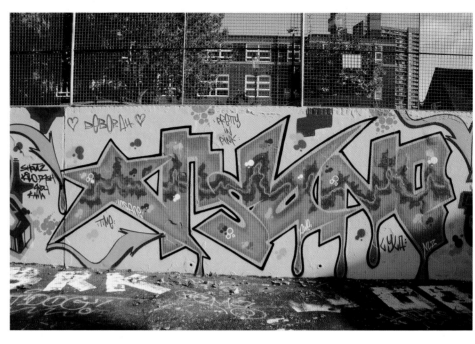

London 2011, photo by Steam156

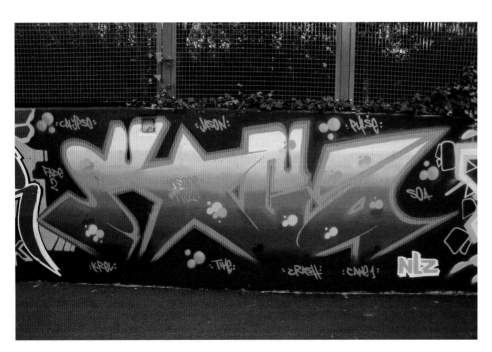

London 2010, photo by Steam156

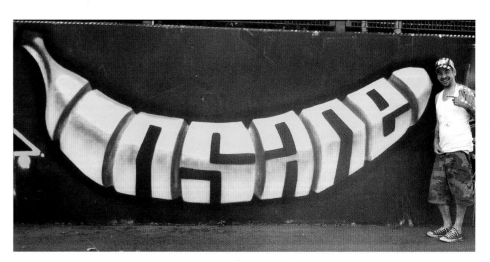

London 2011, photo by Insane

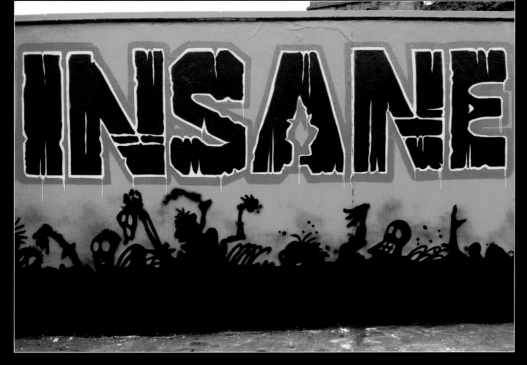

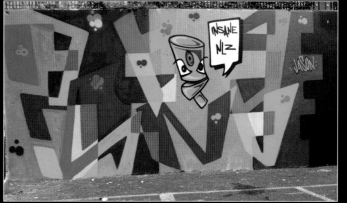

London 2011, photo by Insane

London 2011, photo by Insane

Meeting of Styles: London 2010, photo by Steam15

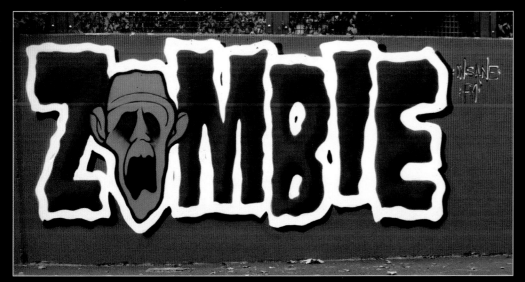

London 2011, photo by Insane

London 2011, photo by Insane

Jadell

Artist = Jadell
Location = West London
Painting since = 1985
Crews = TO (The Others)
Quote = When I do outlines these days, I'm still trying to satisfy that urge to be "up there" with the best of that early-80s New York subway style of letters. I know it's really obvious, and that was the style that most of us teenagers learnt in the UK when graffiti first came over, but that's why I feel it's very satisfying when you can still pull off original-looking letters in this day and age—when there really is no standard of what a "good" style of lettering looks like. Once this is mixed up with what eventually comes out of my head, then it ends up looking fairly satisfying to me.

Colours and paint techniques are a way different ball game now than they were in the 80s. So, with regard to that, I'm constantly trying to catch up with what's going on, as well as trying my own techniques that sit well with my style.
Website = www.jadell.co.uk

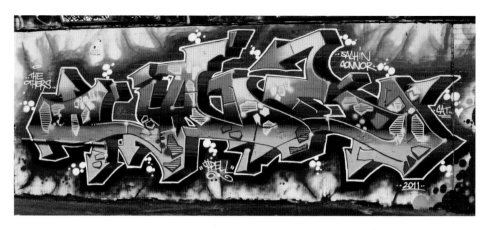

London 2011, photo by Jadell

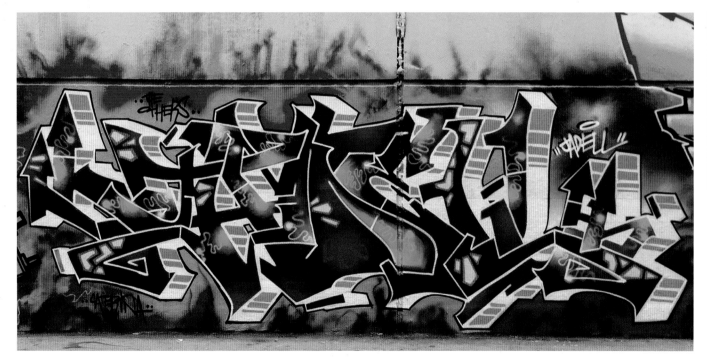

London 2011, photo by Jadell

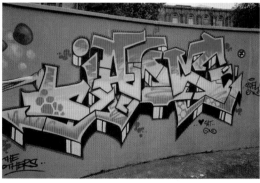

London 2010, photo by Steam156

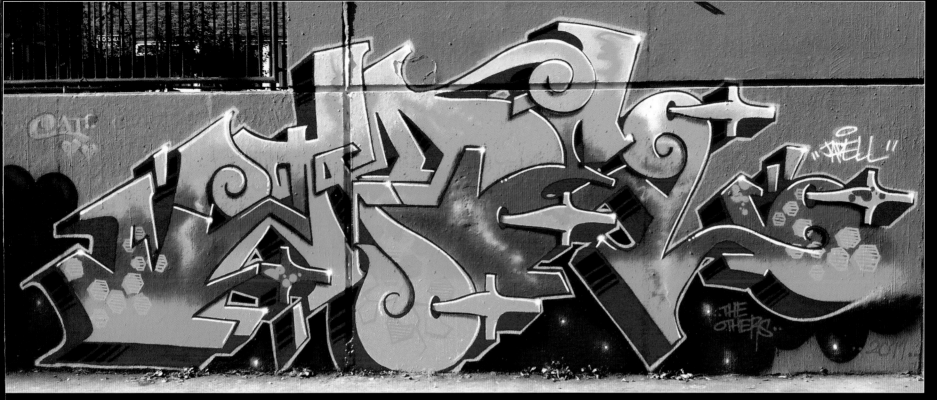

London 2011,
photo by Jadell

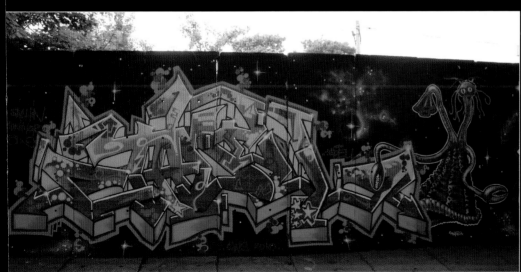

London 2011, photo by Steam156

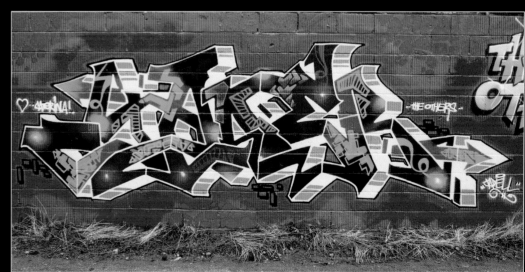

London 2010, photo by Jadell

Jiroe

Artist = Jiroe
Location = Liverpool
Painting since = 1994
Crews = HA (Heavy Artillery), ADL (Another Day Lost), RTS (Ringo the Starr)
Quote = Graffiti means perfecting your craft, it means not jumping the queue, it means painting all the time, it means friends, it's taking back a little public space, it's fun, it's fucking annoying, it should mean humility and complementing people, it should be paying respects when they are due to people that influenced you, it should be standing on your own two feet regardless of what anybody else thinks, it's yours and nobody can take that away from you, it's a ridiculous boys club, it's pretty hair raising at times, it's grown ass men commenting on each others pink bubble highlights and then claiming they're hardcore criminals on the Internet. It's people I like, it's pretty much always letters and sometime characters.
Website = www.heavyartillerycrew.com

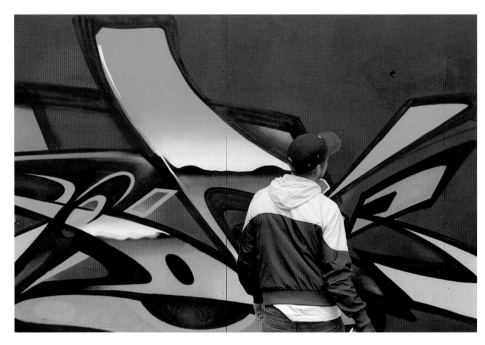

Meeting of Styles: London 2011, photo by Steam156

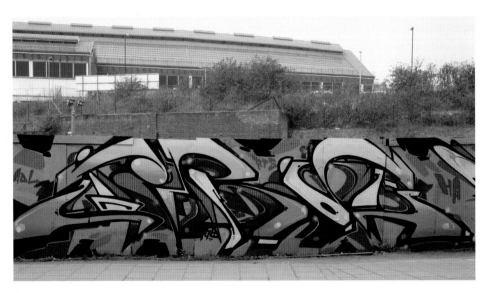

Brighton 2011, photo by Steam156

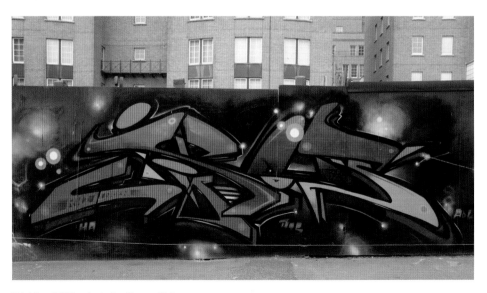

Brighton 2011, photo by Steam156

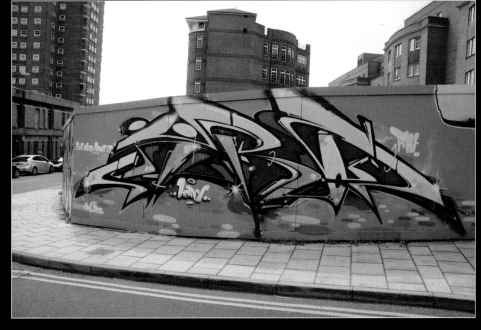

Brighton 2011, photo by Steam156

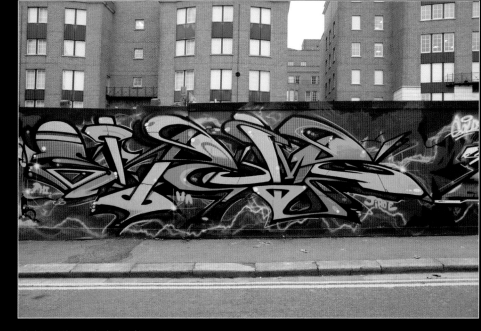

Brighton 2011, photo by Steam156

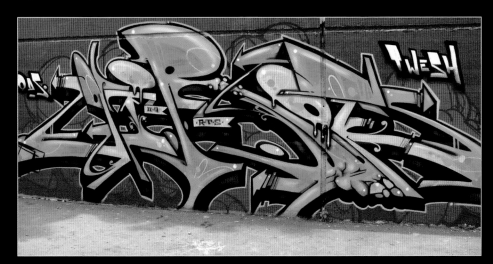

London 2009, photo by Steam156

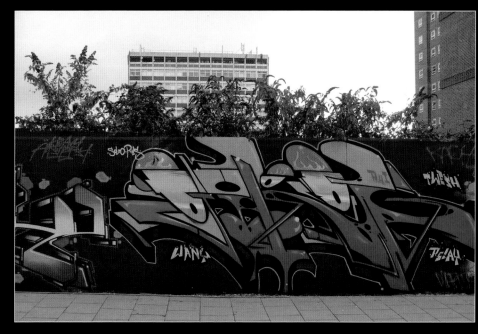

Brighton 2009, photo by Steam156

Keen Roc

Artist = Keen Roc
Location = East London
Painting since = 1985
Crews = Rocstars Nyc (Roc On City), AWE (All World Experts)
Quote = Style is everything, style is the essence of writing, so it's really important to have a good style that is unique to you and recognised as your style. A good style needs NO colour. It's not about techniques or colours, its purely about the style, and by the style I mean the form, flow, and shape of your letters. Style is the key to the door of Masterdom.
Website = www.keen1roc.blogspot.com

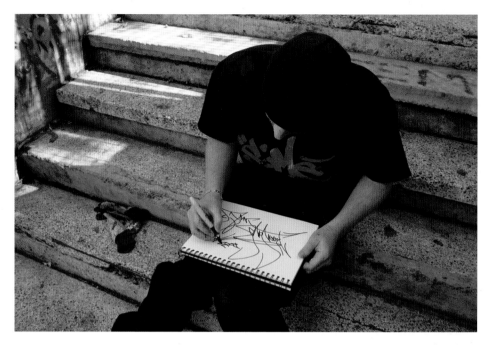

London 2011, photo by Steam156

Bio Style Exchange: Berlin
2011, photo by Keen Roc

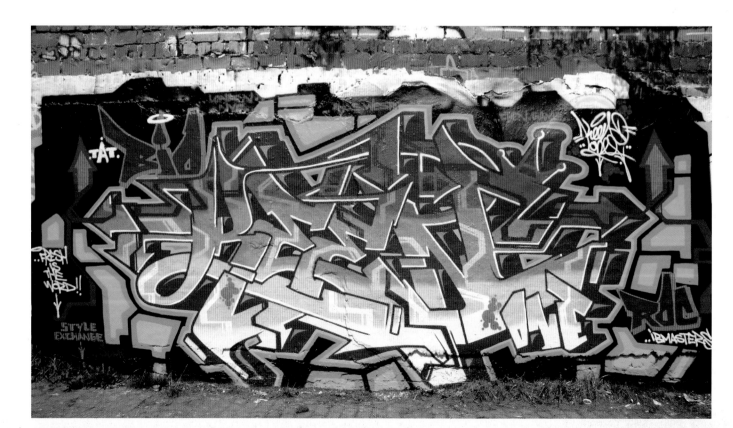

104

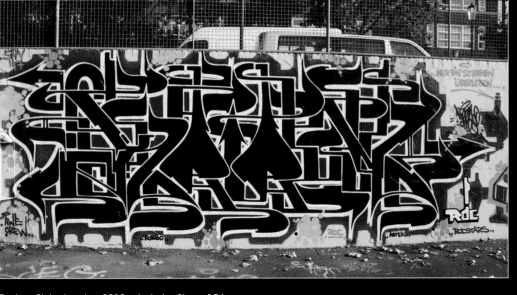

Eastern Style, London 2010, photo by Steam156

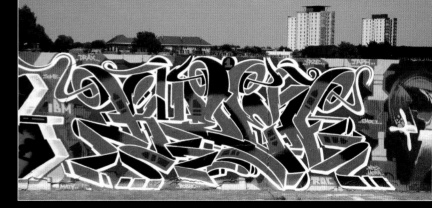

Flow Style, London 2011, photo by Keen Roc

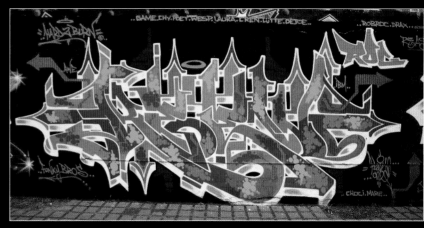

Push through Style, Berlin 2011, photo by Keen Roc

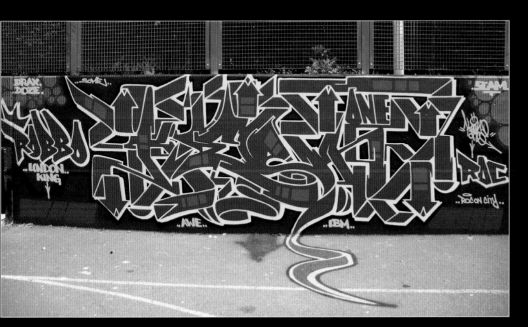

Royal Blue Fold Style, London 2011, photo by Keen Roc

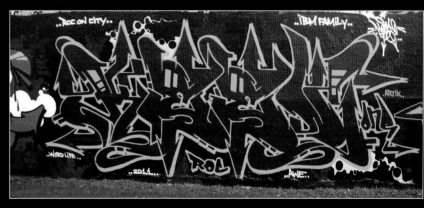

Basic Style, Berlin 2011, photo by Keen Roc

Kelzo

Artist = Kelzo
Location = Manchester
Painting since = 1984
Crews = ICA (Inner City Artists), TPA (The Public Animals)
Quote = Graffiti is my life and has been for the last 27 years. It's helped me progress as a human being. When I was a young kid in the 1980s and 90s, I could have been influenced by all the street crime and drug dealing in south Manchester but I chose to focus on my artwork and painting. When people say "graffiti saved my life," in my case it really did—it helped me achieve things I didn't think I would. I've travelled around the world painting and made good friends and had a great time.
Website = www.kelzo.com

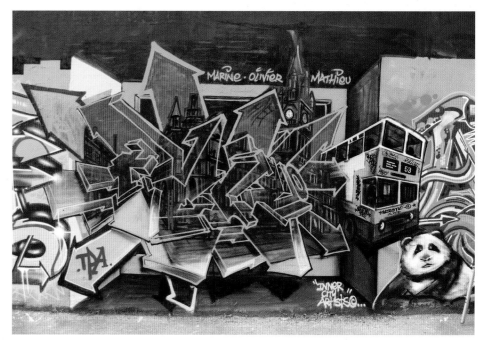

Made in Manchester, Manchester 2009, photo by Kelzo

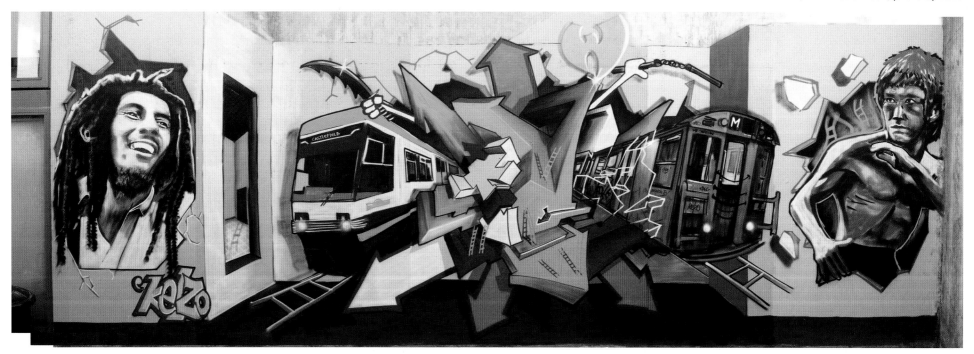

Kickin Style into Touch Since 1984, Manchester 2011, photo by Kelzo

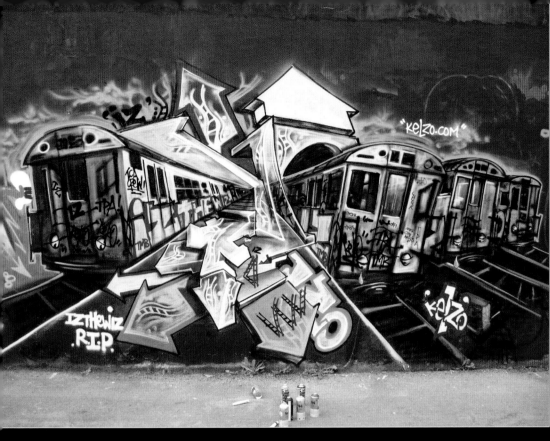

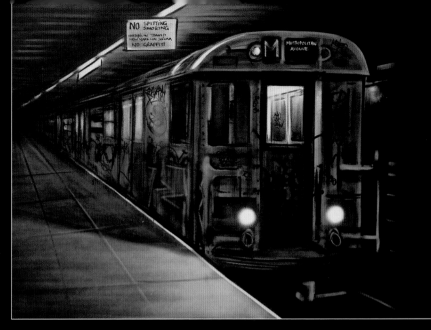

A True Inspiration-NYC Subway, Manchester 2010, photo by Kelzo

z the Wiz Tribute Wall, Manchester 2009, photo by Kelzo

Rockin the Silvers, Manchester
2010, photo by Kelzo

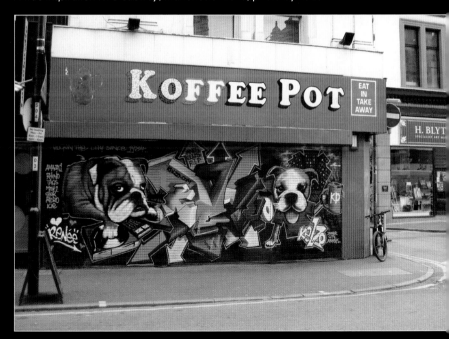

Rockin the City since 1984, Manchester 2011, photo by Kelzo

Kemef Inc

Artist = Kemef Inc
Location = Birmingham
Painting since = 1984
Crews = ADZ (Adicz Cru, aka Kemef inc), CIA (Crazy Inside Artists)
Quote = I think our style will always have an element of old school feel to it, maybe with a few extra ingredients to give it some flavour—good colours and flow/energy are also a must.
Website = www.flickr.com/photos/kemefinc

Dudley 2011, photo by Kemef Inc

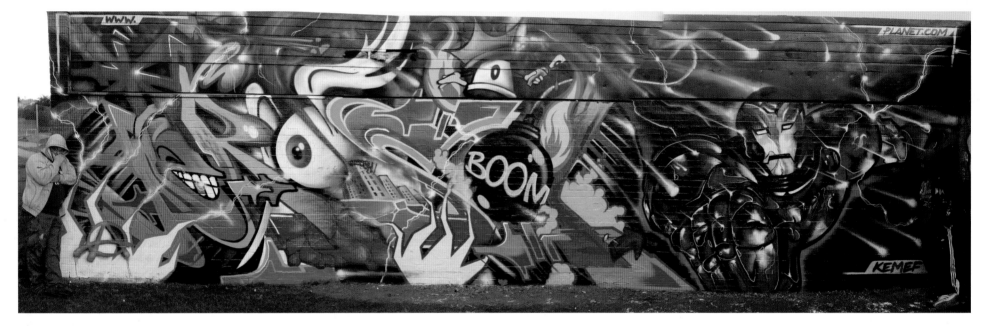

Aerosolplanet Tribute Wall, Dudley 2010, photo by Kemef Inc

Paint Robot, Dudley 2010, photo by Kemef Inc

Me Funk Em, Dudley 2010, photo by Kemef Inc

Lost in Music, Kem/Mef/Title, Southport 2011, photo by Kemef Inc

ndeva (Kem)/mske (Mef), Dudley 2010, photo by Kemef Inc

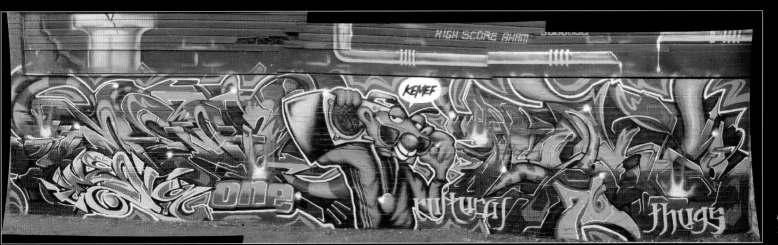

Pink Panther Part 2, Dudley 2010, photo by Kemef Inc

Kilo

Artist = Kilo
Location = Cambridge
Painting since = 1984
Crews = Sinstars, FBA (Fast Breaking Art)
Quote = For me, style is EVERYTHING (tags, hand style, lettering, etc.)—if you don't have style you can't really call yourself a graffiti WRITER. In this day and age there seems to be an abundance of what I would call "background artists"...meaning they do fancy hi-tech colour schemes with either whack letters or no letters at all!!!
Website = www.alfresh.co

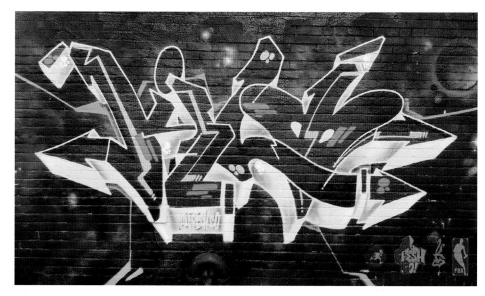

Bronx NYC 2011, photo by Kilo

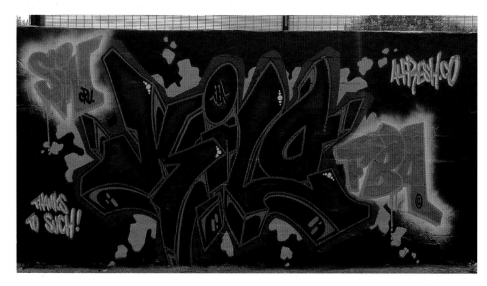

Sheffield 2011, photo by Kilo

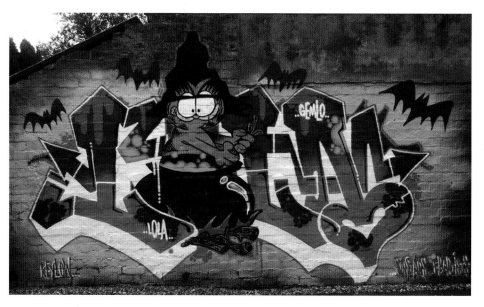

Birmingham 2011, photo by Kilo

110

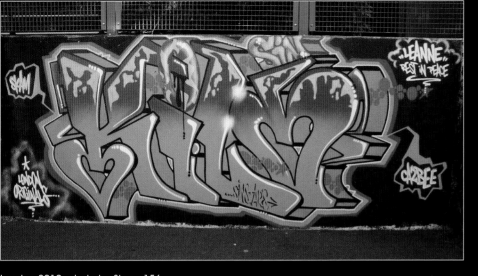

London 2010, photo by Steam156

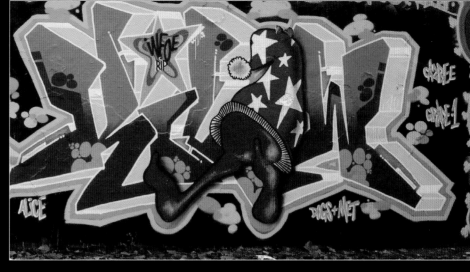

London 2010, photo by Steam156

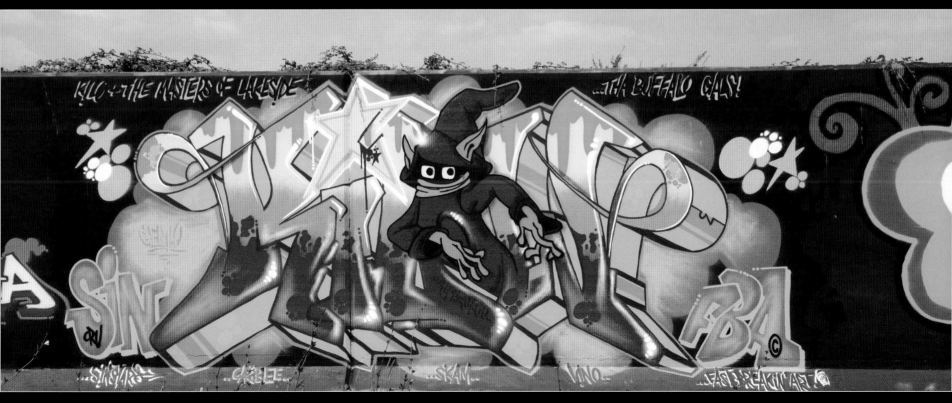

Essex 2011, photo by Steam156

Lovepusher

Artist = Lovepusher
Location = London
Painting since = 1985
Crews = none
Quote = Within the graffiti culture, style ultimately is one of the most important aspects of writing. Style helps define you as an individual, but also provides viewers with an insight as to how you visually see the world. There are infinite possibilities in terms of how a letter could look; style simply helps us to see these many variations.
Website = www.flickr.com/photos/lovepusher

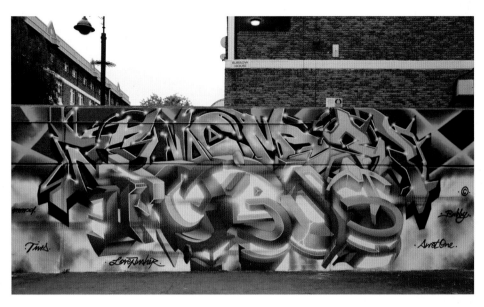

London 2011, photo by Steam156

London 2009, photo by Steam156

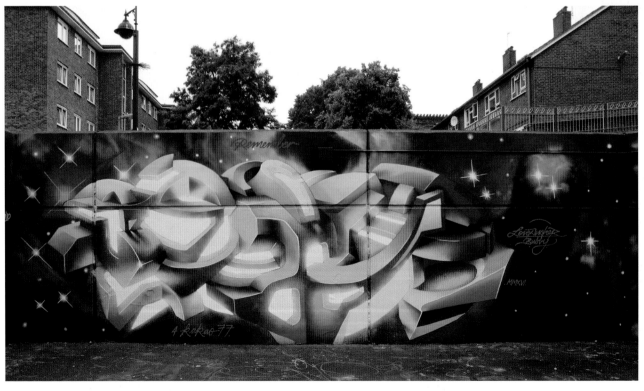

London 2010, photo by Steam156

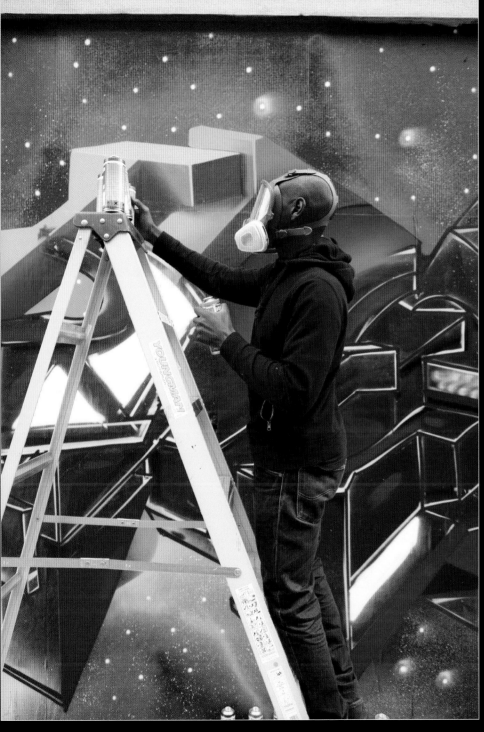

Meeting of Styles: London 2011, photo by Steam156

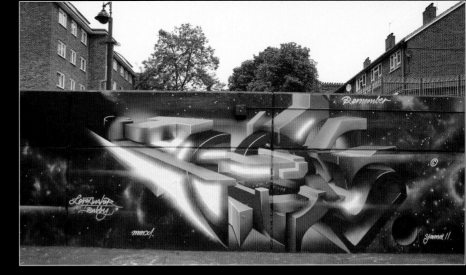

London 2011, photo by Steam156

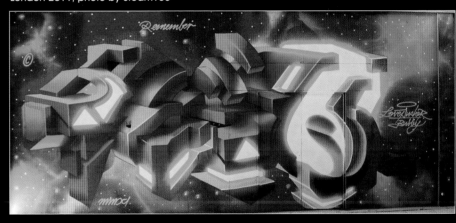

Meeting of Styles: London 2011, photo by Steam156

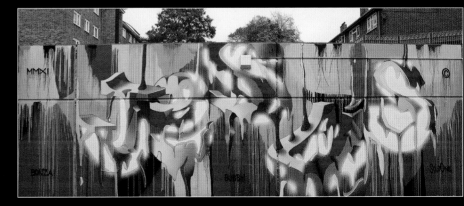

London 2011, photo by Steam156

113

Mac1

Artist = Mac1
Location = Birmingham
Painting since = 1993
Crews = Aim, Ad Infinitum
Quote = Without this art form, I wouldn't be alive.
Website = www.flickr.com/photos/mac_1/

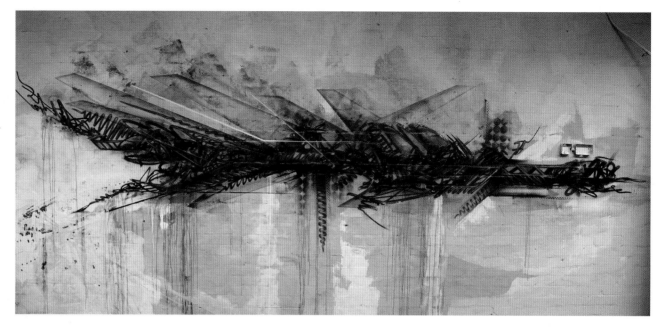

Black Country Crossing, West Midlands 2011, photo by Mac1

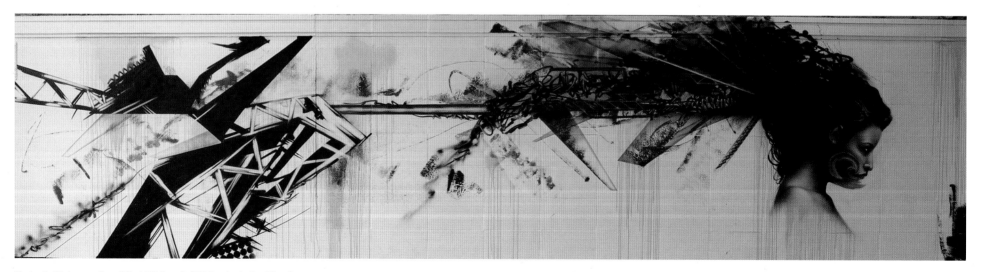

Celestial Intervention, West Midlands 2011, photo by Mac1

114

Bio Organic, West Midlands 2011, photo by Mac1

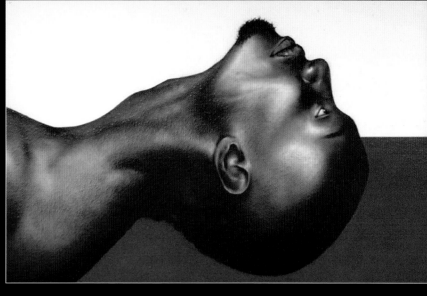

Sauce Gallery installation: West Midlands 2010, photo by Mac1

Omie, aerosol study, West Midlands 2011,

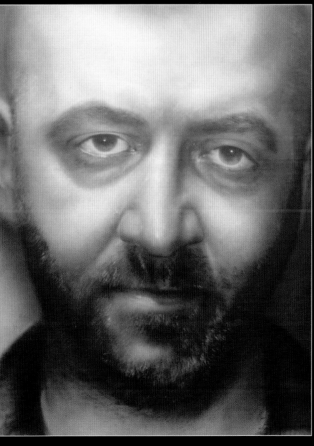

Trev, West Midlands 2010, photo by Mac1

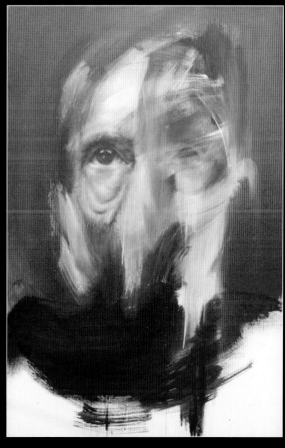

Uncle Bill, West Midlands 2009, photo by Mac1

Mash

Artist = Mash
Location = Newcastle
Painting since = 1989
Crews = Simply Rockers
Quote = I love the total freedom to display my work on a large scale. My huge passion for letterforms will never abate. Whether it's hand-styles or full colour pieces, it still gives me a massive buzz to this day. I have also met so many great friends along the way.
Website = www.flickr.com/photos/mash-one

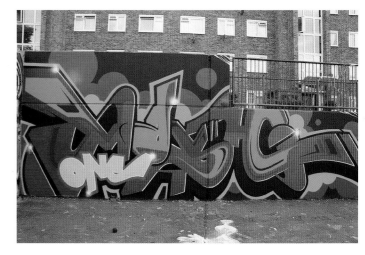

London 2011, photo by Steam156

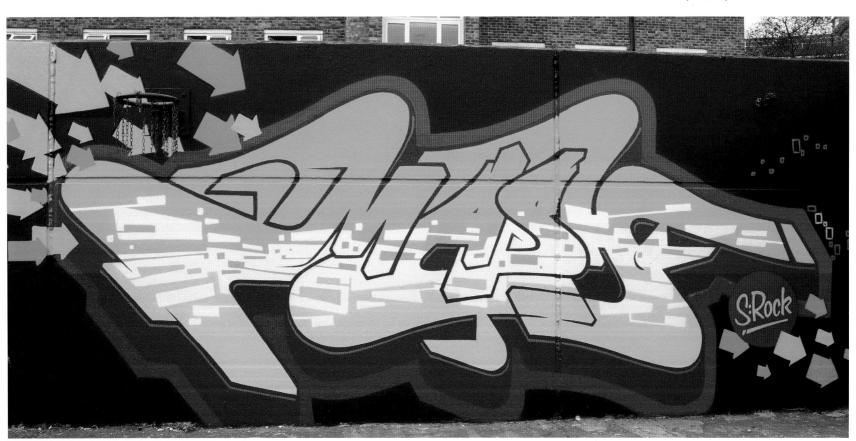

London 2011,
photo by Steam156

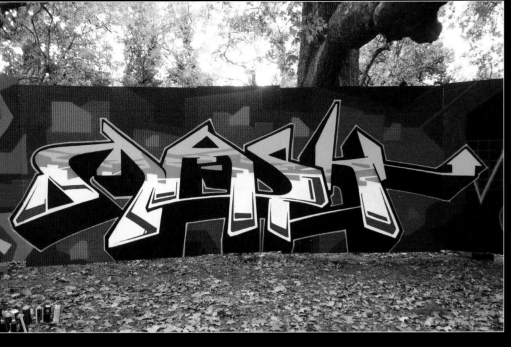

Surrey 2011, photo by Mash

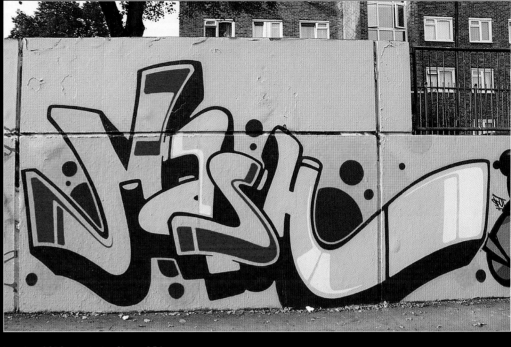

London 2010, photo by Steam156

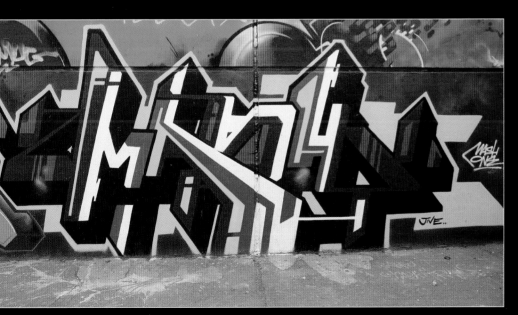

London 2011, photo by Steam156

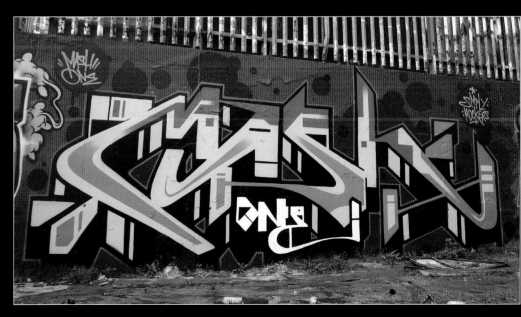

Surrey 2011, photo by Mash

Mear

Artist = Mear
Location = London
Painting since = 1984
Crews = VOP (Visual Orgasm Productions), KTC (Koast2coast)
Quote = Graff has been a part of my life for 25 years, so it means a lot to me. It has opened doors for me and taken me to places I may never have been. It means I will always have something to fall back on in life. It's like being a super hero, being able to have a talent you can use for good or evil.
Website = www.vopstars.com

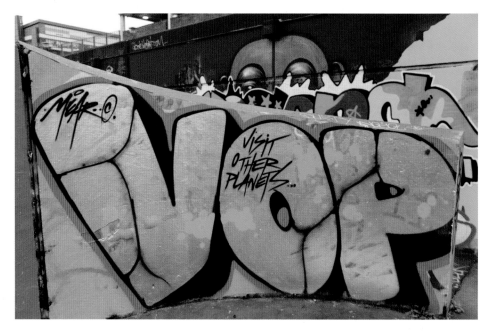

London 2010, photo by Steam156

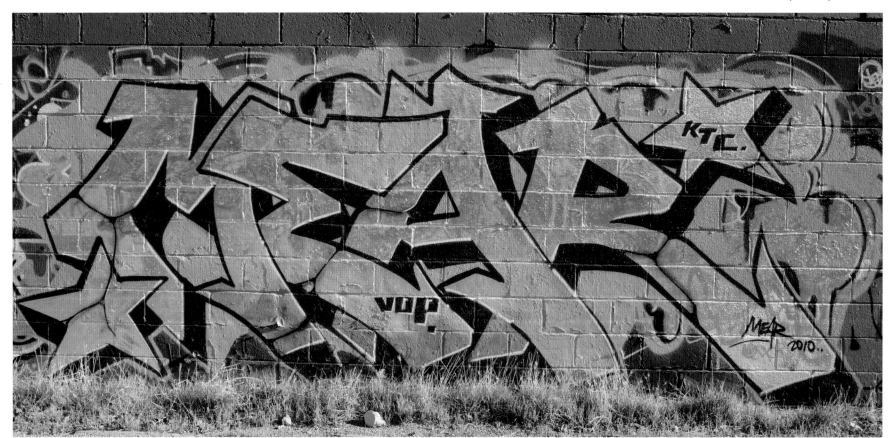

London 2011,
photo by
Steam156

118

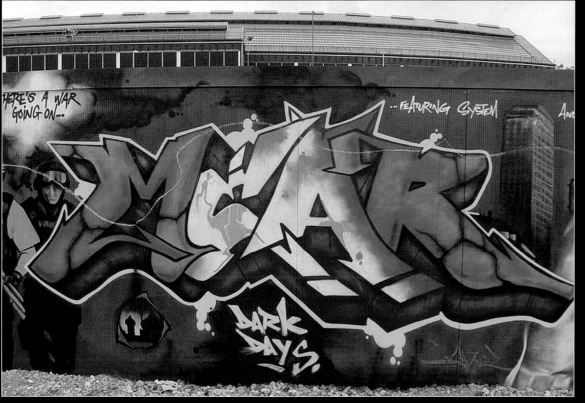

Brighton 2006, photo by Steam156

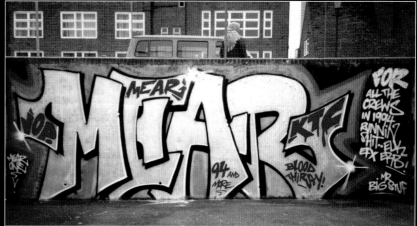

London 1994, photo by Stylo

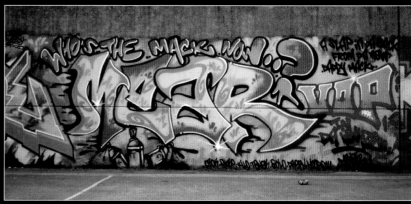

London 1994, photo by Stylo

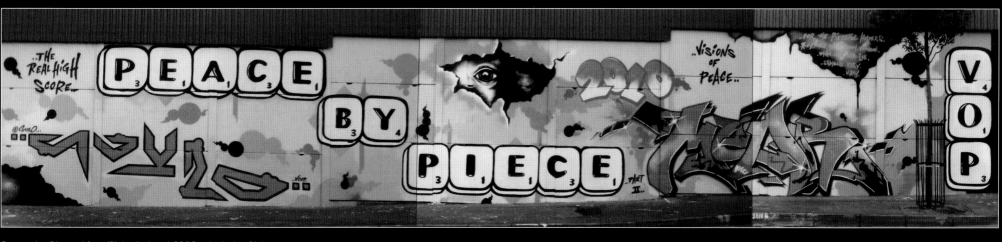

Peace by Piece, Mear/Stylo, Ireland 2010, photo by Stylo

Merc

Artist = Merc
Location = South East London
Painting since = 1983–1988 and 1999–present
Crews = ACR (All City Rebels)
Quote = My style switches between computerised to my take on 80s NYC letters with a major dose of the original London style blueprint, varying between straight letters and wild, while trying to keep things traditional and as fad-free as possible.

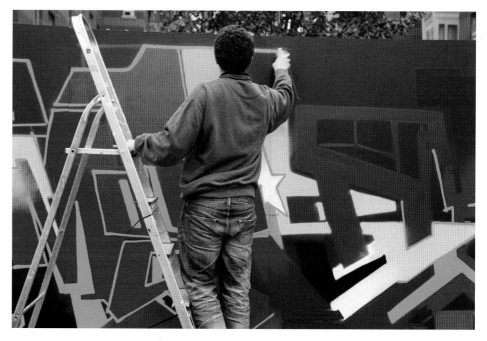

Meeting of Styles: London 2011, photo by Steam156

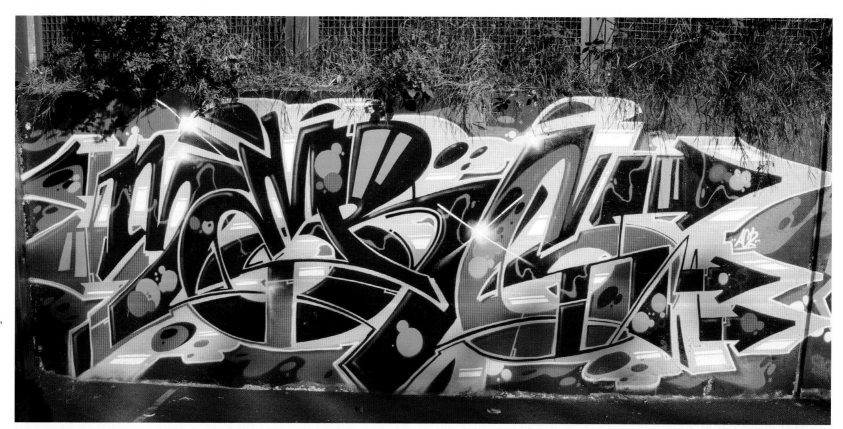

London 2010,
photo by
Steam156

120

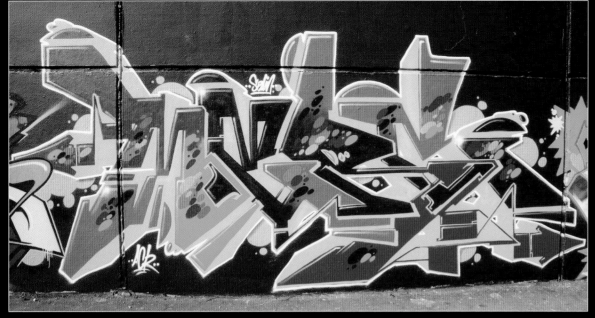

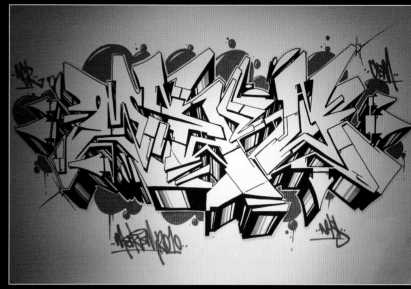

London 2011, photo by Steam156

Sketch for London black books show, photo by Steam156

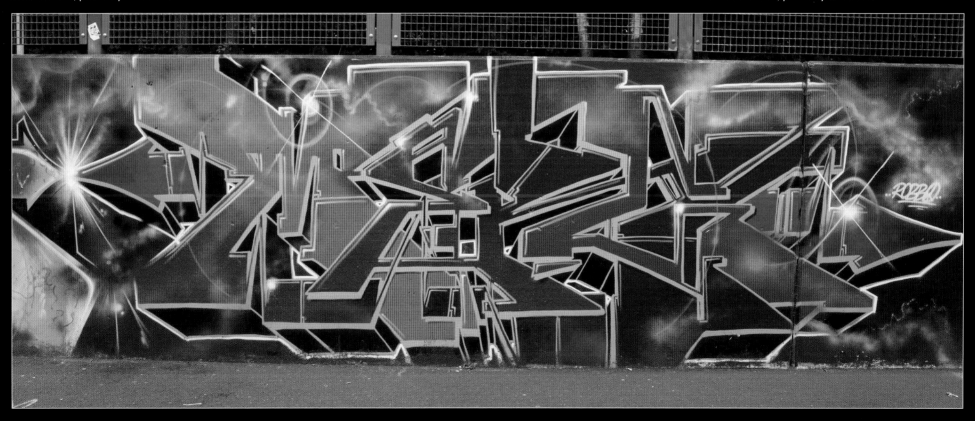

London 2011, photo by Steam156

Meros

Artist = Meros
Location = Kent
Painting since = 2007
Crews = GOLDS
Quote = Graffiti excites me, it keeps me on my toes and I continue to learn a lot about myself through doing it. I've met some of my closest friends throughout my time painting. I'd say it's a very important part of my life.
Website = www.flickr.com/photos/goldcrew

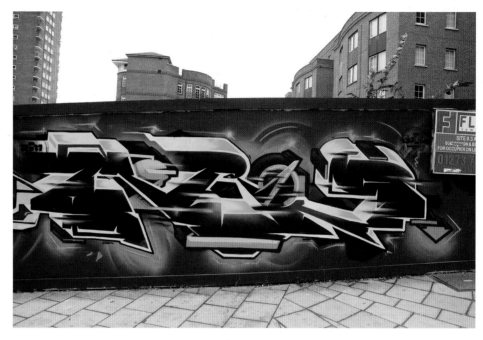

Brighton 2011, photo by Steam156

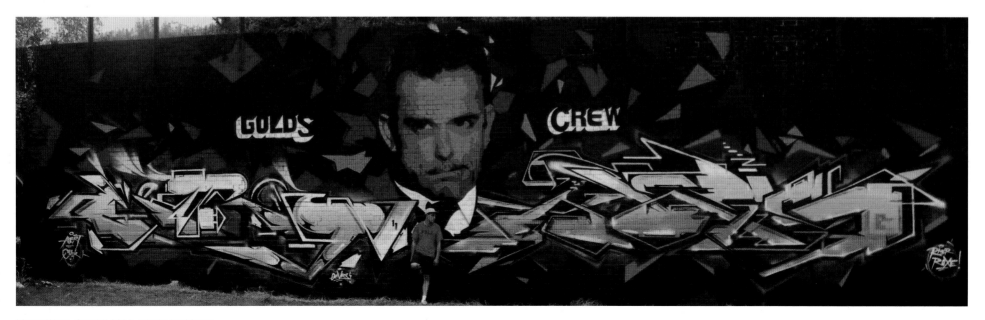

Meros/Akes, Cardiff 2011, photo by Meros

122

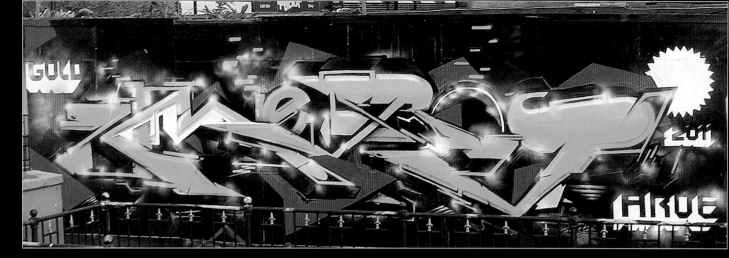

Dover 2011, photo by Meros

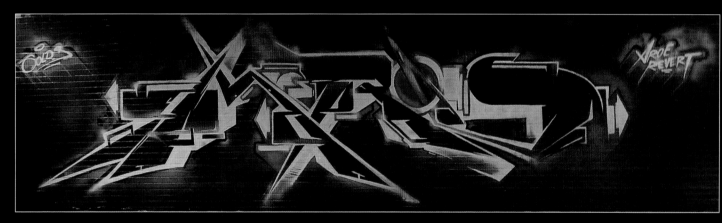

Kent 2010, photo by Meros

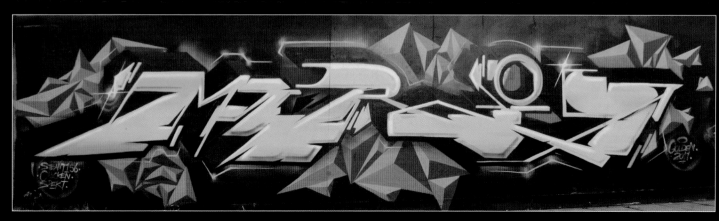

Brighton 2011, photo by Meros

Mighty Mo

Artist = Mighty Mo
Location = London
Painting since = 1998
Crews = BC (Burning Candy/Before Chrome)
Quote = You could definitely say I have a cartoons style: flat colours, black outlines, and no fades. I guess you could call me a logo writer but another way of looking at it is that it's a throw up that developed into a character. When I work with other people, I will usually make my character mesh in different ways. I have different gigs with different people and in some ways different styles. With BC crew we like to do huge ugly monsters and crazy logo combinations. When I paint with Mau Mau, we like to paint more of an illustrative scene (*e.g.* monkeys and foxes flying airplanes). When I'm on my own, it's usually just getting up. I use spray paint or roller poles, no stencils! Spray paint for climbing, rollers for special occasions. In other words, I often like to climb high or go big, throw ups and huge rollers, shock value bombing.

London 2011, photo by Mighty Mo

Mighty Mo/Mau Mau, London 2010, photo by Mighty Mo

London 2011, photo by Steam156

London 2011, photo by Steam156

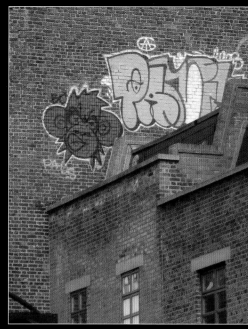

Mighty Mo/Panik, London 2010, photo by Steam156

London 2011, photo by Steam156

Nylon

Artist = Nylon
Location = East Anglia and the South Coast
Painting since = 1985
Crews = none
Quote = My style is poppy, sloppy, colours, no cut backs, big eyes, fun characters, just basic lettering, no frills graffiti, no fancy pants.

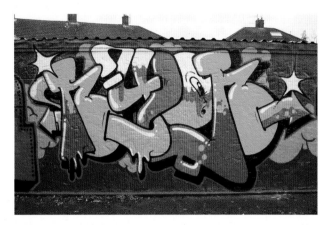

Bristol 2009,
photo by Nylon

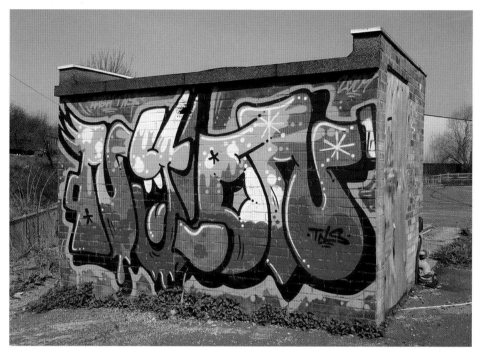

Suffolk 2009, photo by Nylon

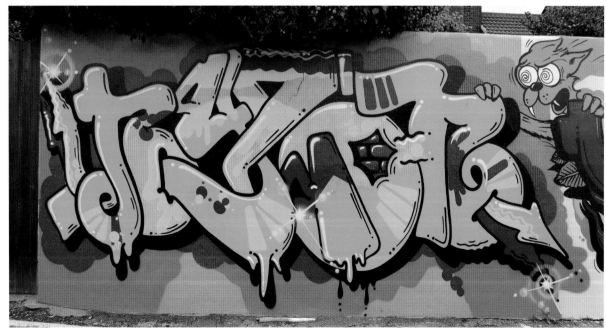

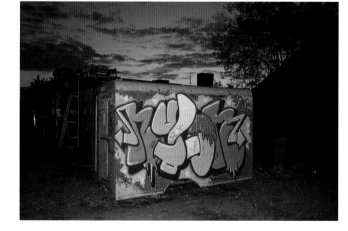

Suffolk 2009, photo by Nylon

Suffolk 2011, photo by Nylon

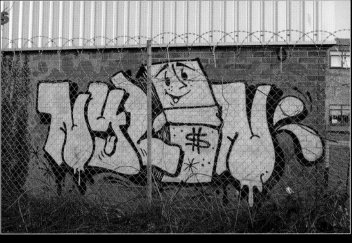

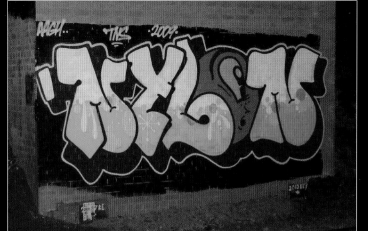

Far left:
Ipswich 2009, photo by Nylon

Left:
Suffolk 2009, photo by Nylon

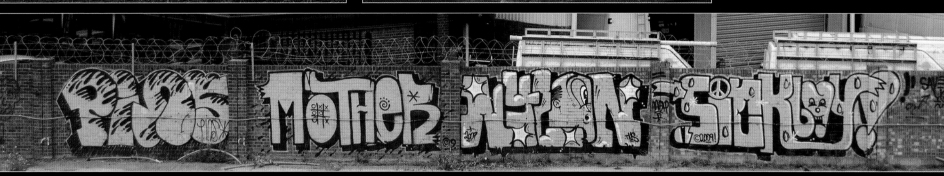

Pins/WTM/Nylon/Sickboy, London 2009, photo by Nylon

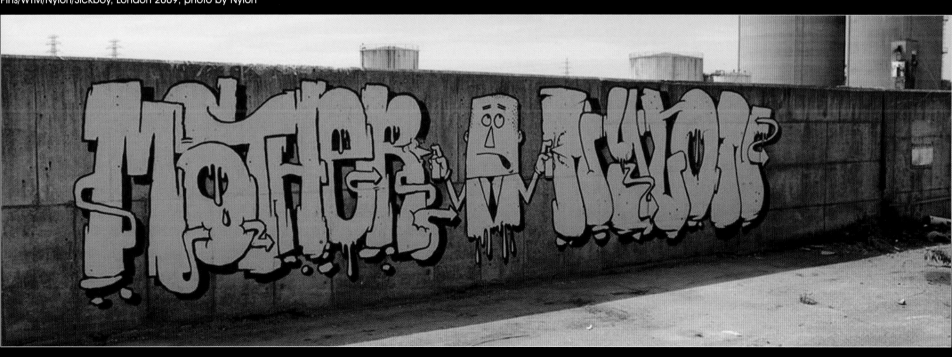

Nylon/Word-to-Mother, Suffolk 2010, photo by Nylon

Odisie

Artist = Odisie
Location = Brighton/London
Painting since = 1991
Crews = none
Quote = I reckon I do a mix of old school graffiti with new school ideas and techniques on top.

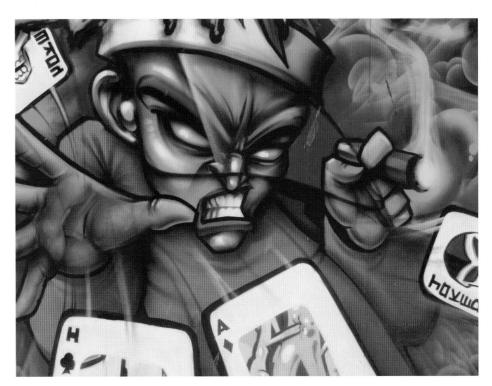

Holdin' Aces (detail), Odisie/Jiroe, Brighton 2009, photo by Steam156

Battle of Waterloo, London 2011, photo by Odisie

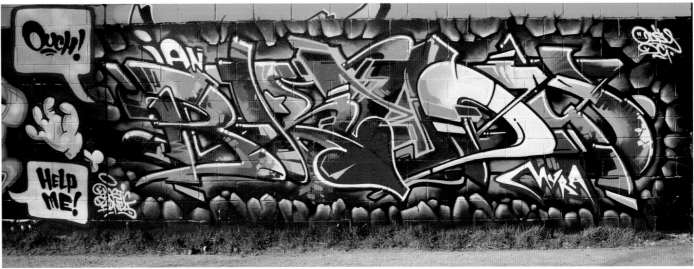

Brady, London 2011, photo by Odisie

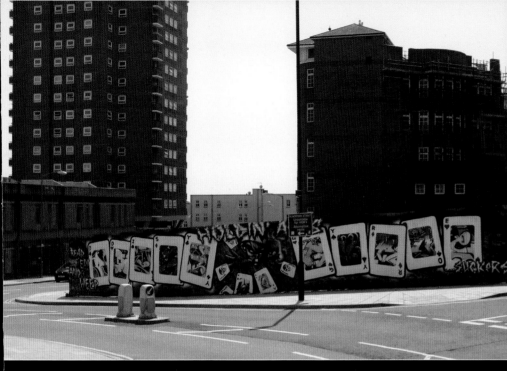

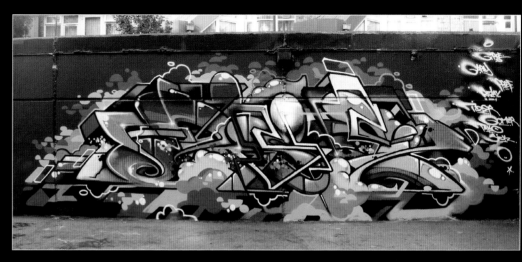

London 2011, photo by Odisie

Holdin' Aces, Odisie/Jiroe, Brighton 2009, photo by Steam156

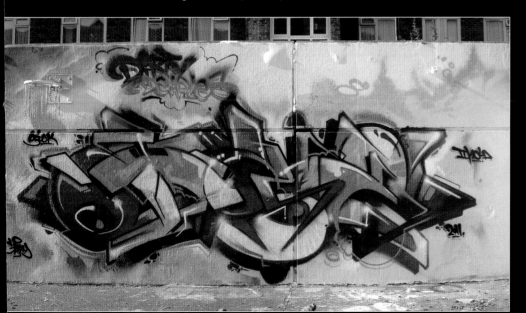

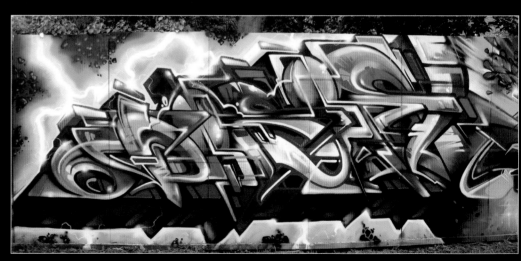

London 2011, photo by Odisie

Part2ism

Artist = Part2ism
Location = Planet Earth
Painting since = 1984
Crews = TAN (The Aerosol Nation), VOP (Visual Orgasm Productions), Ikonoklast
Quote = Style is everything that you are. It defines your identity to the world. You can tell what a person is like just from how and what they paint. I'm a shapeshifter, so you can tell from the constantly changing streams of work I put out that I like to take risks and go beyond what others define as pigeon holes. To me, style is about progression.

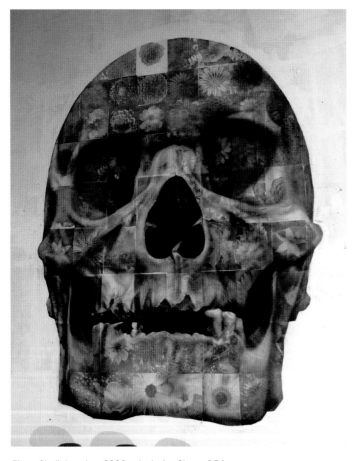

Flora Skull, London 2009, photo by Steam156

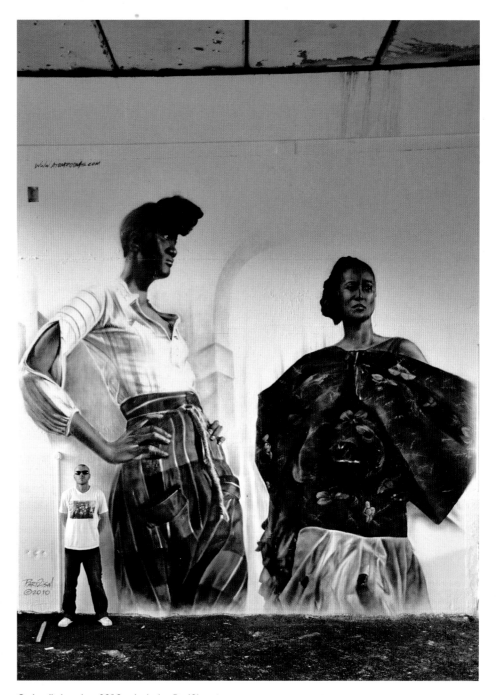

Catwalk, London 2010, photo by Part2ism

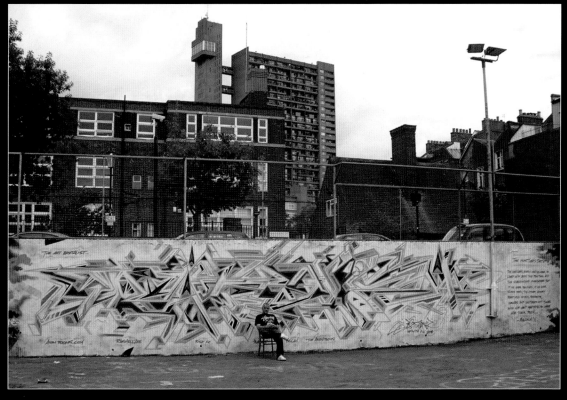

Brutalism, London 2010, photo by Part2ism

Canvas, 2011, photo by Part2ism

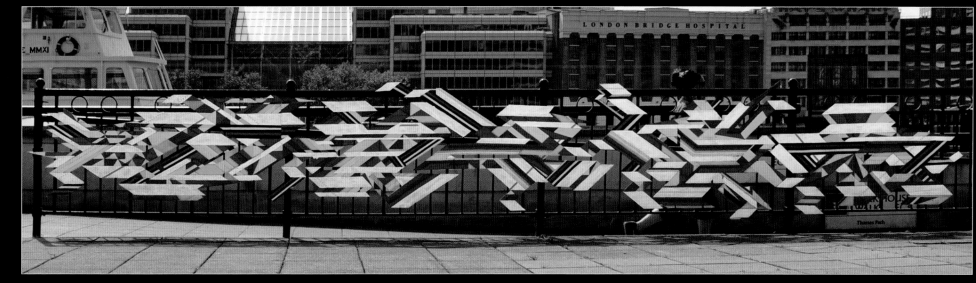

Signal Test, London 2011, photo by Part2ism

PIC

Artist = PIC
Location = North London
Painting since = 1981
Crews = WRH (We Rock Hard)
Quote = You've either got it or you ain't. And I ain't!

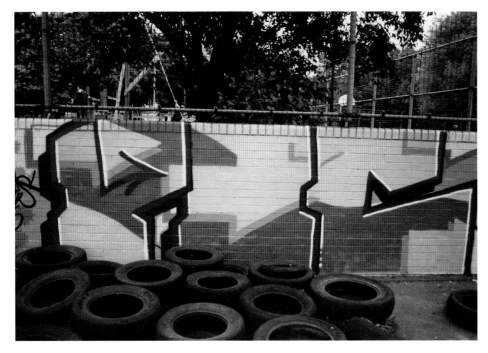

London 2007, photo by PIC

London 2011, photo by PIC

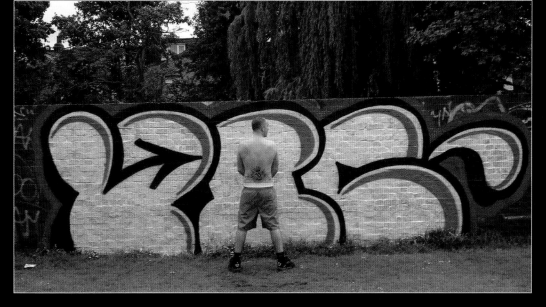

London 2010, photo by PIC

London 2011, photo by PIC

London 2009, photo by PIC

London 2005, photo by PIC

London 2006, photo by PIC

Ponk

Artist = Ponk
Location = Bristol
Painting since = 1997
Crews = Heavy Artillery
Quote = Style is everything. We all have it, it's just a case (for me) of continually searching to be individual and pushing to be known, respected, and remembered.
Website = www.heavyartillery.com

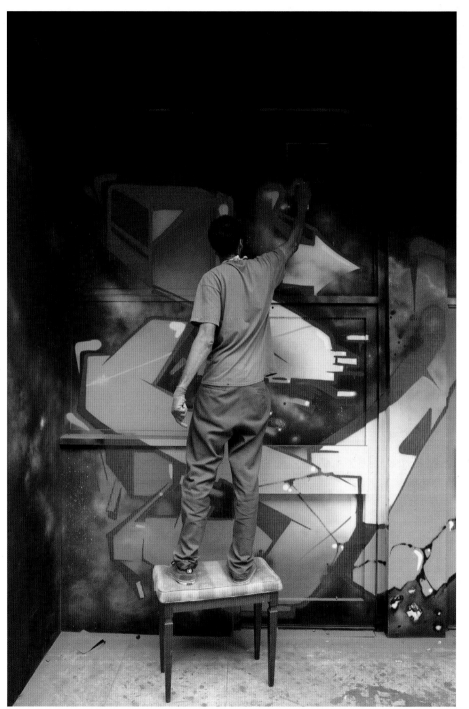

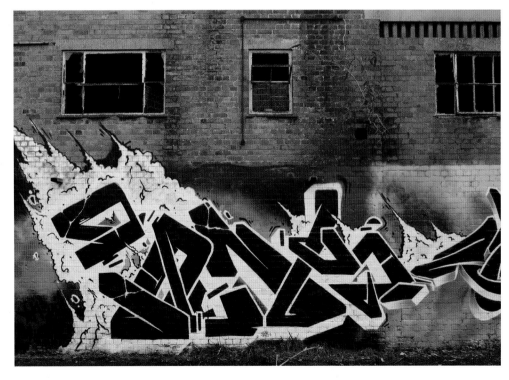

Bristol 2010, photo by Ponk

See No Evil Event: Bristol 2011, photo by Steam156

134

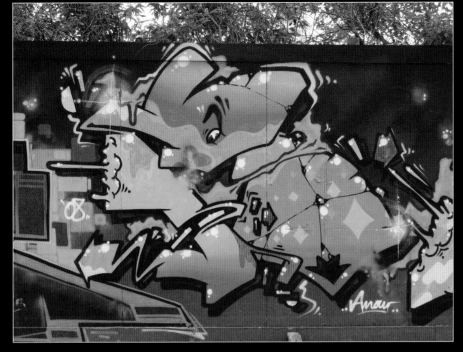

Brighton 2008, photo by Steam156

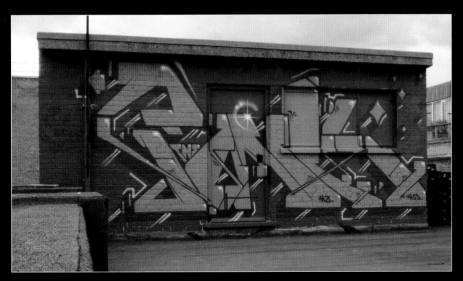

London 2010, photo by Ponk

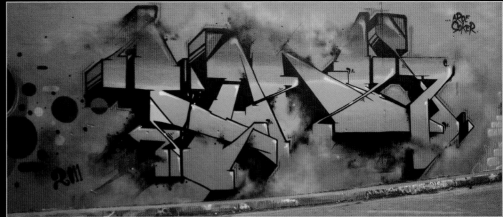

London 2011, photo by Ponk

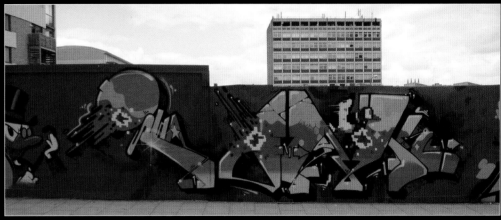

Brighton 2010, photo by Steam156

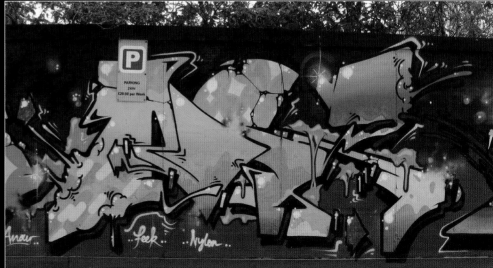

Brighton 2008, photo by Steam156

Pref

Artist = Pref
Location = North West London
Painting since = 1994
Crews = ID (Ivory Dukez)
Quote = My style is always evolving. I'd like my style to be about an approach or a spirit of doing, rather than a particular visual solution. I'm interested in finding new and innovative ways to paint my name without losing the attitude and feel of traditional graffiti.
Website = www.flickr.com/photos/prefid

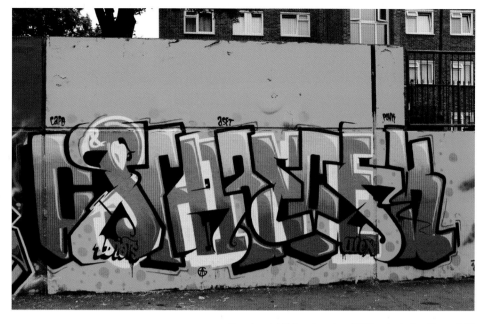

Crack and Shine, London 2011, photo by Steam156

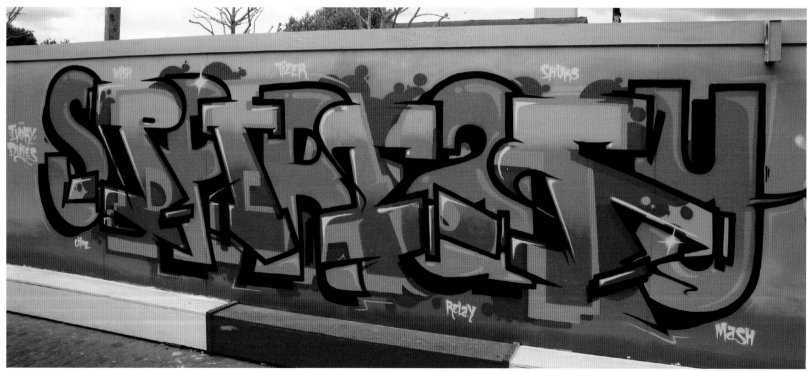

Spray Beast, London 2011, photo by Steam156

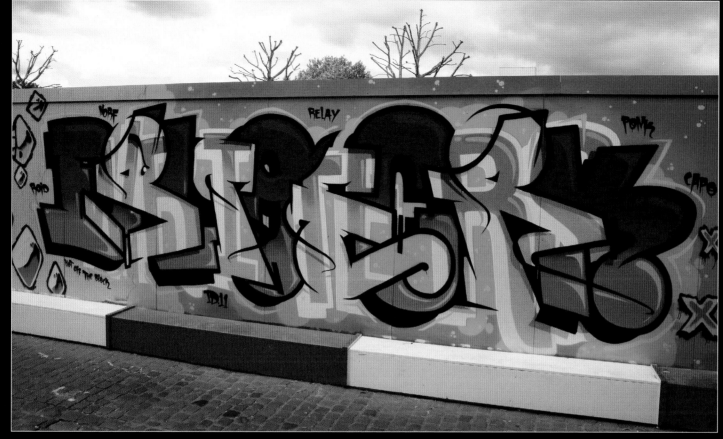

Writers Block, London
2011, photo by Steam156

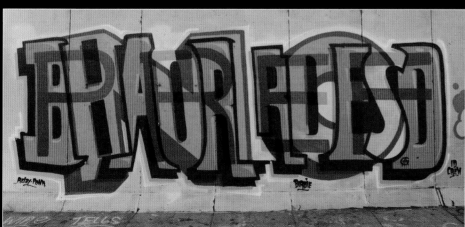

No Holds Barred, London 2011, photo by Steam156

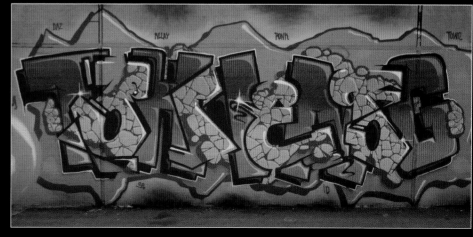

The Thing, London 2010, photo by Steam156

Prime

Artist = Prime
Location = London
Painting since = 1985
Crews = ASK (All Star Kings), THR (The Hellraisers), WRH (We Rock Hard)
Quote = For me, real graffiti has a power like no other form of expression and that power is most potently realised when an individual just claims a space and does something meaningful with it. No censorship but his or her own, and with that freedom there is a kind of responsibility to at least try to do something dope.
Website = www.londonlegends.co.uk

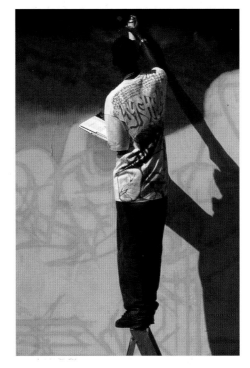

Unity Event: 1993, photo by Steam156

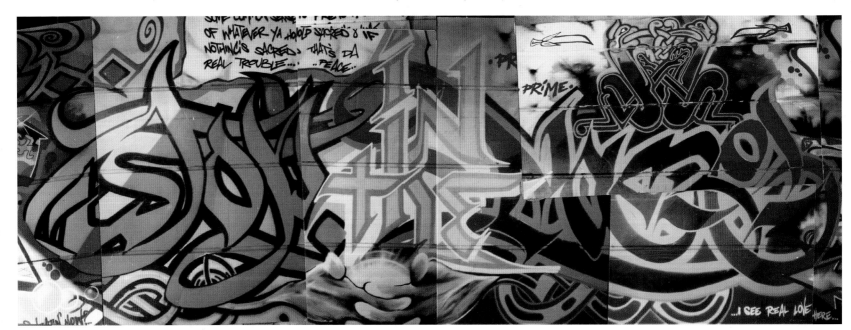

Stop in the Name, Ireland 1993, photo by Prime

138

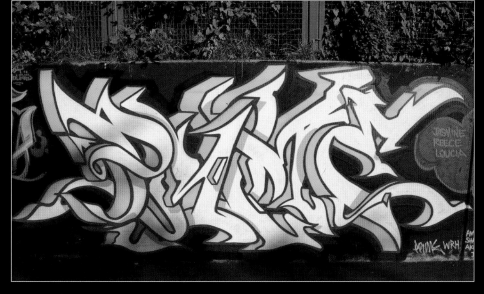

London 2010, photo by Steam156

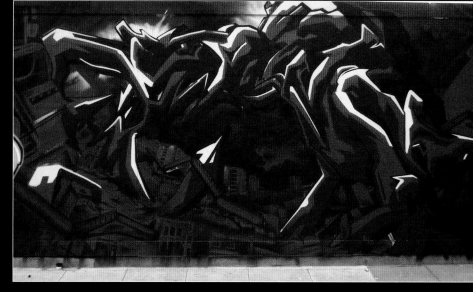

Meeting of Styles: London 2009, photo by Steam156

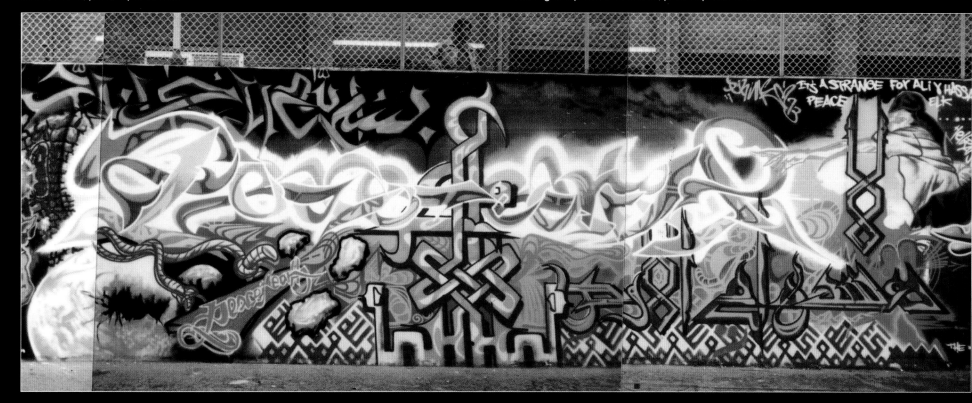

Peace of Earth, London 1993, photo by Prime

Probs

Artist = Probs
Location = London
Painting since = 2004
Crews = End of the Line
Quote = Graffiti is a fight. You are fighting for space, with other graffiti artists, with authority, with advertisers and fly posters. You better be prepared to throw down if you want to be noticed.

You are going to have to destroy your opposition totally to become a champion.
Website = www.endoftheline.co

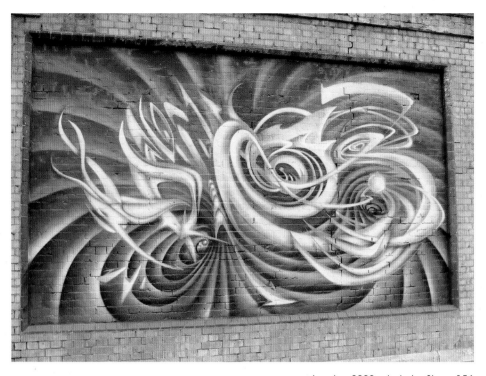

London 2009, photo by Steam156

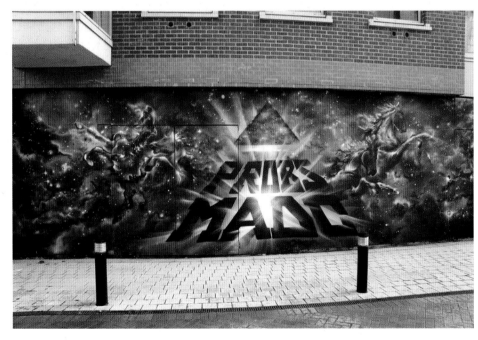

Probs/MadC, London 2010, photo by Steam156

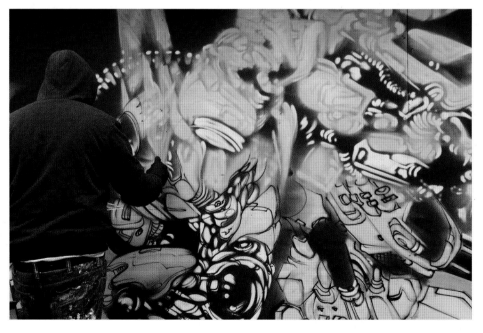

Meeting of Styles: London 2011, photo by Steam156

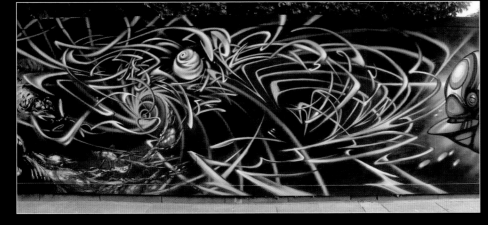

Meeting of Styles: London 2009, photo by Steam156

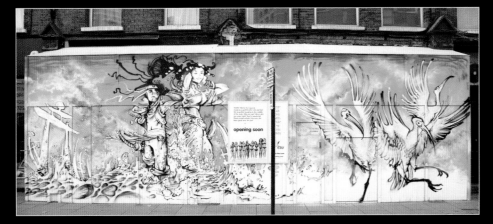

London 2011, photo by Steam156

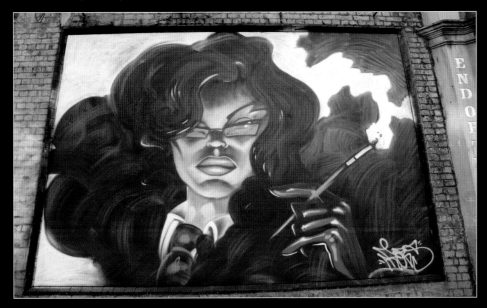

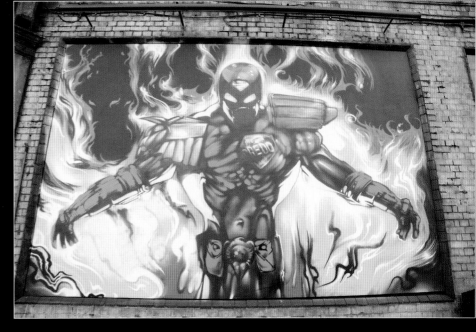

London 2011, photo by Steam156

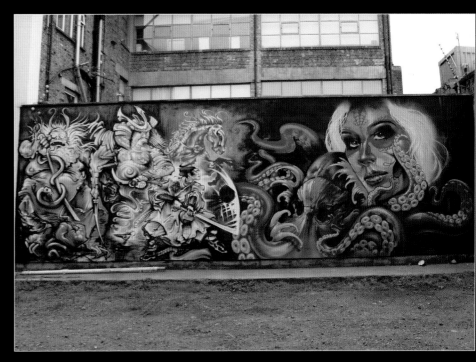

Probs/Dan Chase, London 2011, photo by Steam156

Proud 2

Artist = Proud 2
Location = Essex
Painting since = 1986
Crews = ERZ (Essex Rockerz)
Quote = No other art form is so blatant in its visual assault. Graffiti is edgy and doesn't take into consideration "please" and "thank you"—and this, for me, is as frustrating as it is liberating.
Website = www.flickr.com/photos/essexrockerz

Parlee, Proud2, & Demane, Aerosolplanet Jam: Tamworth 2011, photo by Steam156

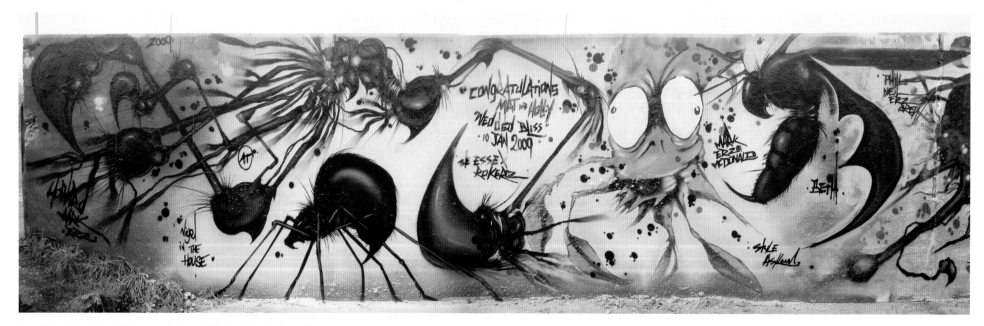

Beast (remix by Proud2/Demane), Essex 2011, photo by Proud2

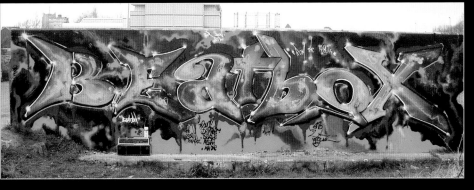

Beatbox, Essex 2009, photo by Proud2

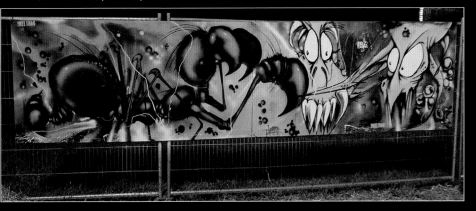

Stinger, Fordham Festival: Cambridge 2009, photo by Proud2

Defcloud/Proud2/Demane, Essex 2010, photo by Proud2

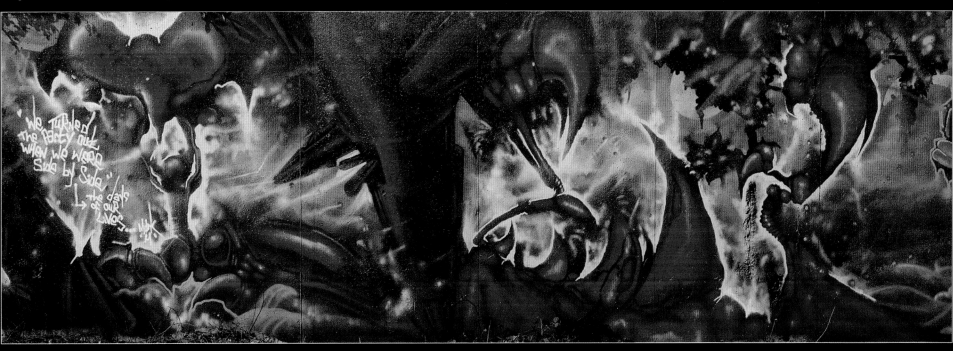

Phat Planet, Proud2/Demane, Essex 1999, photo by Proud2

143

Quest

Artist = Quest
Location = South London
Painting since = 1985
Crews = none
Quote = I wouldn't say that having a good style is that important as long as you have your own style and a real drive and passion.

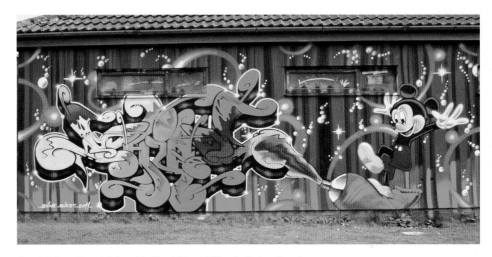

Hey Mickey, Quest/Shine, Hertfordshire 2011, photo by Quest

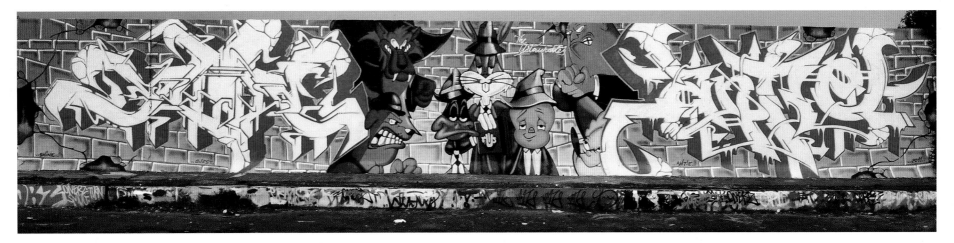

The Untouchables, Quest/Shine/Ante, London 2011, photo by Quest

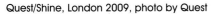
Quest/Shine, London 2009, photo by Quest

Terminator, Quest/Shine, London 2009, photo by Quest

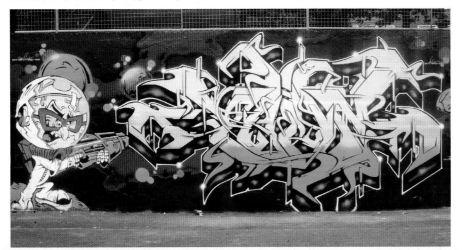

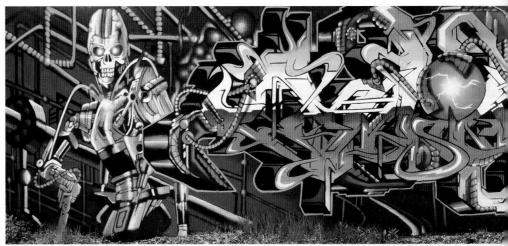

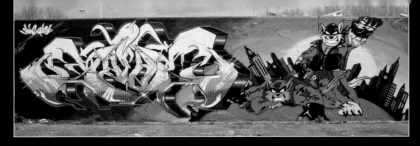

Far left:
Quest/Shine, Chelmsford 2010,
photo by Quest

Left:
Quest/Shine, St Neotts 2009,
photo by Quest

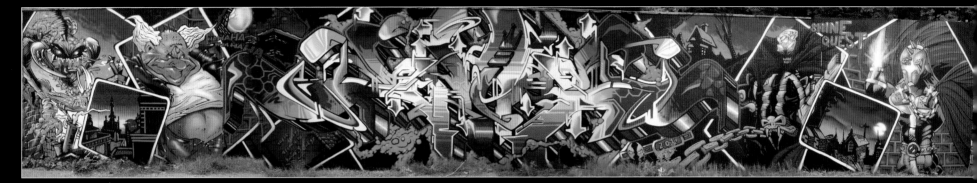

Spawn Mega Production, Quest/Shine, London 2011, photo by Ques

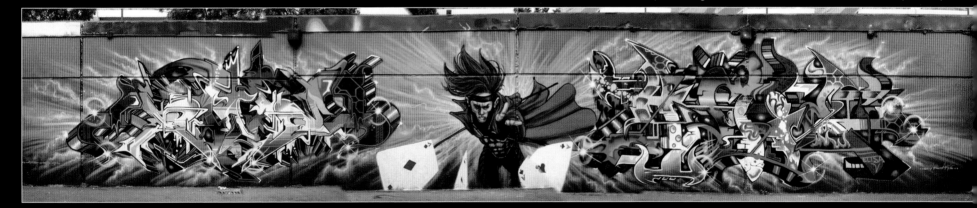

Quest/Shine/Brave/Ante, London 2011, photo by Ques

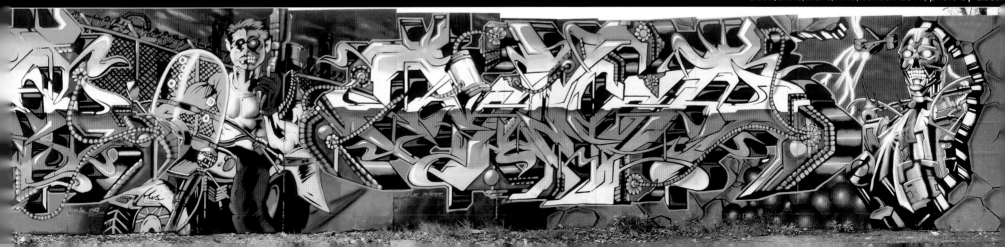

Rebus

Artist = Rebus
Location = Brighton
Painting since = 2006
Crews = none
Quote = Style is important to me but not as fundamental as expression.
I do graffiti because it allows me to be free. I often find my pieces are
affected by how I feel at the time, so I like to be able to mix my letter forms
and shapes.
Website = www.flickr.com/photos/3rdeyevision/

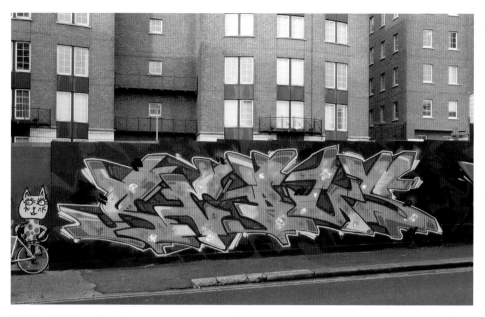

Brighton 2010, photo by Rebus

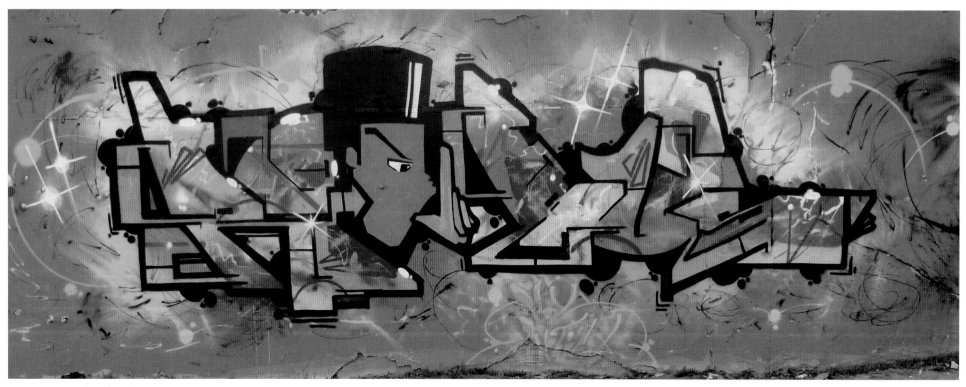

Brighton 2011, photo by Rebus

146

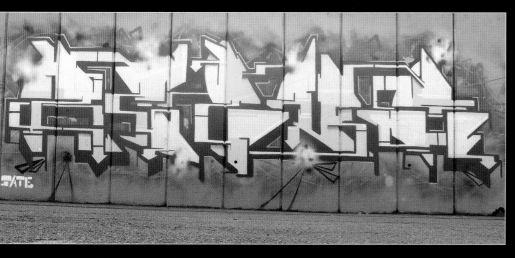

Portsmouth 2011, photo by Rebus

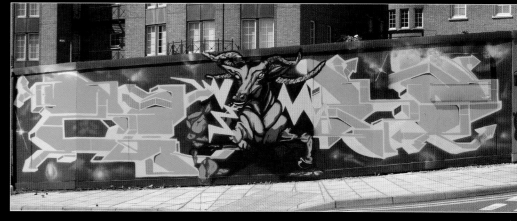

Brighton 2011, photo by Rebus

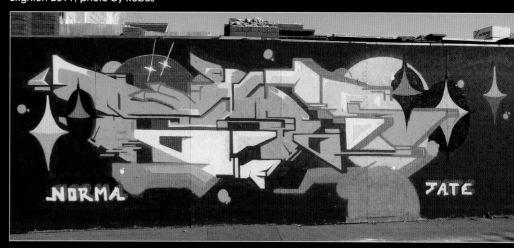

Brighton 2011, photo by Rebus

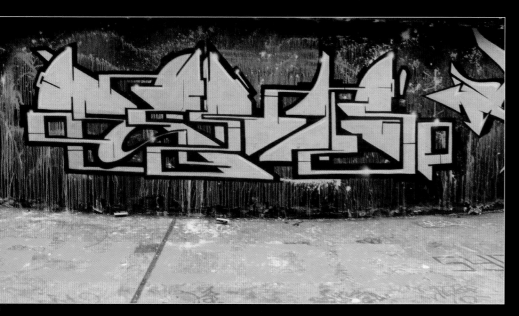

Brighton 2011, photo by Rebus

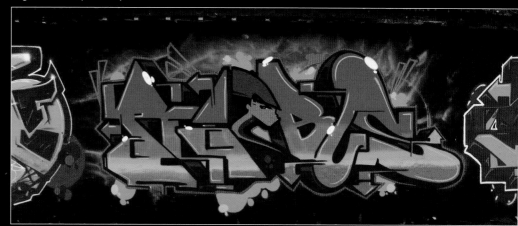

Relay

Artist = Relay
Location = London
Painting since = 1986
Crews = ID (Ivory Dukez), HA (Heavy Artillery)
Quote = I wouldn't have a clue how to describe my style to be honest. I suppose my letters have always had quite sharp ends with a pretty off-key shape or flow to them. I used to paint my letters with a lot of space between them, almost making them individual (which I suppose is still a "hang over" from doing the type of graffiti that has to be fast and legible). However, at the moment I am trying to draw my letters in closer and make my pieces a little more symmetrical. I would have to say the L and Y cause me the most anguish. I find that the L leaves very little room for change or development without making it look like it's not actually an L. There aren't many people that have Ys in their names (especially on the end), which gives you a good idea how much of a pain in the arse it is.

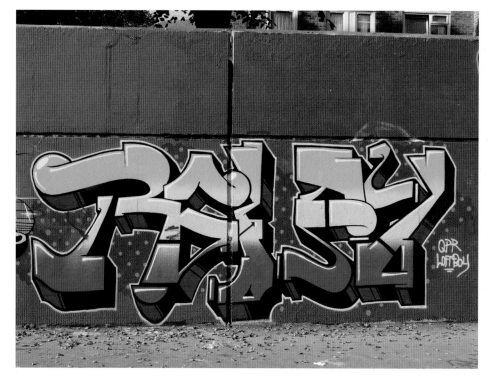

London 2009, photo by Steam156

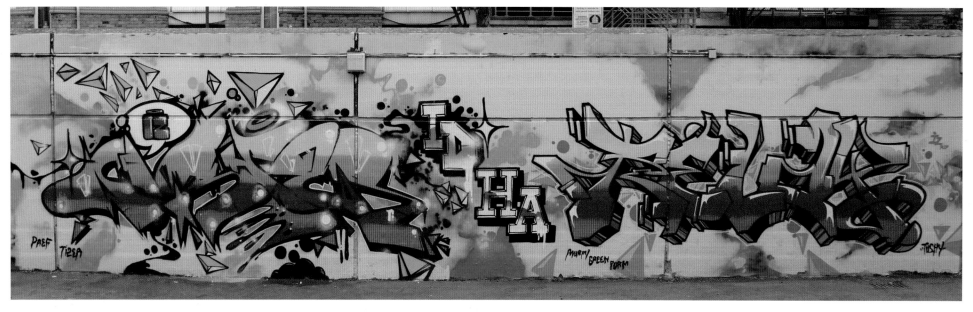

Relay/Wisher, London 2011, photo by Steam156

148

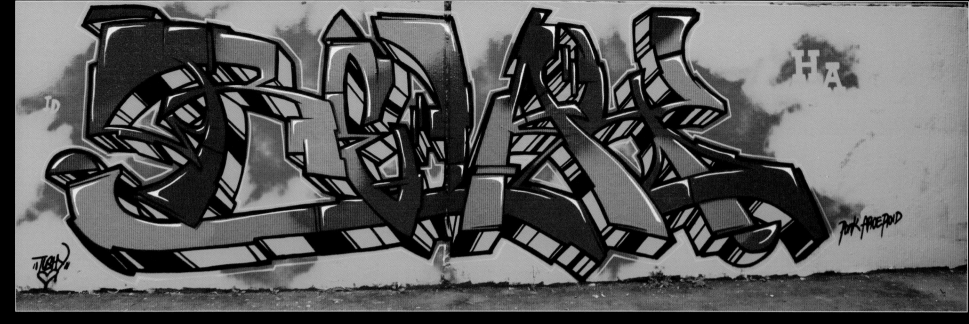

London 2011, photo by Steam156

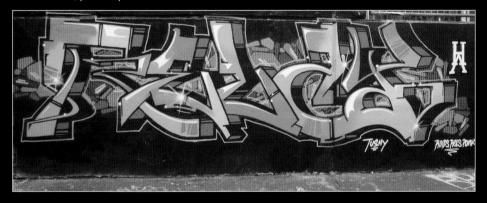

London 2011, photo by Steam156

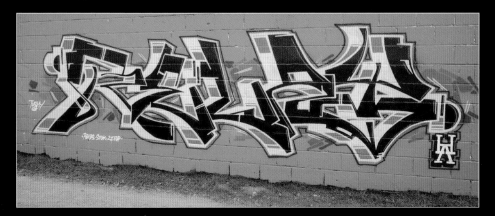

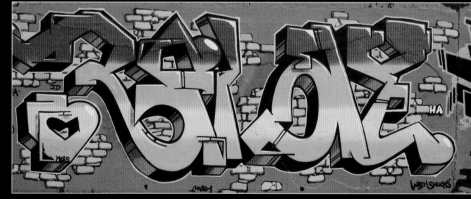

London 2009, photo by Steam156

Robbo

Artist = Robbo
Location = North London
Painting since = 1984
Crews = WRH (We Rock Hard), UA (United Artists), PFB (Prophets from Beyond)
Quote = For a very long time graffiti consumed my life; pretty much everything I did was directly connected to graffiti. I lived for it...racking, sketching, painting, and bombing.

It never leaves you but, in my case, life got in the way...having a family, running a business, and trying to stay out of jail for the aforementioned reasons. I decided to retire, having felt I'd achieved everything I could...I wanted to go out at the top of my game.

It remained this way for a long time until a street artist went over one of my earliest pieces. It brought me out of retirement and I found I still had the hunger I had many years before; it still gave me a buzz and I immersed myself into it once more. The scene had changed a lot since I'd been away—the techniques were different, the paint was better, and even the kind of writers I was meeting were different. I found a new vigor and new influences...I loved it.

I was influenced in my early years initially by the old skinheads who used to put their names everywhere, in particular: Wilko2, Rolo, Bozo, and Invader. Seeing these names in my area made me want to write my name everywhere, too. I was, later on, influenced by the work of old school graffiti writers like Kosh, Shades, and Jap302...these people made me want to paint big colourful pieces.
Website = www.teamrobbo.org

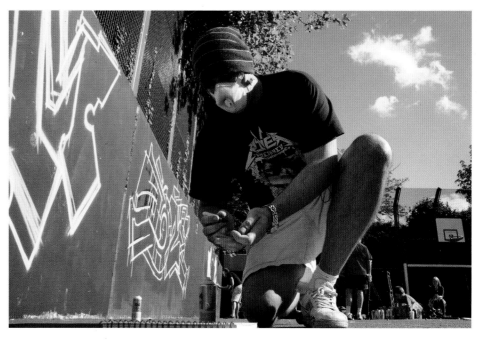

London 2010, photo by Steam156

London 2010, photo by Steam156

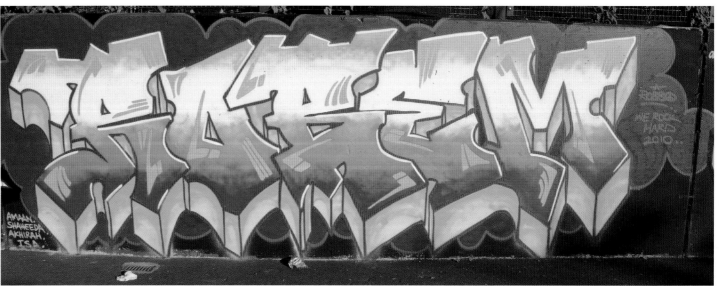

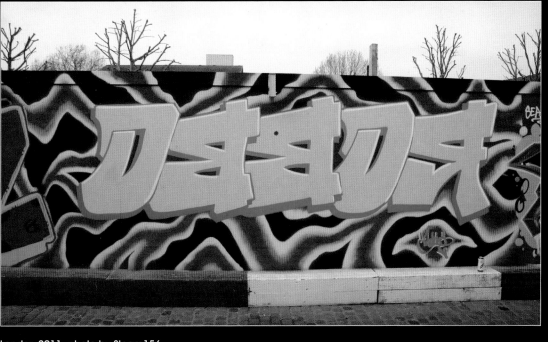

London 2011, photo by Steam156

Pure Evil Gallery: London 201[...]
photo by Steam156

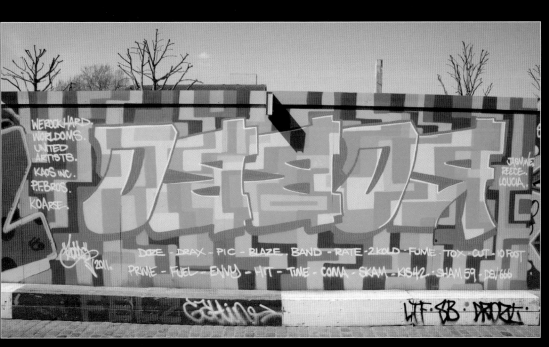

London 2011, photo by Steam156

Signal Gallery Show: London [...]
photo by Steam156

Rocket01

Artist = Rocket01
Location = Sheffield
Painting since = 1994
Crews = none
Quote = I would describe my style as organic sci fi—biobotanical—a bit weird with elements of surrealism and 3-D effects! I'm heavily influenced by nature, plants and animals, science, and technology!
Website = www.rocket01.co.uk

Pitcher Plant, canvas, 2009, photo by Rocket01

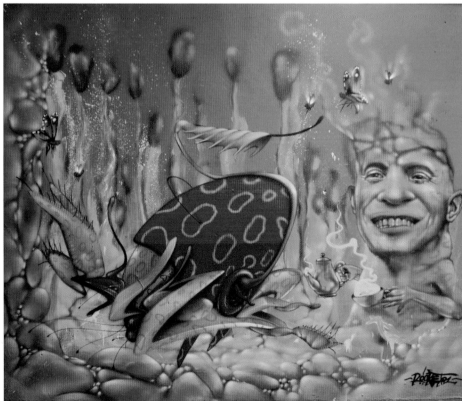

Sheffield 2010, photo Rocket01

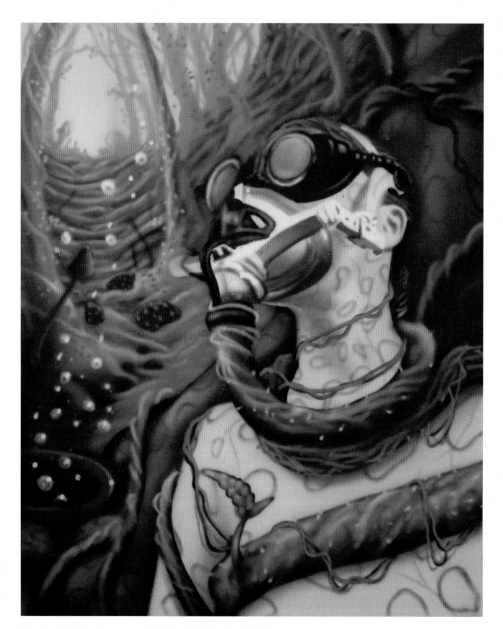

The Deadly Forest, canvas, 2009, photo by Rocket01

152

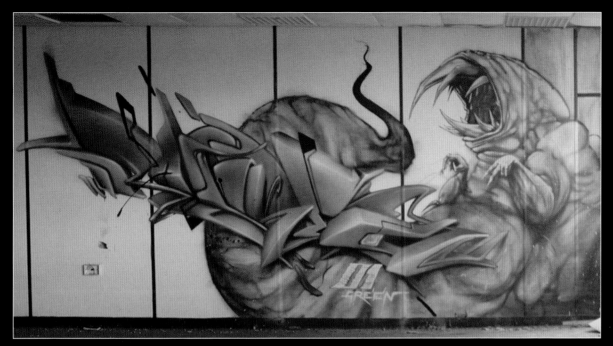

Sheffield 2011, photo Rocket01

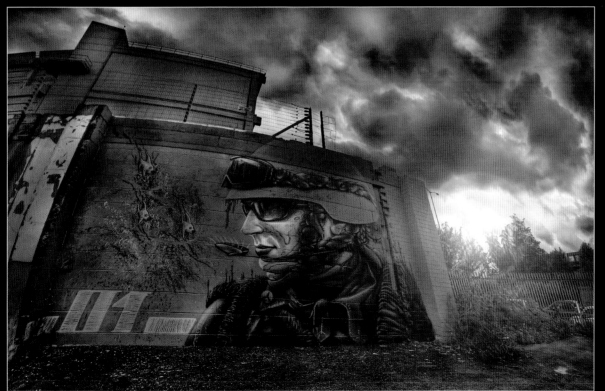

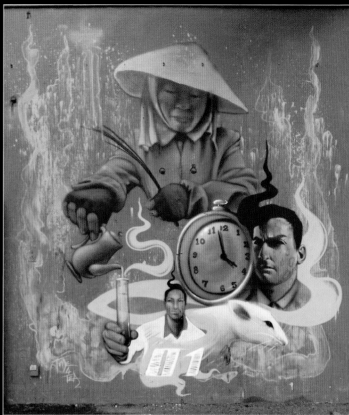

Time for Tea, Sheffield 2011, photo by Rocket01

Nature's Soldier, Sheffield 2011, photo by Rocket01

153

Rowdy

Artist = Rowdy
Location = Bristol
Painting since = 1987
Crews = BC (Burning Candy), SOF (Souls on Fire)
Quote = I still tag, and though the letter form has been absent in many of my works over the last few years, the "graffiti" attitude remains. I like the no red tape, health and safety aspect to it. Your crew becomes like family: we were like a secret society, are we still? Graff is a constant reminder that no one should control your life.
Website = www.getrowdy.info

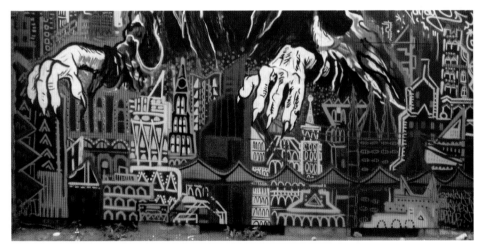

Newcastle 2011, photo by Rowdy

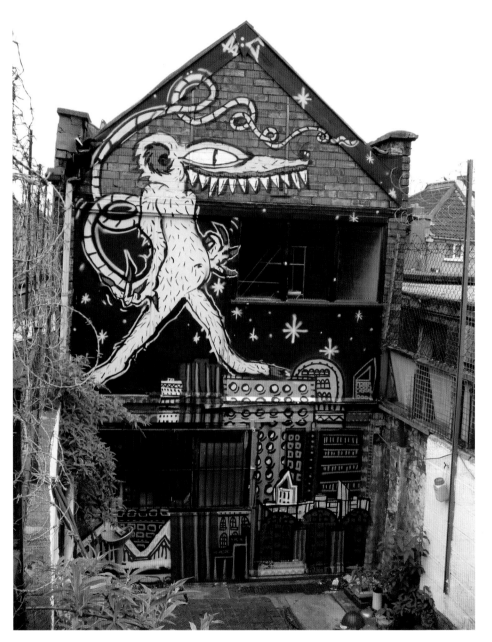

Bridget Mouse, Bristol 2009, photo by Rowdy

154

Process Report, Dead Woman's Bottom, Somerset 2003, photo by Rowdy

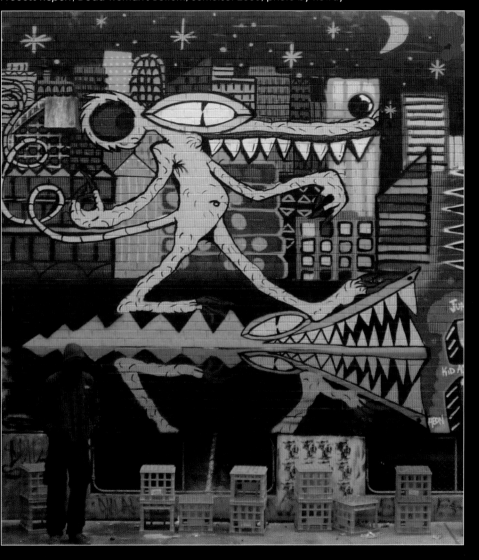

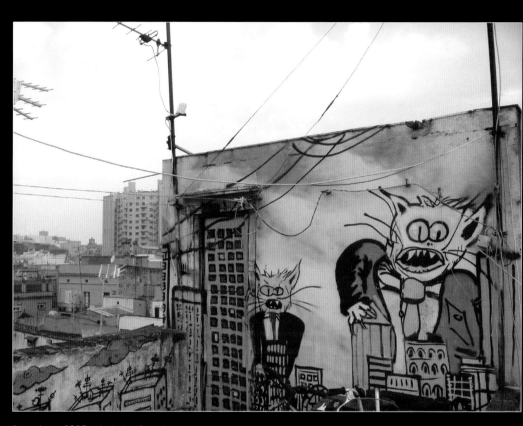

Barcelona 2007, photo by Rowdy

Melbourne, Australia 2010, photo by Rowdy

155

Sepr

Artist = Sepr
Location = Bristol
Painting since = 2000
Crews = ASK (After Skool Klub), KTF (Keeping Things Fresh)
Quote = Growing up in Bristol, there was a lot of great artists about who inspired me style wise in different ways. From letter writers like Soker, Paris, Inkie, Ryder, and Dicy to character artists like Catoe, Feek, and Cheo to more abstract artists like Xenz or SOF. They all had something in their work that I really liked, whether it was the style, content, flow, technique, or whatever. So I'm sure in some way they all had a subconscious affect on my own work. I mean that's a pretty varied list of people, style wise! I always drew avidly as a kid and to this day I still love cartoons and comics, so this has blatantly had an influence on my style. People who are friendly and have a positive attitude to painting and life in general influence me to keep painting and develop my style.
Website = www.sp-sepr.co.uk

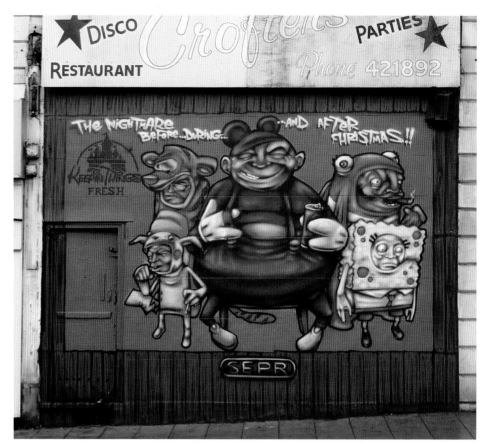

Bristol 2009, photo by Sepr

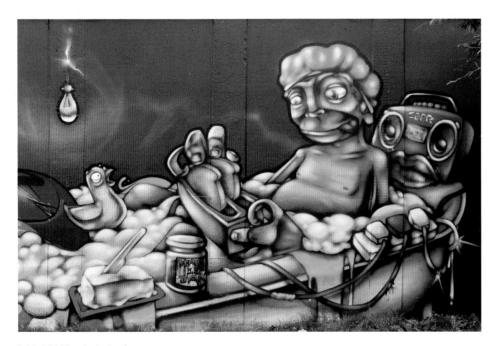

Bristol 2011, photo by Sepr

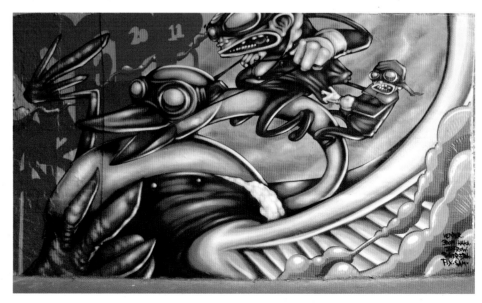

Bristol 2011, photo by Sepr

156

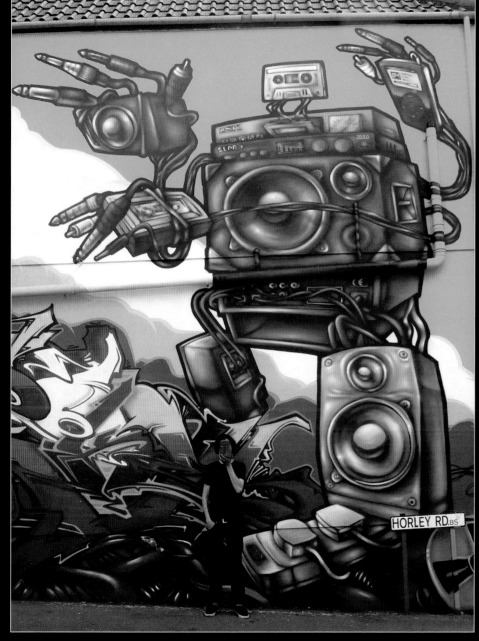

Bristol 2010, photo by Sepr

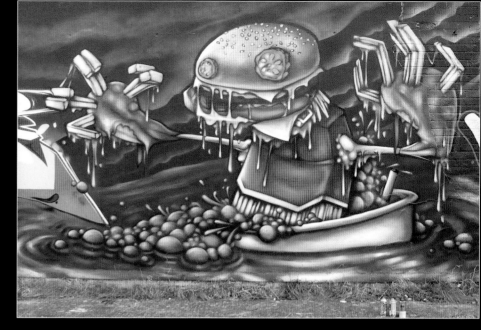

Corsham 2010, photo by Sepr

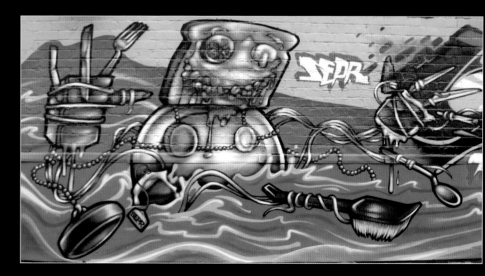

Bristol 2011, photo by Sepr

Shades

Artist = Shades
Location = North London
Painting since = 1982
Crews = TDC (The Demon Cans), The Undercover Artists
Quote = It's important to have good style but its all down to the individual; most true graffers all have a different style, that's what makes graffiti a unique art form. I know the graffiti world self imposes its own set of rules, but for me it's about freedom of expression, getting a buzz out of taking risks, enjoying myself, and doing my own thing.

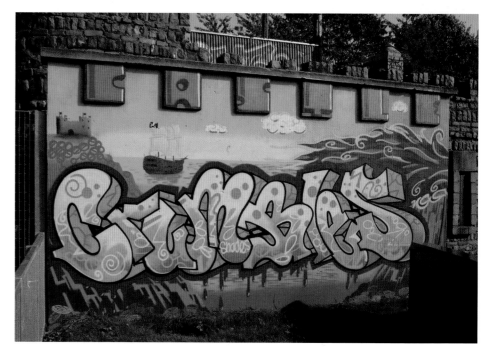

Crumbles Castle, Shades/PIC, London 2006, photo by Shades

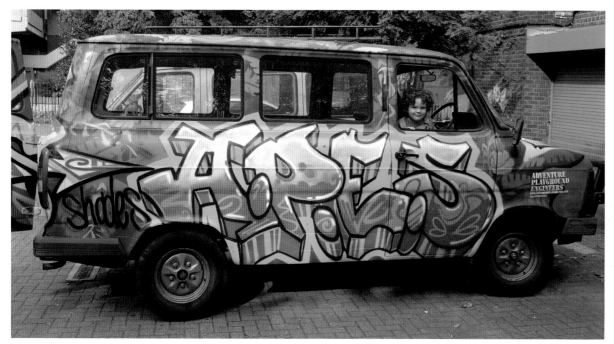

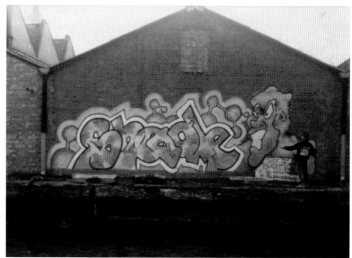

London 1983, photo by Shades

Apes: Adventure Playground Engineers, London 2005, photo by Shades

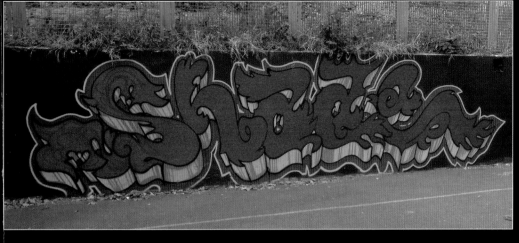

London 2010, photo by Shades

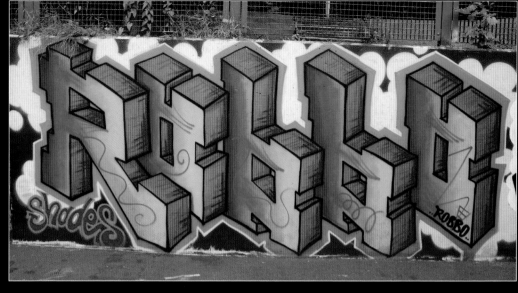

Robbo by Shades, London 2011, photo by Steam156

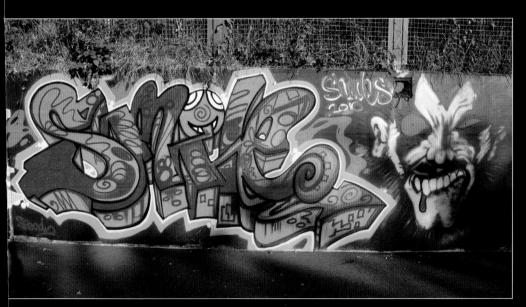

London 2010, photo by Steam156

Essex 2011, photo by Shades

SHEONE

Artist = SHEONE
Location = South London
Painting since = 1984
Crews = ROCKGROUP, TRANSCEND
Quote = Graffiti is a fine balance between being personally expressive with spray paint and nostalgia for an extinct American form of flamboyant ghetto criminality.
Website = www.blackatelier.com

Tear Down Love, London 2011, photo by Steam156

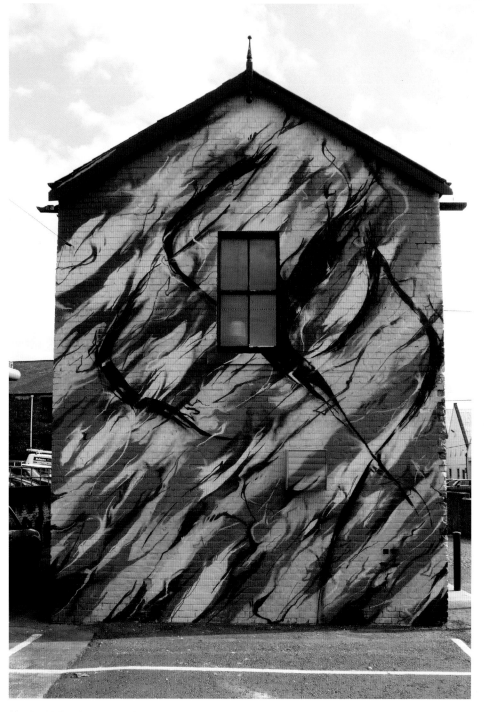

Blacklightning, Newcastle 2011, photo by SHEONE

Dot Com Pop, Glasgow 2011,
photo by SHEONE

Meeting of Styles: London 2010, photo by Steam156

Detail, Niort, France 2011,
photo by SHEONE

Detail, Newcastle 2011,
photo by SHEONE

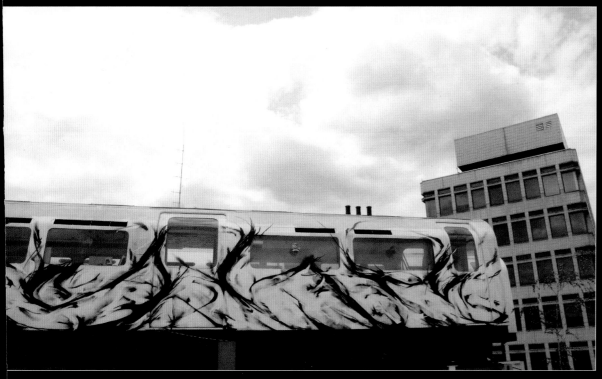

London Iron, London 2010, photo by SHEONE

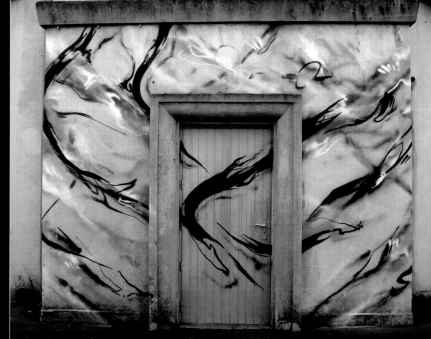

13Menthol, Niort, France 2011, photo by SHEONE

161

Shine

Artist = Shine
Location = South London
Painting since = 1985
Crews = none
Quote = My style—wild or semi-wild, sharp to a point with twists and turns, overlaps with thin and fat extensions, also an added twist of old and new school flavour.

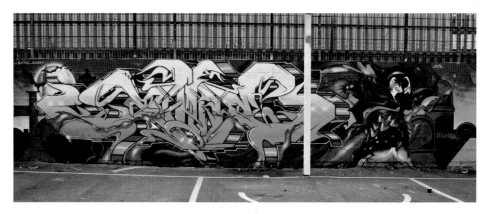

Shine/Quest, Nottingham 2010, photo by Shine

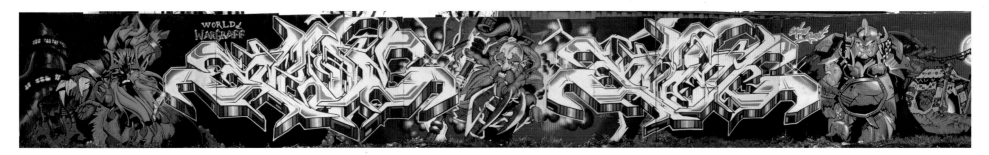

Warcraft, Shine/Quest, London 2010, photo by Shine

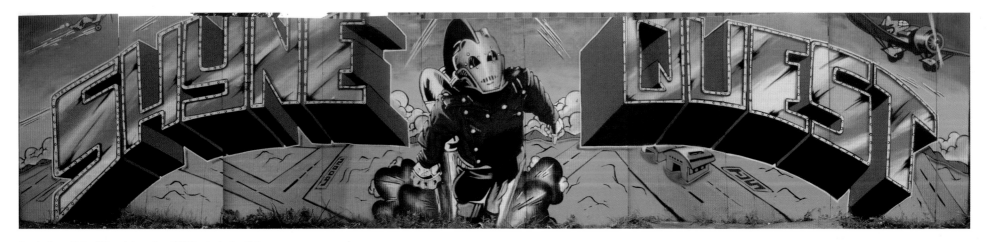

Rocketeer, Shine/Quest, London 2009, photo by Shine

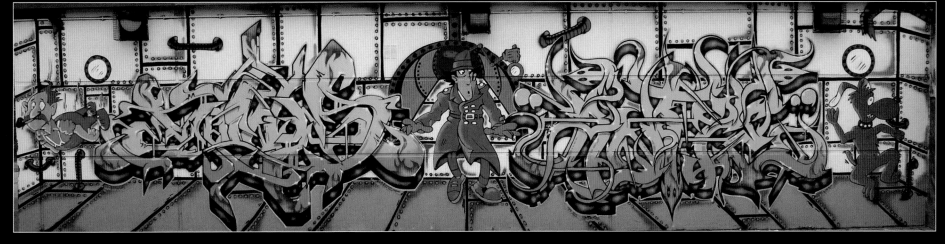

Go Go Gadget, Shine/Quest/Ante, London 2009, photo by Shine

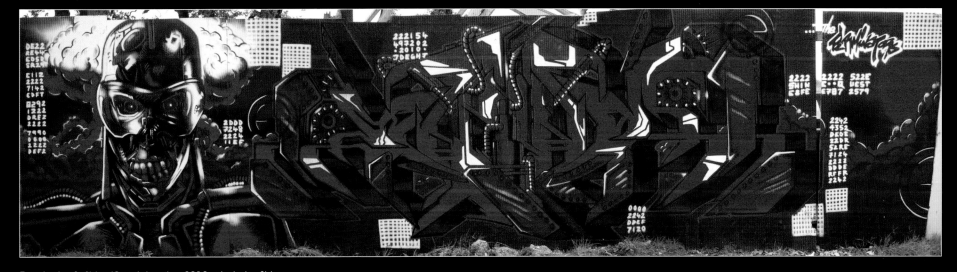

Terminator 2, Shine/Quest, London 2010, photo by Shine

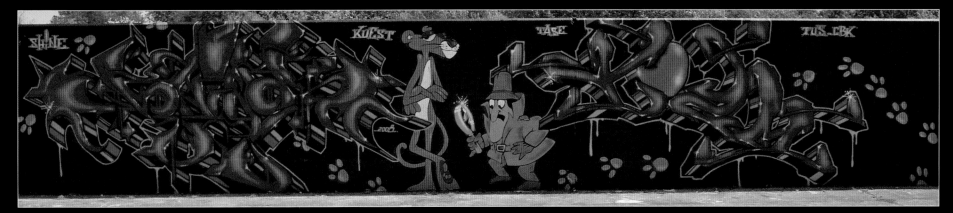

Pink Panther, Shine/Quest/Tase, Essex 2009, photo by Shine

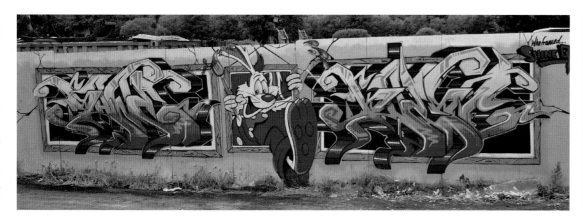

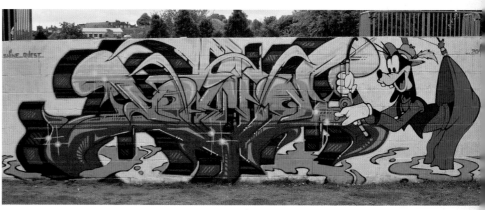

Who Framed Shine and Quest, Shine/Quest, London 2010, photo by Shine

Hook Line and Sinker, Shine/Quest, Sussex 2011, photo by Shine

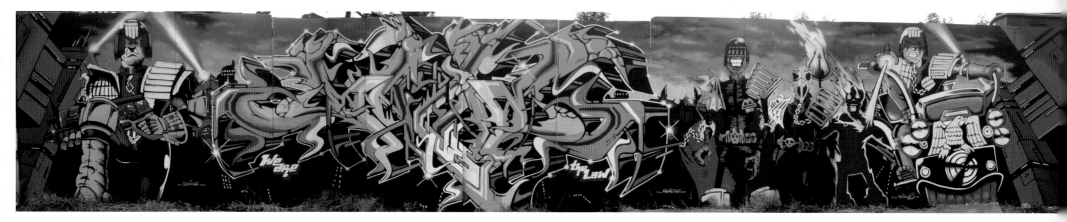

Judge Dredd, Shine/Quest, London 2009, photo by Shine

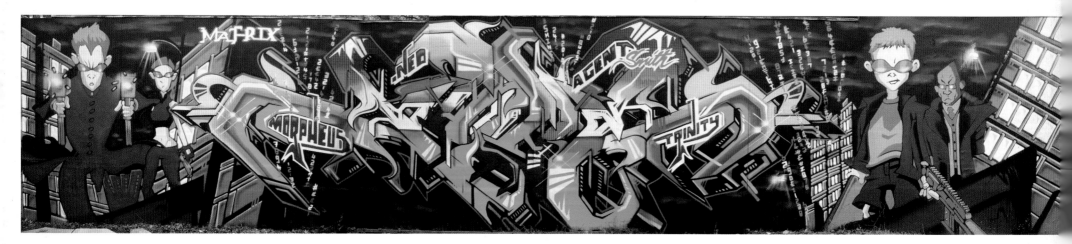

Matrix, Shine/Quest, London 2010, photo by Shine

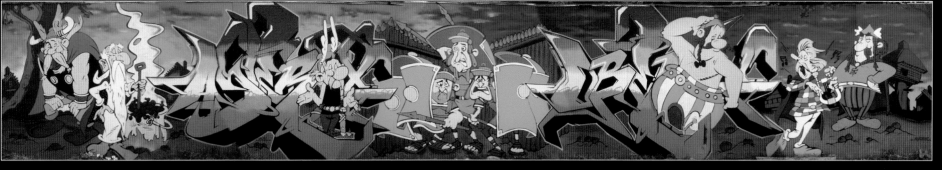

Shine/Asterix/Quest, London 2009, photo by Shine

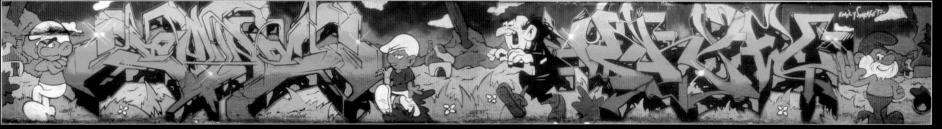

Smurfy, Shine/Quest/Tecow, Middlesex 2011, photo by Shine

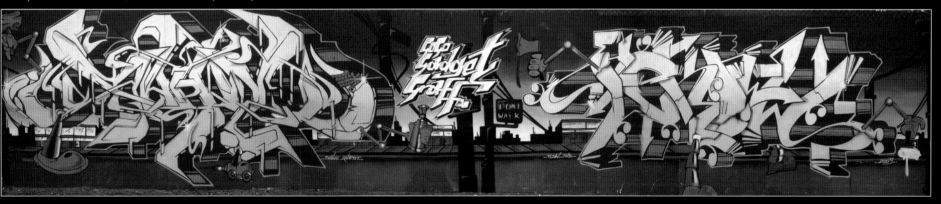

Go Go Gadget, pt2, Shine/Quest/Tecow, London 2009, photo by Shine

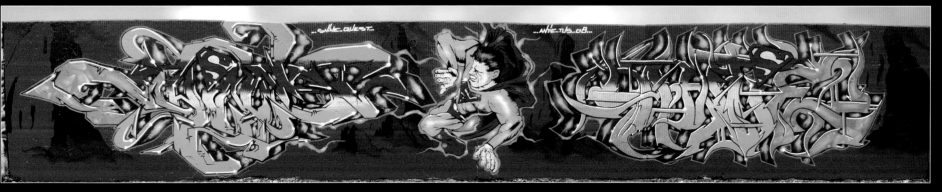

Supershine, Shine/Quest/Ante, Essex 2009, photo by Shine

Shok1

Artist = Shok1
Location = London
Painting since = 1984
Crews = none
Quote = My style—"Barking mixed with hissing, a gurgling, a screeching. Dogs being hurled about and then charging back into the fray with a vengeance.

The flashlight illuminates parts of some 'thing.' A dog. But not quite. Impossible to tell. It struggles powerfully." (From the screenplay for the 1981 John Carpenter film, *The Thing*).
Website = www.shok1.com

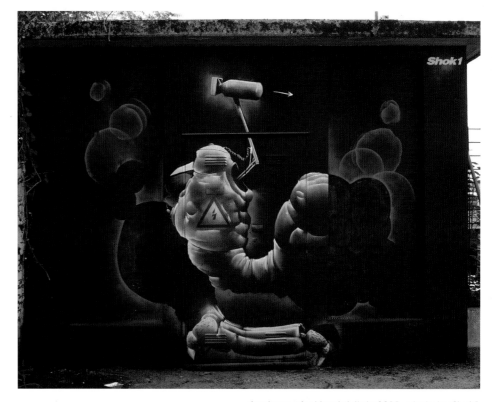

Anatomy of a Vandal, Italy 2011, photo by Shok1

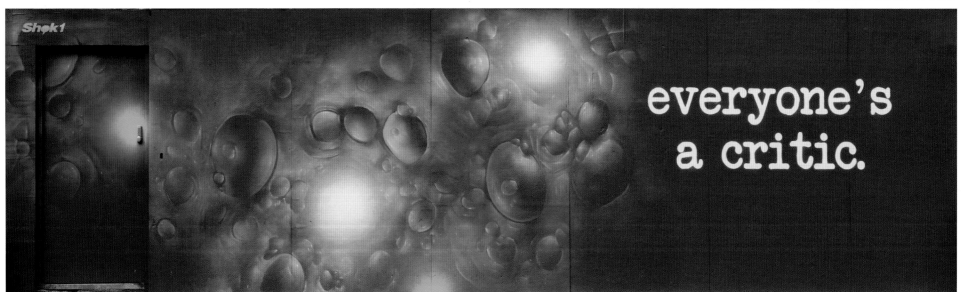

Critic Abstract, London 2011, photo by artofthestate

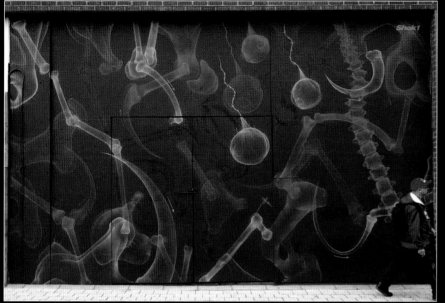

Far left:
DanseMacabre, London 2011, photo by Shok1

Left:
Punk Character, Los Angeles 2009, photo by Shok1

Organic Abstract, London 2011, photo by artofthestate

167

Shucks One

Artist = Shucks One
Location = South London
Painting since = 1990
Crews = ID (Ivory Dukes), UZN (Universal Zulu Nation), SDM (Shut Down Melbourne)
Quote = Graffiti means a great deal to me, but personally, if you're doing the same thing you did when you were 16, and now you're a grown man, you should try and keep it in perspective. You should remember why you loved it then, but bring maturity and fresh attitude to it. I feel that just writing your name and obsessing over yourself is not all that positive, and too many people just come to this movement and take and take. Graffiti culture should be something you give back to and add on to—however you do that is up to you.
Website = http://thekoolskool.blogspot.com

London 2011, photo by Steam156

London 2011, photo by Lee102

168

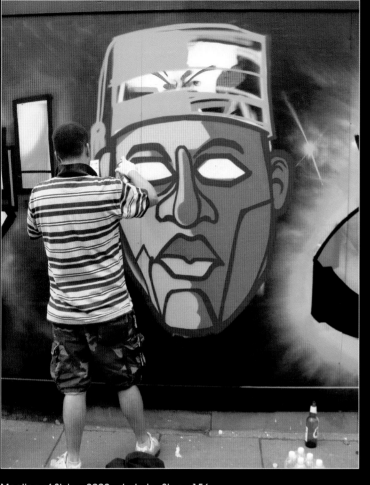

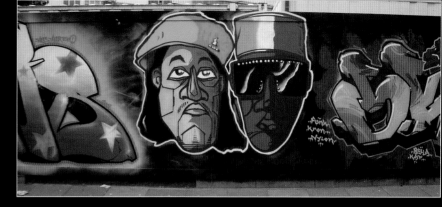

London 2009, photo by Steam156

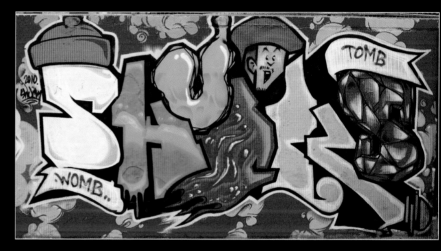

London 2010, photo by Lee102

Meeting of Styles: 2009, photo by Steam156

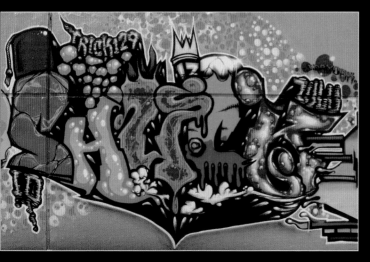

London 2009, photo by Steam156

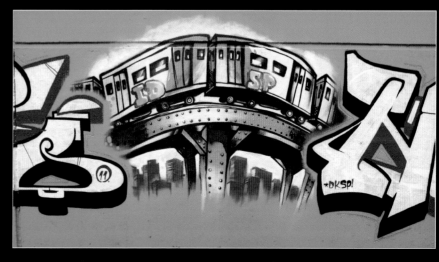

London 2011, photo by Lee102

Shye131

Artist = Shye131
Location = East London
Painting since = 1988
Crews = DPC (Da Perfect Crime)
Quote = Firstly, I like letters to look like letters, so I guess I'm more of a traditional style writer. I think it's important beyond question to let the letters do the talking, simplicity is key, letter shape, form, shapes, they're all painted in a way that if you're a true b-boy you'll understand why those shapes and flows are like they are.

If I use arrows, chips, cracks, glows etc. etc., all must be used for a reason, not as random gap fillers. They'll flow better when swinging off a letter in the right direction and in proportion. I guess I'm a perfectionist, and anyone who paints with me knows this!! To fill-in, subtle colour blends, cleanliness, strong lines—for me it's all about choosing colours that complement the style and flow as well as working together.

I think my style has developed very gradually and my improvements are in the detail of the work—it's all about the details, mate, and finding that fine balance between not enough and too much!!!

So, really, my style is bright, colourful, legible, swinging, flowing letters...you see a SHYE131 piece and you'll know it straight away!!!
Website = www.flickr.com/SHYE131

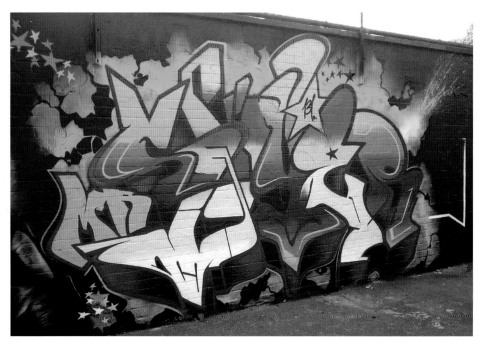

Surrey 2011, photo by Steam156

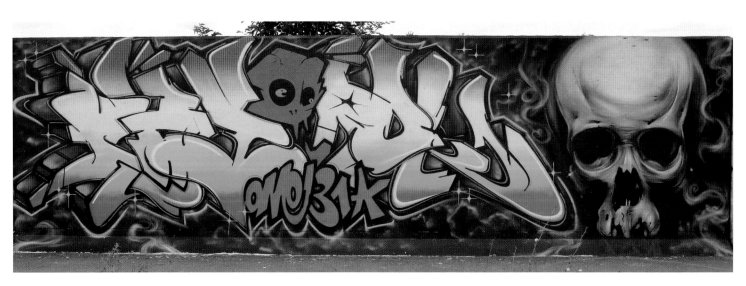

Essex 2010, character by Trans1,
photo by Steam156

170

Portsmouth 2011, photo by Steam156

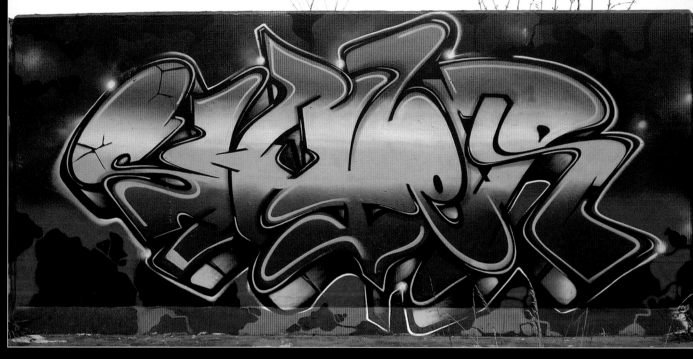

Essex 2011, photo by Shye131

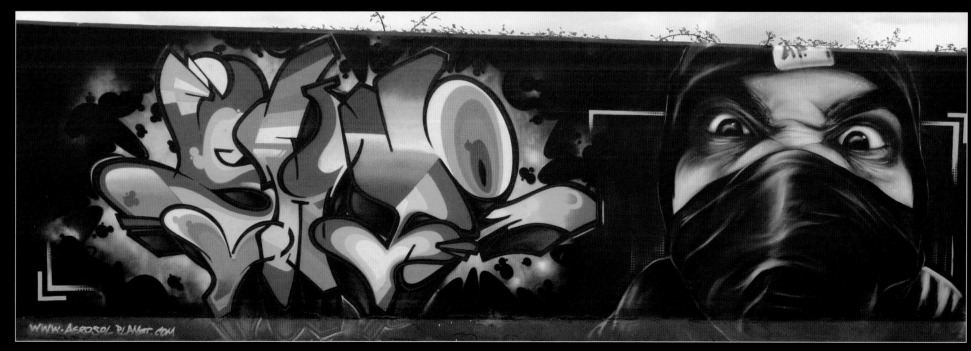

WWW.AEROSOL-PLANET.COM

Shye131/Trans1, Old School Jam: Essex 2010, photo by Steam156

Skam

Artist = Skam
Location = West London
Painting since = 1983
Crews = Mad Ethnicz, Foundationz Cru
Quote = Graffiti means many different things. When I first got into doing graffiti, it was about marking out your turf, your neighbourhood, and peeps you roll with—similar to old punk or football graffiti. Fans putting their club names up and letting others know this is a so-and-so area. As a young teen, we used to write "PFP" all around where we lived, which stood for "powis funk patrol," which was our gang/crew/hood name at the time. It wasn't anything to do with the NYC or piece. It was basically getting our gang name up in the area. Back then it was about your peeps, etc. But yes, it was about marking your turf. Later on we started writing "KREW" all over west London. "KREW" stood for "Kings Ruling Every Where," which is the first all hip-hop elements crew in the UK. So, for me it's basically saying this is me or my crew. Letting others know who you are, etc.

London 2011, photo by Lee102

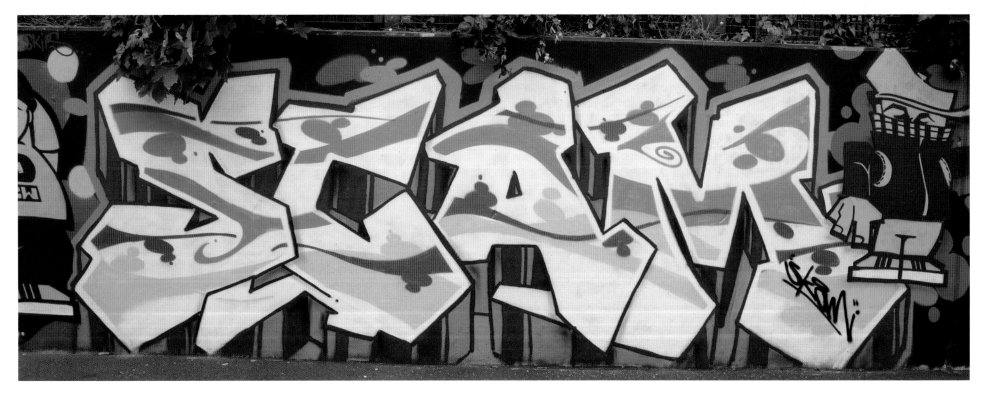

Skam, characters by Crok, London 2011, photo by Steam156

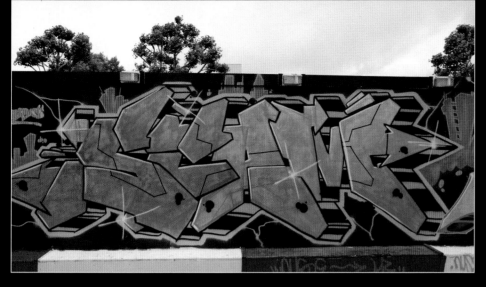

London 2011, photo by Skam

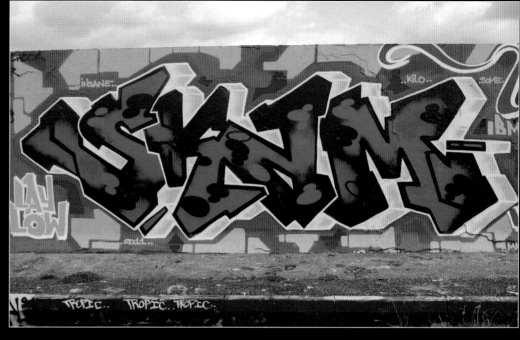

London 2011, photo by Lee102

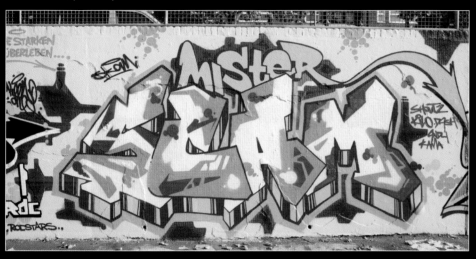

London 2011, photo by Steam156

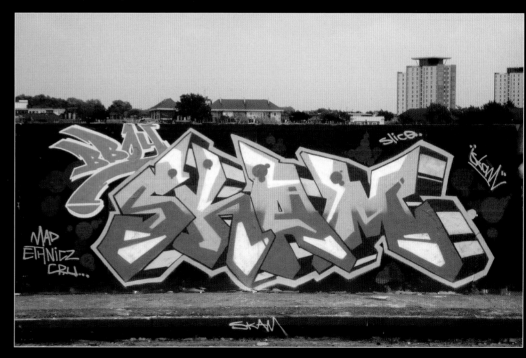

London 2011, photo by Skam

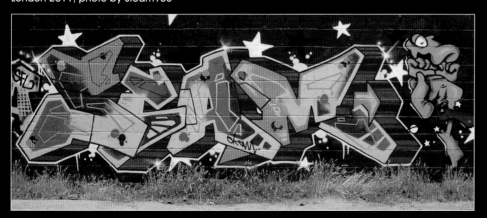

London 2011, photo by Lee102

Skire

Artist = Skire
Location = East London
Painting since = 1985
Crews = SIN (Strength In Numbers)
Quote = Describing "my style" is a tough one; I hate labels for starters. I guess my standard letters are a product of mid-80s influences. Although I never directly copied, you can't help being affected by what's around you and when I first painted in 1985, the main graffiti fix was New York via *Subway Art* and *Style Wars*.

As graffiti became my life, I spent every bit of free time travelling the underground between halls of fame catching photos. At first I was more into taking photos than painting; the balance shifted around the end of 1988 and more time was spent stocking up and painting. By this time London graffiti was imprinted on my brain. I was a huge fan of TCA, ERZ, and London Giants, but for me personally, style influence was from pure letter writers like Kast, Cazbee, Skam, etc.

I moved away from standard letters for a while around 2004 partly out of a desire to paint more freely and partly due to an accident that involved smashing my right hand up pretty badly and losing some use of that all-important cap pushing finger. I painted left handed for about a year and this resulted in much less structured letters, and now I seem to have drifted back to a point somewhere between pre- and post-broken hand. I've always had a kind of just-go-with-it attitude towards style, choosing to turn up with a bag of paint and see what happens rather than spend time on an outline. Honestly, I don't remember the last time I turned up at a wall, outline in hand—it must have been early 90s. I don't sketch more than doodle the odd letter now and again—I don't care for black books. So, back to describing my style? It's just letters painted on a wall, name it as you please, I really don't care.

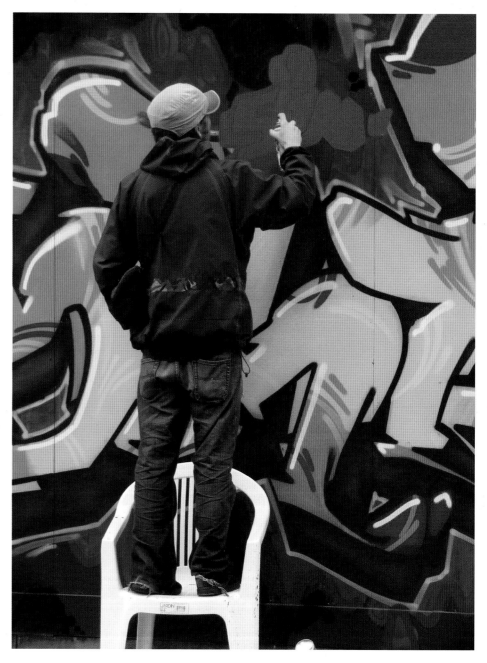

London 2009, photo by Steam156

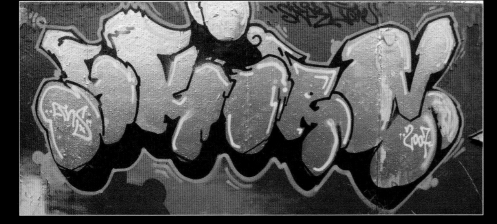

Essex 2007, photo by Steam156

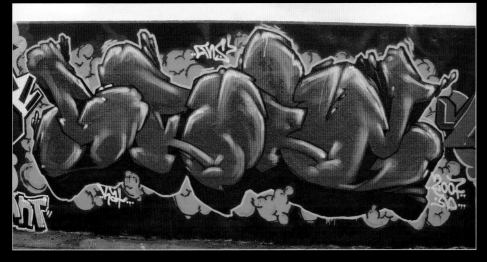

Essex 2007, photo by Steam156

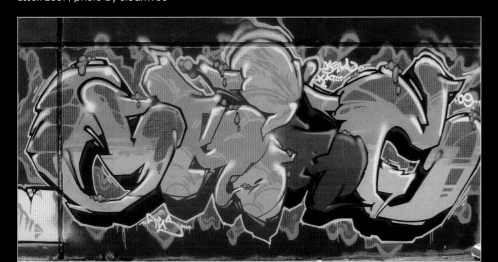

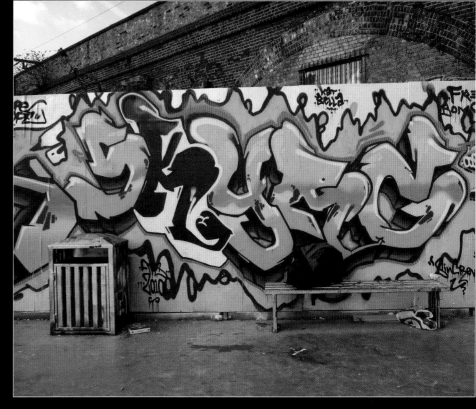

London 2010, photo by Steam156

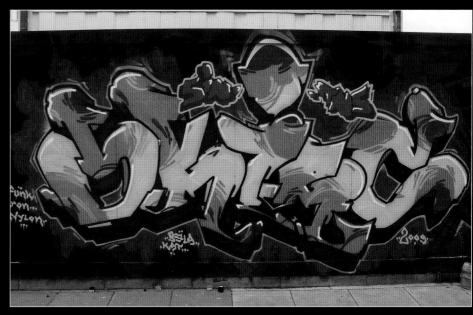

London 2009, photo by Steam156

Skore

Artist = Skore
Location = Kent
Painting since = 1984
Crews = TRC (The Troubled Children)
Quote = Graffiti is my life. Graffiti is "me." It is my life blood and the way I represent who I am to the world.... It is also boring, clichéd, and full of one dimensional, ignorant dullards, precious queens, insecure losers, horrendous egotists, and attention seekers...but also some incredible individuals. Some of the most amazing characters you could ever hope to meet.

Graffiti to me is domination. The urge to compete, project yourself, puff up your chest and scream...and at the same time tickle the old creative testicle.... It is liberating, creative naturism, the soul laid bare (for those brave enough to lose ourselves in the moment—the graff trance).... Graffiti is history, memories, friendships, mad experiences, adrenalin, pride, expression, self-realisation, ego...a life's lesson.
Website = www.flickr.com/skoretrc

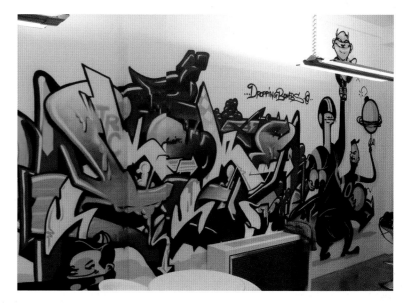

Skore/Crok, London 2009, photo by Steam156

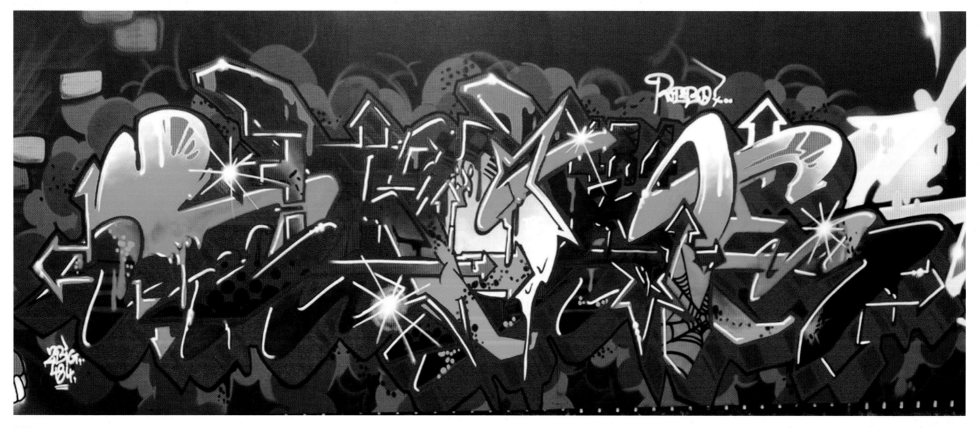

Meeting of Styles: London 2011, photo by Lee102

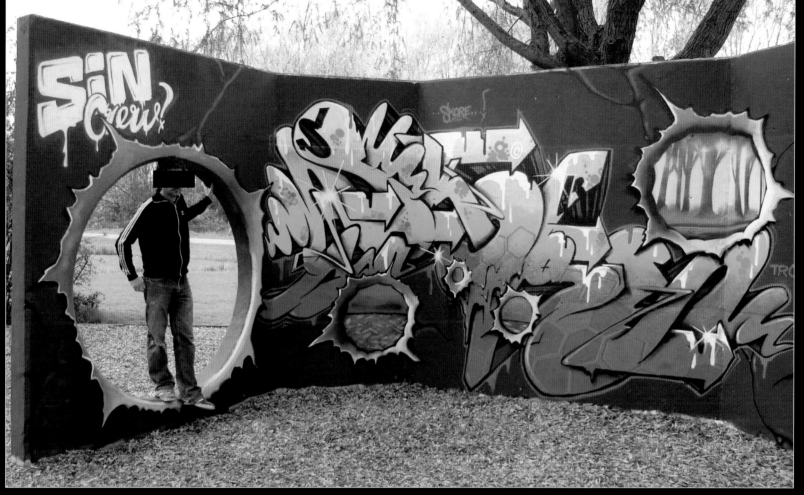

Kent 2011, photo by Skore

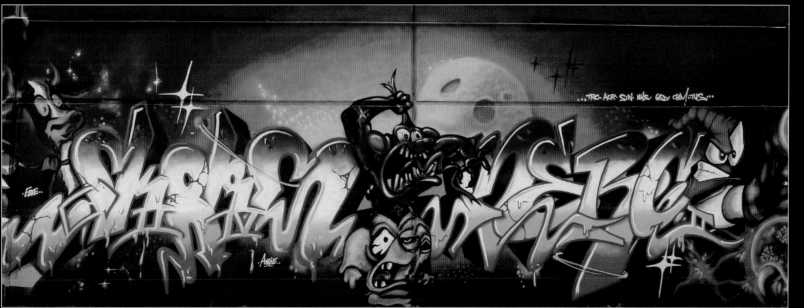

Skore/Merc, London 2009, photo by Steam156

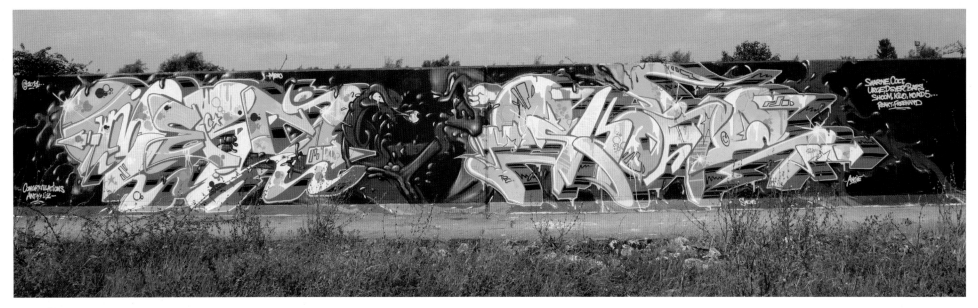

Skore/Merc, Essex 2009, photo by Steam156

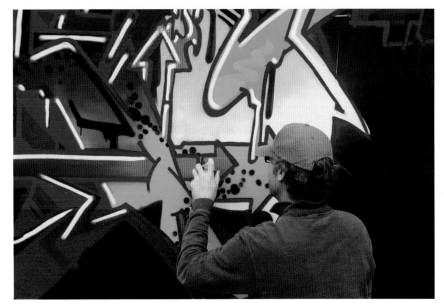

Meeting of Styles: London 2011, photo by Steam156

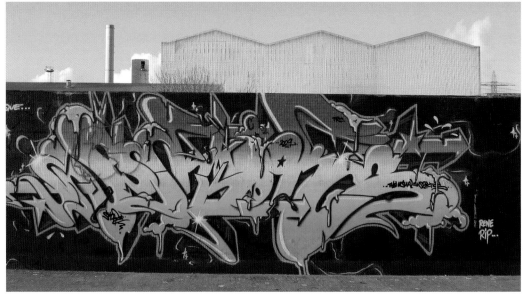

Essex 2009, photo by Steam156

Kent 2011, photo by Skore

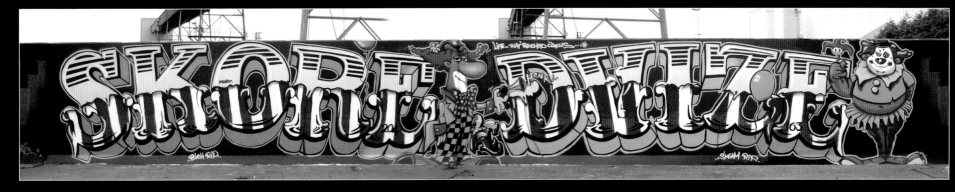

Essex 2009, photo by Skore

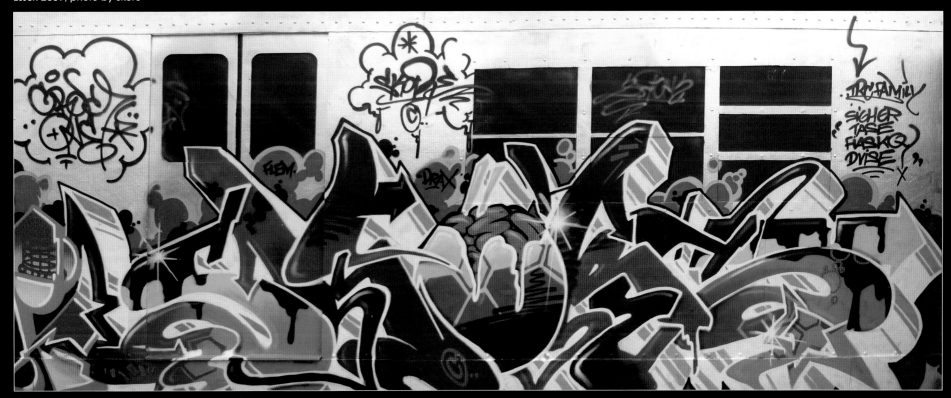

Cambridge 2011, photo by Skore

179

Smug

Artist = Smug
Location = Glasgow
Painting since = 2000
Crews = Infamous Last Words
Quote = I paint photo-realistic and bold comic-styled characters. My letter style is traditional, semi-wild style letters with bold outlines and a slight German flavour to them. I try to paint large, vibrant, and bold.
Website = www.smuglife.com

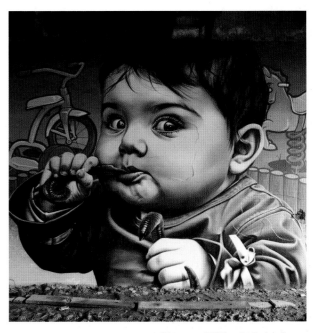

Glasgow 2011, photo by Smug

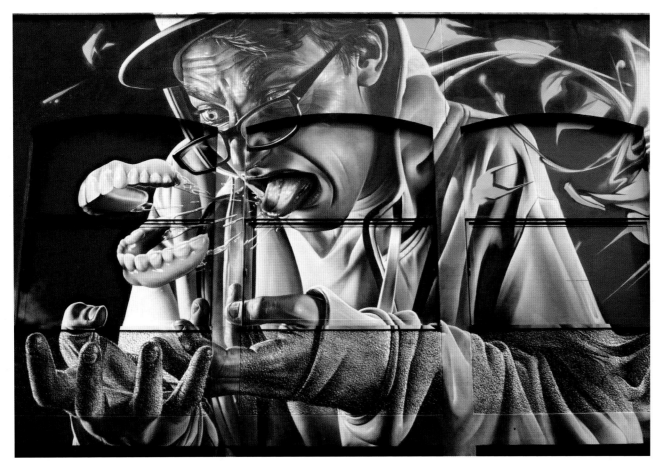

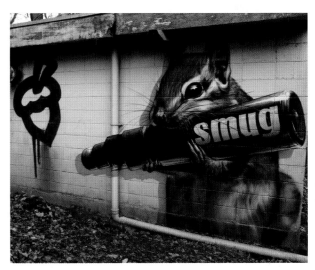

Scotland 2011, photo by Smug

See No Evil Event: Bristol 2011, photo by Smug

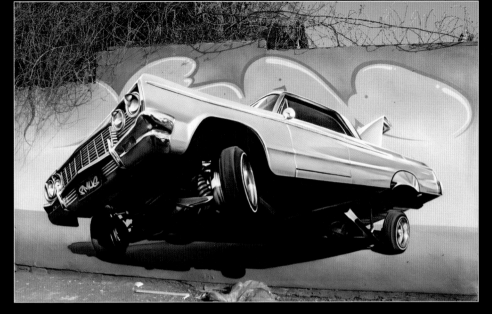

Liverpool 2011, photo by Smug

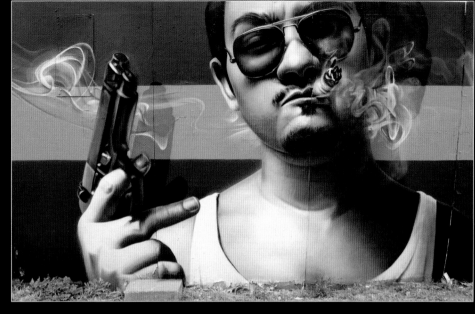

Brighton 2010, photo by Smug

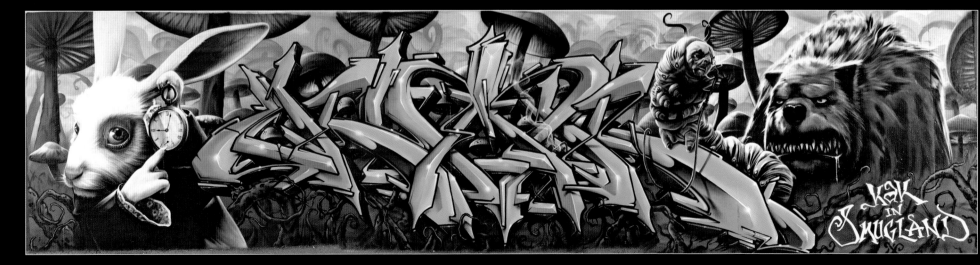

Cambridge 2011, photo by Smug

Snatch

Artist = Snatch
Location = London
Painting since = 80s
Crews = PFB (Plenty Fresh Burners), TO (The Others)
Quote = Graffiti means to me, blank space, some colours, some time. The rest is straight from your mind, and anything can appear. If it's great, there's no buzz like it in the world. But if it's not, there's nobody to blame but yourself. And you have to keep going, keep pushing and improving. It's about creating something as good as you can manage, but within the unwritten, intangible rules/aesthetic of what graffiti is—or should feel like, really. And people are constantly innovating, so the competition is fiercer than ever. But you're competing against yourself as much as anyone else. It's about delivering that "Whoa!" moment to the viewer—but also not giving too much of a damn what anyone else thinks.
Website = www.flickr.com/photos/snatchone

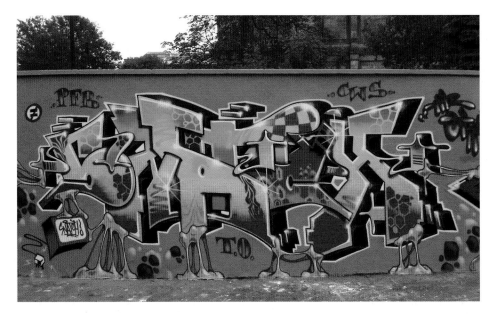

London 2010, photo by Snatch

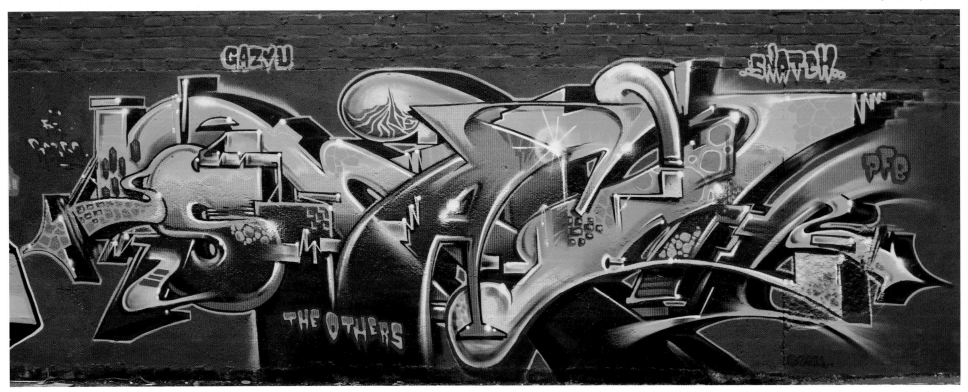

London 2011, photo by Snatch

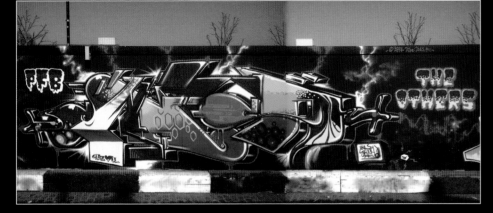

London 2011, photo by Snatch

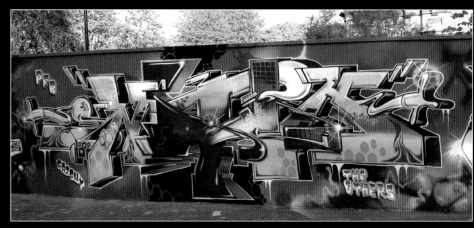

London 2011, photo by Snatch

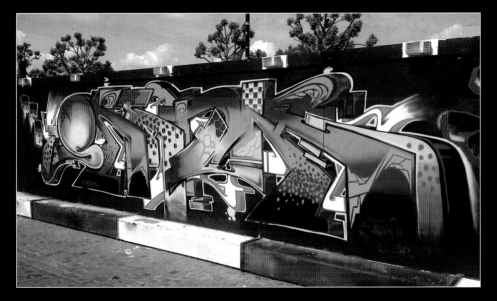

London 2011, photo by Snatch

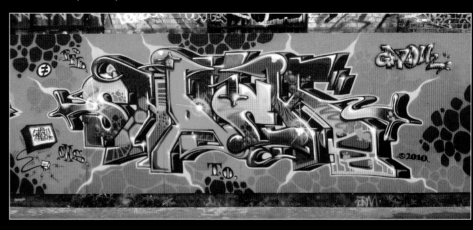

London 2010, photo by Snatch

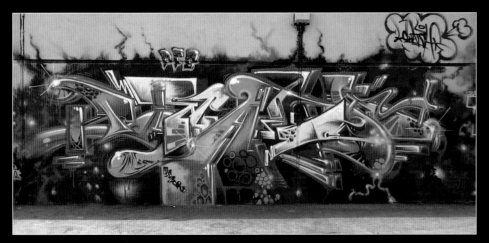

London 2011, photo by Snatch

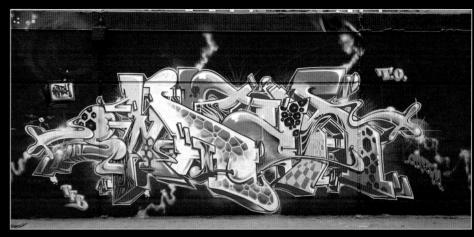

London 2011, photo by Snatch

Snoe

Artist = Snoe
Location = London
Painting since = 1986
Crews = TRP (The Rollin People), GWR (Great Western Rockers)
Quote = Graffiti nowadays is something I do for myself, my crew and partners, and my close friends.

It means everything to me, it is me, and I will NEVER get it out of my blood. It has opened so much more of the world to me and I have met so many great (and strange) people through it.

Its amazing that graffiti has become so diverse, but with that, it has also become diluted and easily accessible. Nostalgia aside, the mystique of graffiti as a secret and surprising art form has gone.

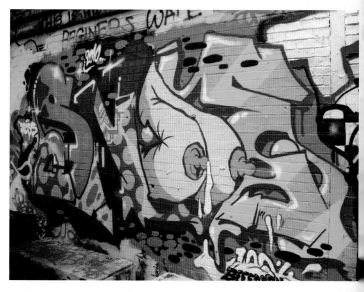

London 2010, photo by Steam156

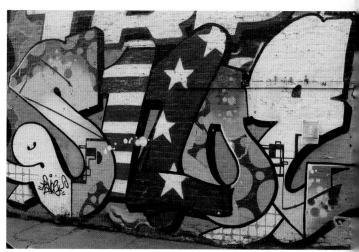

London 2010, photo by Steam156

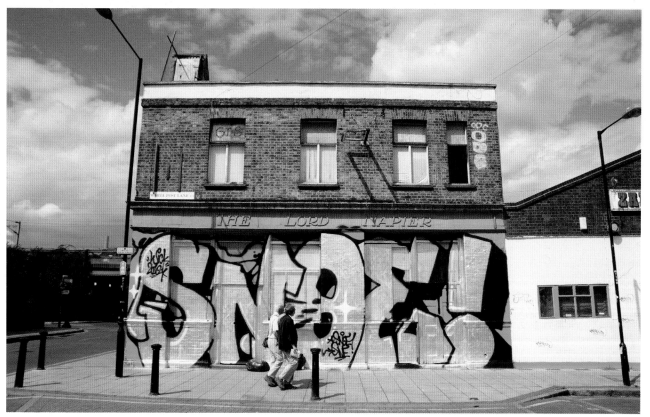

London 2010, photo by Steam156

184

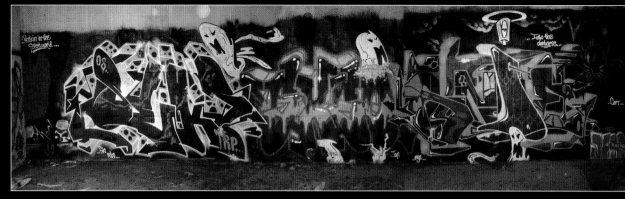

Snoe/Seks/Scarce, Cornwall 2008,
photo by Snoe

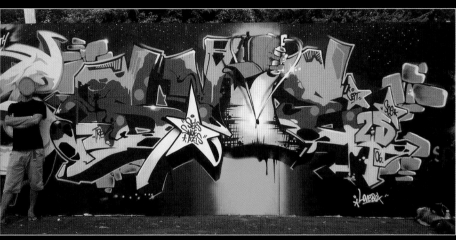

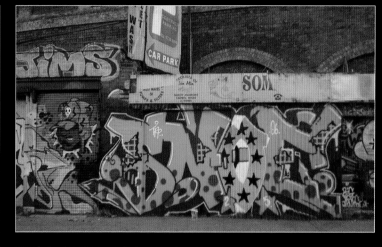

Far left:
Lovebox Weekender:
London 2006, photo
by Snoe

Left:
London 2006, photo
by Snoe

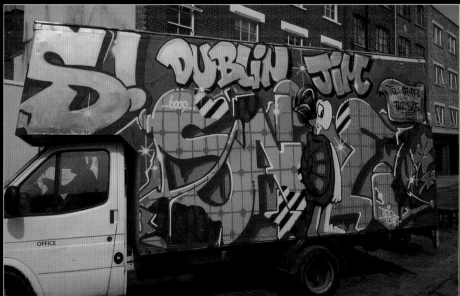

London 2008, photo by Snoe

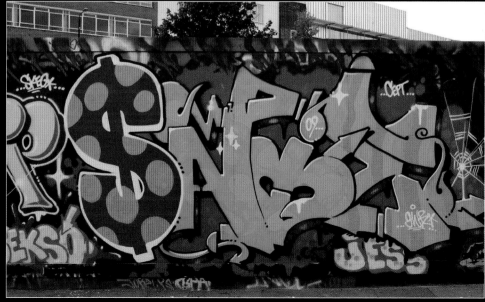

London 2009, photo by Steam156

Snug

Artist = Snug
Location = London
Painting since = 1990
Crews = none
Quote = I have drawn cartoons all my life, and any teenager even remotely interested in art in the mid 80s couldn't fail to be touched by those formative "golden" years of British graffiti. I lived very near Ladbroke Grove way back when, and was blown away by all its shapes and forms, bombing, throwups, huge productions, etc. Many writers learned how to draw after discovering graffiti, whereas I had already been drawing for sometime so it was more the artistic productions that really excited me more than the actual raw essence of tagging and bombing. Although I love every aspect of it none the less.

Graffiti means many different things to me in equal doses of love and hate. I have deep admiration and always will for those who continue to paint illegally or otherwise, for that is the true nature of the game.
At school I wasn't very good at anything to do with sport or academics and was permanently reminded of that. Naturally, when I left, graffiti gave me a purpose and therefore a confidence whilst young and has definitely rubbed off on me in later life.

There will be a time soon when I will have to give up using spray paint altogether for health reasons, but I will remain inspired by the art form forever.

I check for graffiti old and new; its impossible not to. It will always have a deep place in my heart till my dying day.
Website = www.snugone.com

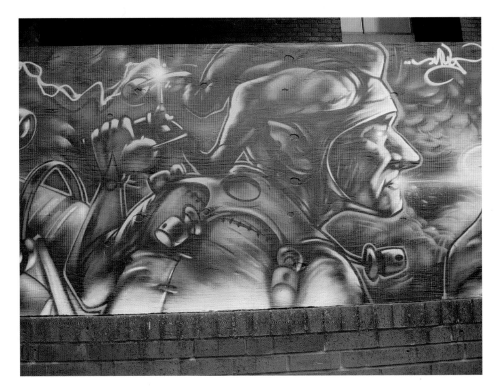

Notting Hill Carnival: London 2004, photo by Steam156

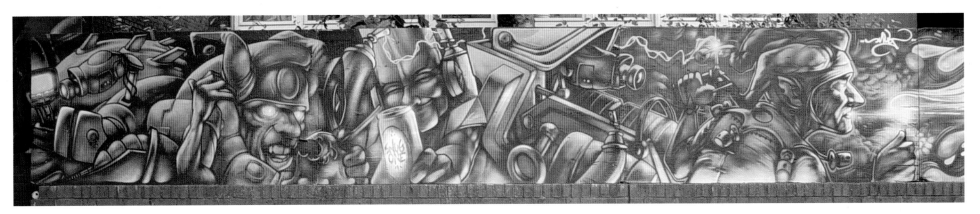

Notting Hill Carnival: London 2004, photo by Steam156

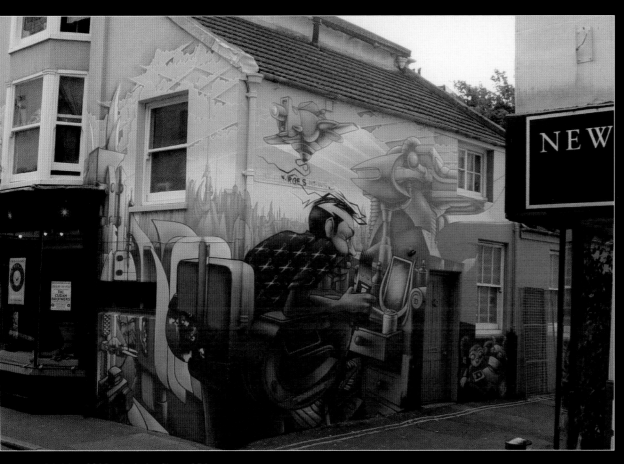

Brighton 2005, photo by Steam156

Canvas 2008, photo by Steam156

187

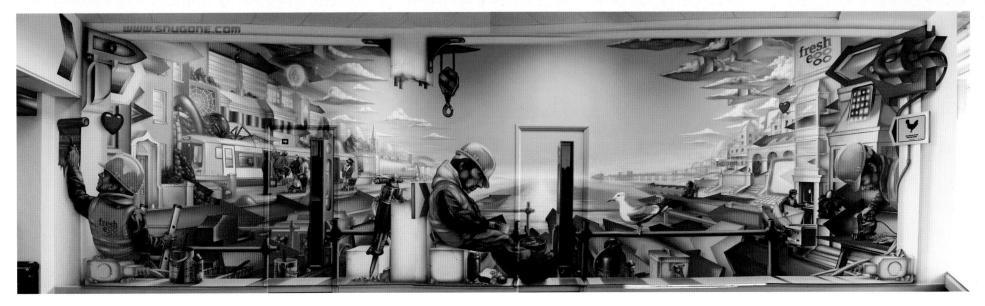

Fresh Egg Mural, Sussex 2011, photo Steam156

Fresh Egg Mural (detail), Sussex 2011, photo by Steam156

Fresh Egg Mural (detail), Sussex 2011,
photo by Steam156

Fresh Egg Mural (detail), Sussex 2011, photo by Steam156

Fresh Egg Mural (detail), Sussex 2011, photo by Steam156

Fresh Egg Mural (detail), Sussex 2011, photo by Steam156

Sokem

Artist = Sokem
Location = Bristol
Painting since = 1991
Crews = ASK (After Skool Klub)
Quote = I would describe my style mostly as a traditional wild style; I like to have plenty of flow and movement to my pieces but with a certain amount of control and order to them.
Website = www.sokemone.com

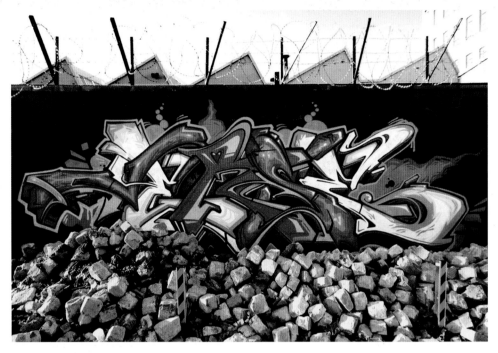

Bristol 2009, photo by Sokem

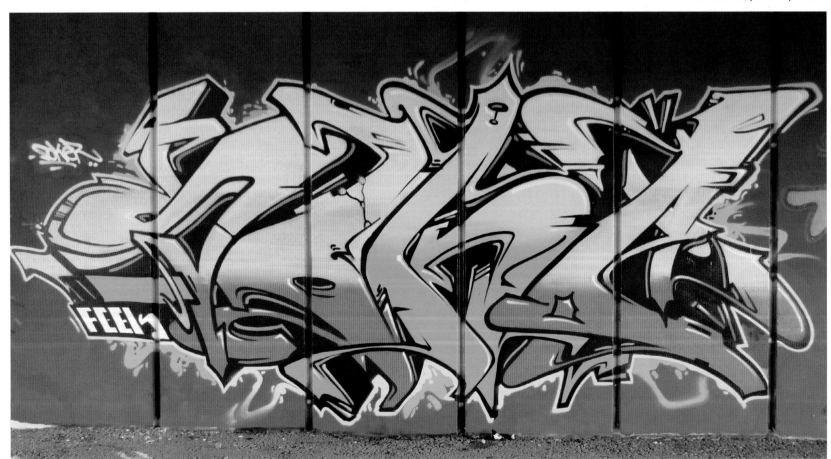

Tamworth 2009,
photo by Sokem

190

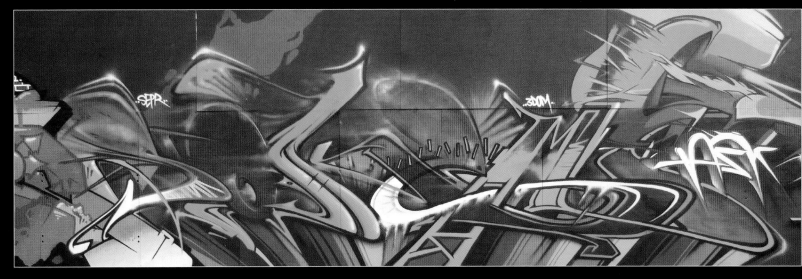

Bristol 2011, photo by Sokem

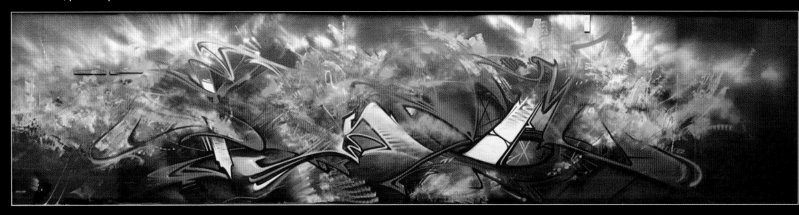

Sokem/Mr Jago, Bristol 2011, photo by Sokem

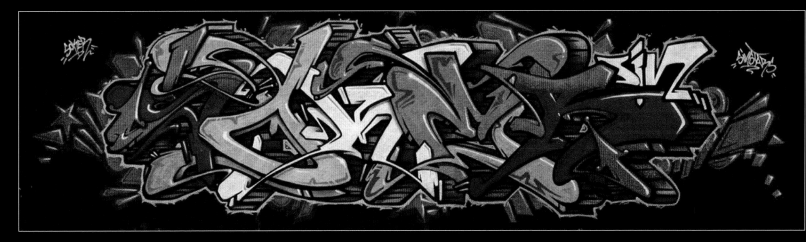

Bristol 2008, photo by Sokem

Solo One

Artist = Solo One
Location = London
Painting since = 1986
Crews = VOP (Visual Orgasm Productions), ILC (In Living Colour)
Quote = I would describe my style as freestyle. I don't plan the pieces, I just go with what happens on the wall. I like to use a mixture of materials instead of just spray paint and try out new ideas. My pieces sometimes look like junk, which is exactly how I like it.
Website = www.soloone.blogspot.com

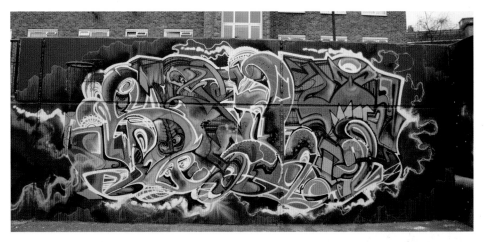

London 2011, photo by Steam156

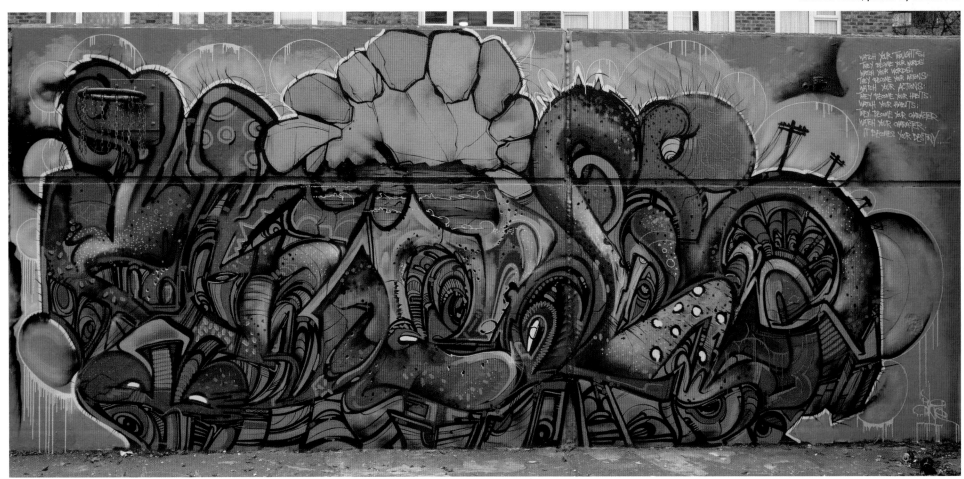

London 2011, photo by Steam156

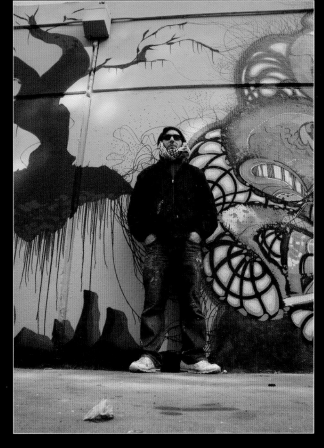

London 2011,
photo by
Steam156

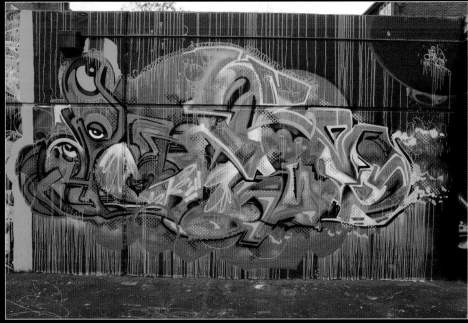

London 2011, photo by Steam156

London 2011, photo by Steam156

London 2011, photo by Steam156

193

Stylo

Artist = Stylo
Location = South London
Painting since = 1984
Crews = VOP (Visual Orgasm Productions)
Quote = Graffiti has allowed me access to amazing places and people I'd never have seen or met otherwise. It's also taught me skills that have given me incredible confidence to cope with everyday life situations. I can't thank it enough.
Website = www.vopstars.com

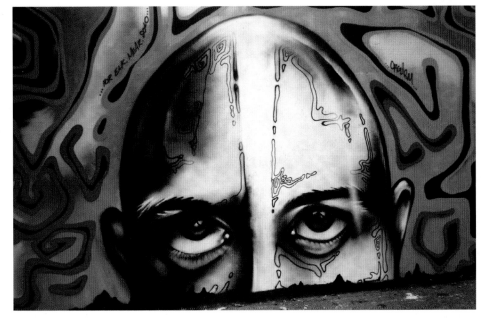

Unity Event: London 1994, photo by Stylo

Nottingham 1995, photo by Stylo

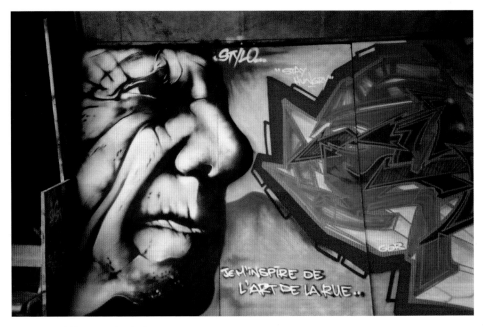

Scotland 1993, photo by Stylo

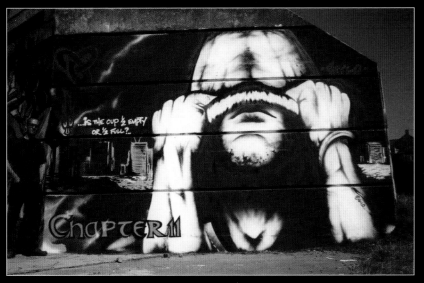

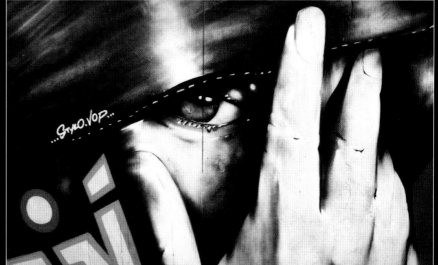

Ireland 1995, photo by Stylo

Brighton 2005, photo by Stylo

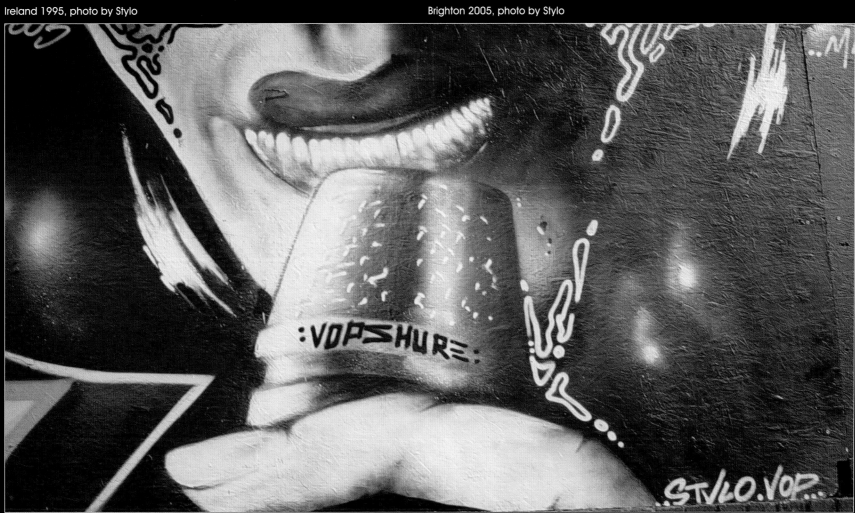

Sweet Toof

Artist = Sweet Toof
Location = London
Painting since = 1986
Crews = none
Quote = I am a graffaholic—my style is what it is and it is important to turn
heads.
Website = www.sweettoof.com

New York 2011, photo by Steam156

London 2011, photo by Steam156

London 2011, photo by Steam156

London 2011, photo by Steam156

London 2010, photo by Steam156

Tek33

Artist = Tek33
Location = London
Painting since = 1986
Crews = BC (Burning Candy)
Quote = Graffiti, it's one of the activities that I spent most of my time researching, studying, and practicing since I was 11 years old. It means a lot, it's one of my favorite things in life. I am a graffiti extremist of the New York Subway-rooted sect, valuing its traditions above all else. I even started a religion on Friday 24th October 2008, "Graffatarianism" practised by "Graffatarians." A Graffatarian uses *Getting Up* and *Subway Graffiti in New York* by Craig Castleman 1982 for guidance in all matters of writing conduct.

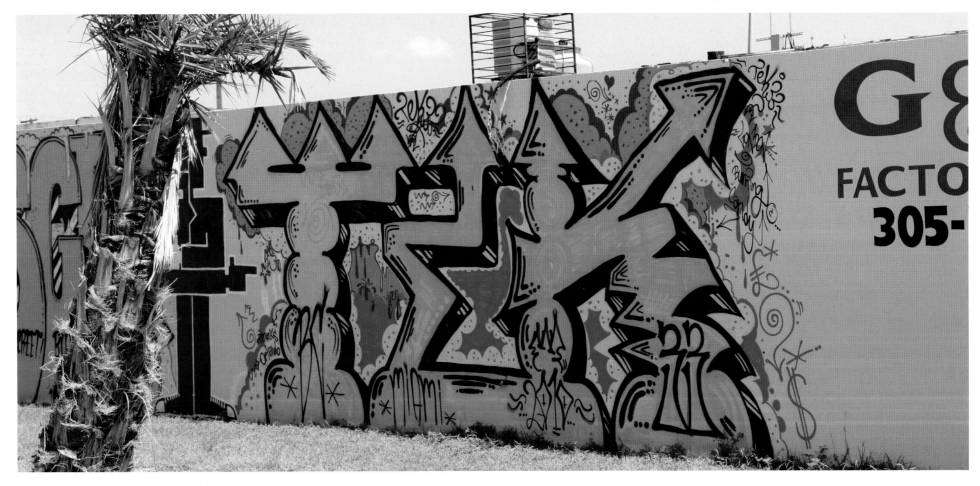

Miami, Florida 2010, photo by Steam156

London 2010, photo by Steam156

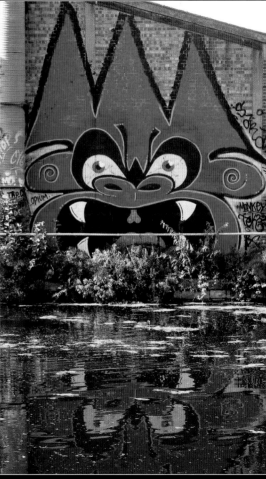

Tek33/Mighty Mo, London 2009, photo by Steam156

Title

Artist = Title
Location = Birmingham
Painting since = 1985
Crews = SFX (Special FX), FTN (Fed the Nonsense)
Quote = When I first got into graffiti as a kid in the 80s, I just wanted to paint burners.... But the buzz of getting up and seeing my name written everywhere soon took over as the most important thing.

After stepping away from the graffiti scene for over 15 years, I returned with a new agenda: to paint burners and to express myself through artwork. It's the buzz of producing pieces and trying to make them better and better every time. That keeps me going nowadays.... It's also become my living, too. So now, as a hobby as well as my business, it's one of the most important things in my life.... Perhaps second only to the health and happiness of my children, friends, and family.
Website = www.graffitibytitle.com

Spray paint on wood, Birmingham 2011, photo by Steam156

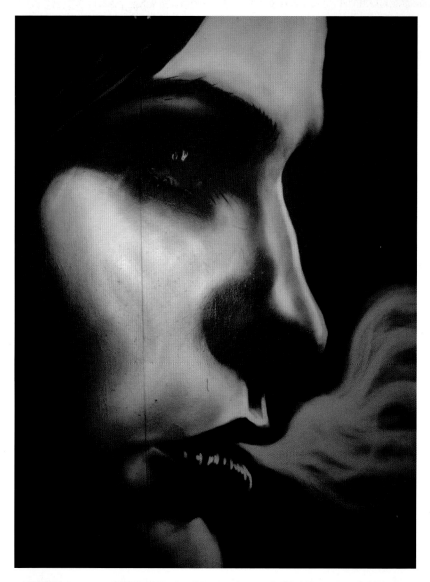

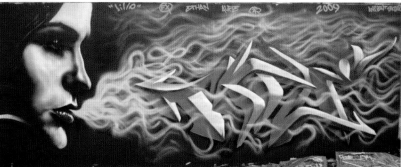

Birmingham 2009, photos by Title

200

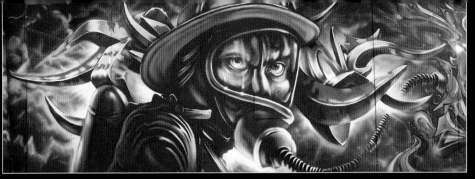

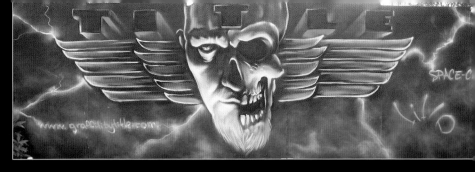

Leamington Spa, 2010, photo by Title

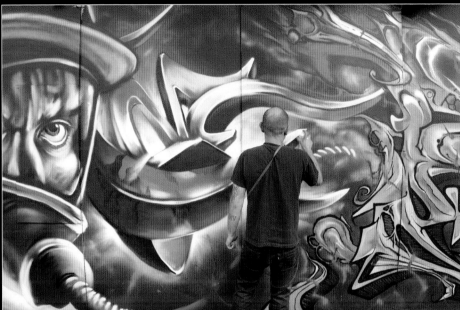

Splash Art Jam: 2011, photos by Steam156

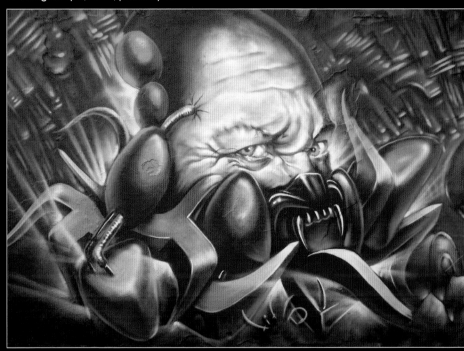

London 2010, photo by Title

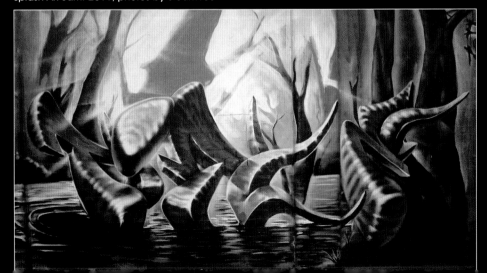

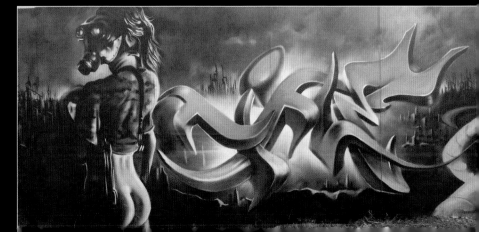

Tizer

Artist = Tizer
Location = South London
Painting since = 1988
Crews = ID (Ivory Dukes), HOD (Hands of Doom), SDM (Sleep Deprived Maniacs)
Quote = For as long as I can remember, I have always been drawing. As a child, my brother and I loved cartoons and comics. As I grew up, I spent a lot of time experimenting. I would always try and change my character design to use different techniques. I now normally tend to portray b-boys or fly girls in my graffiti. Hip-hop was what got me into this sub-culture. I have always loved classic b-boy characters so I like to acknowledge my early inspiration.
Website = www.tizerone.blogspot.co.uk

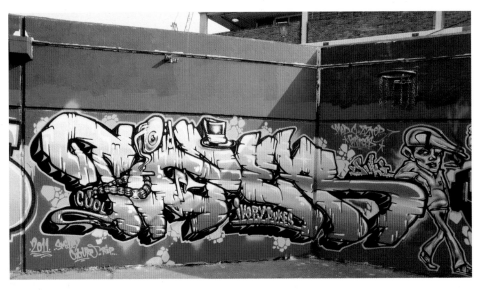

London 2011, photo by Steam156

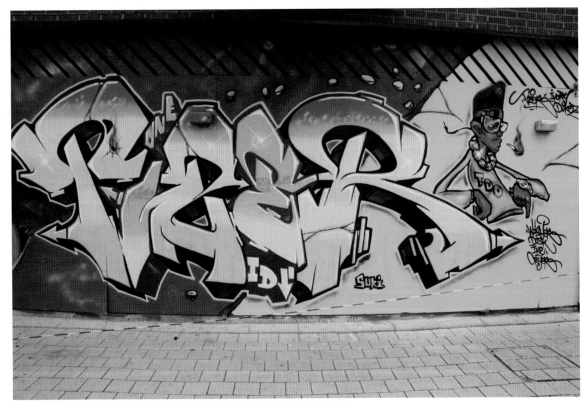

Meeting of Styles: London 2010, photo by Steam156

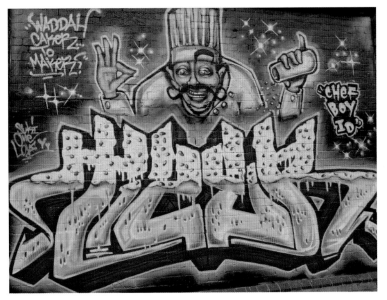

London 2008, photo by Steam156

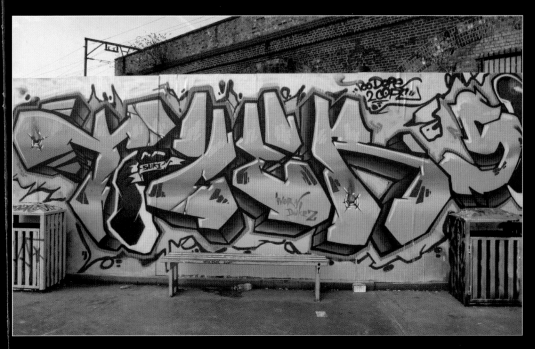

London 2010, photo by Steam156

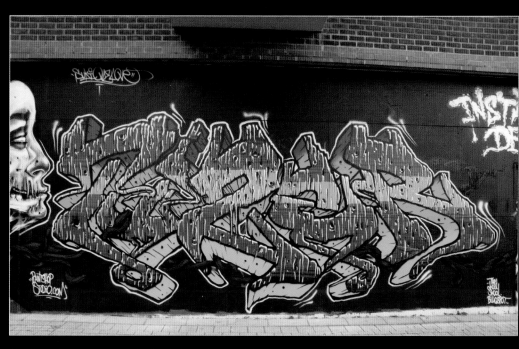

Meeting of Styles: London 2011, photo by Steam156

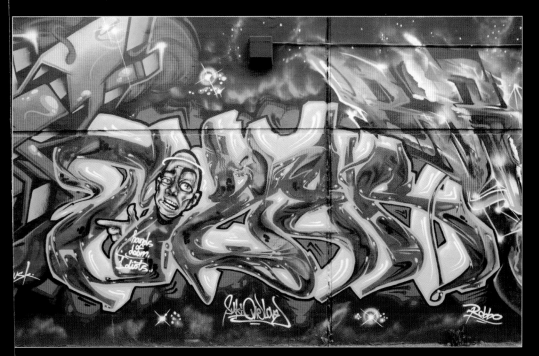

London 2011, photo by Steam156

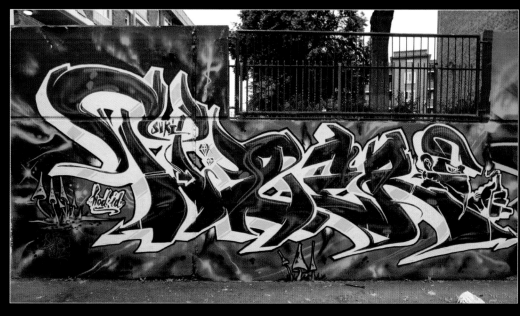

London 2011, photo by Steam156

Trans1

Artist = Trans1
Location = Kent
Painting since = 1983
Crews = DSZ (DREAM SKEMEZ), TND (The Next Dimensions)
Quote = I've been doing this since I was 11 years old. It's in my veins! Graffiti has been a faithful, unquestioning brother to me. It's always been there for me, even when I've been through some dark times in life. It's brought me some of my closest friends, people I can trust. It's opened up many doors that otherwise would have stayed closed. Most of all, it's given me a great deal of happiness and positivity. Graff means different things to different people. There's no right or wrong with it. It's about individualism. Everybody has their very own graffiti history. Like little pieces of a giant puzzle, and when all the pieces come together it creates the whole picture. Let positivity reign supreme and let the haters step off. Graffiti for life.

London 2008, photo by Trans1

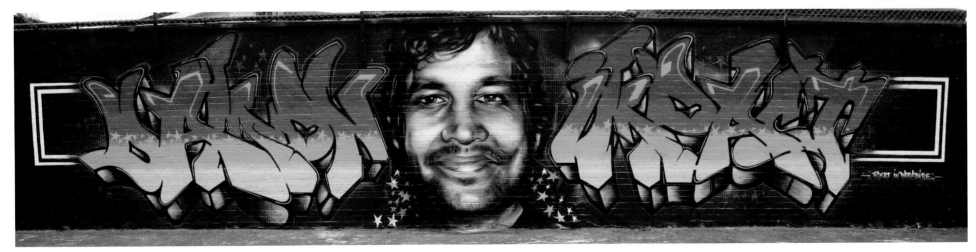

RIP Damon, Trans1/Shye131, Surrey 2011, photo by Trans1

Essex 2011, photo by Trans1

London 2011, photo by Trans1

Meeting of Styles: Germany 2010, photo by Trans1

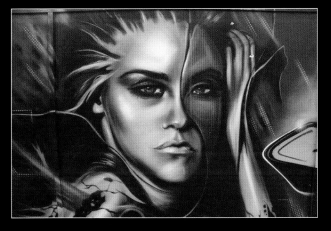

Portsmouth 2011, photo by Steam156

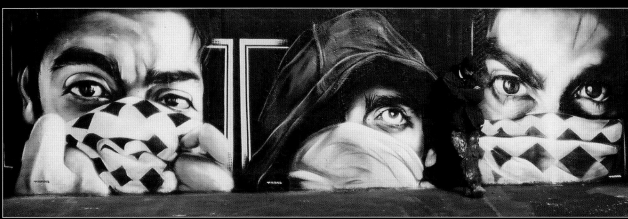

London 2009, photo by Trans1

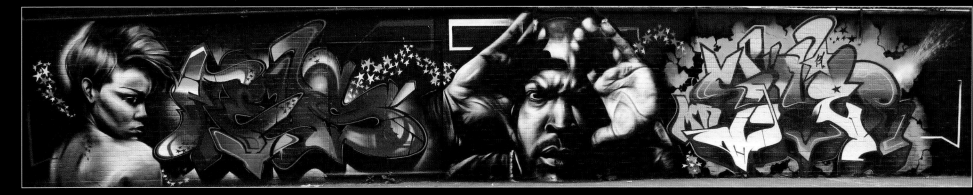

Trans1/Shye131, Surrey 2011, photo by Trans1

Upstart

Artist = Upstart
Location = South London
Painting since = 2004
Crews = SIN (Strength in Numbers), GB (Good Boys)
Quote = My style is what comes out on the day. I always have a "rough" sketch and finalise it on the wall. Sometimes as much symmetry and parallel lines as I can. It depends on the day.

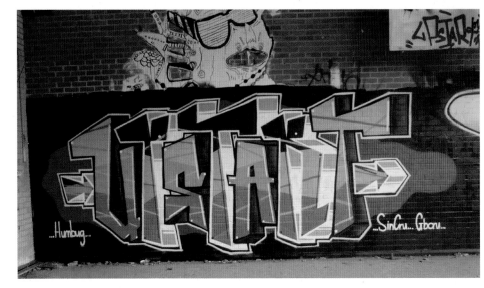

London 2011, photo by Upstart

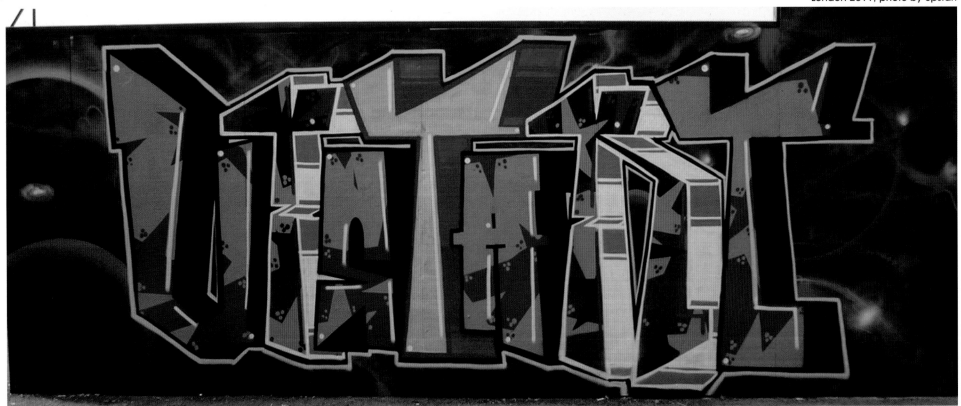

London 2011, photo by Upstart

206

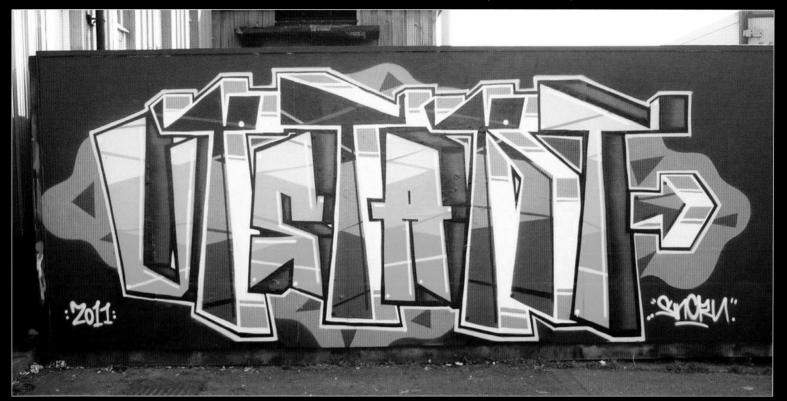

London 2011,
photo by Upstart

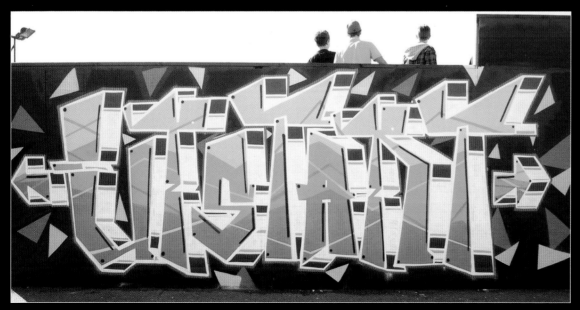

London 2011, photo by Upstart

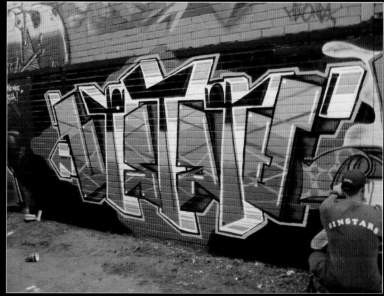

London 2011, photo by Upstart

Urge

Artist = Urge
Location = East London
Painting since = 1983–1989 and 2008–present
Crews = DPC (Da Perfect Crime), AKS/AKZ (Arse Kickers)
Quote = As a kid, "graffiti" was a way of life; every day was an adventure and gave an element of risk. It was an underground culture that had no care for what society's opinion was of it. Now, it's an industry, big business where "graffiti" has changed its meaning. It's a day's escape out with the lads where you no longer need eyes in the back of your head.
Website = www.flickr.com/photos/grrurge

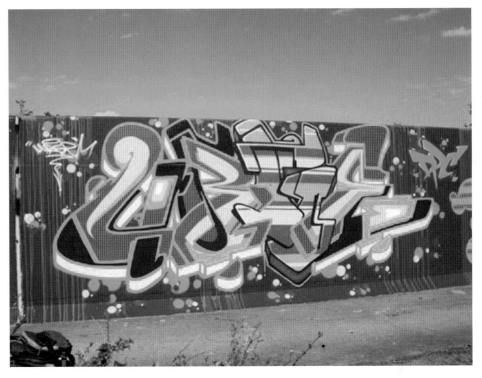

Essex 2011, photo by Urge

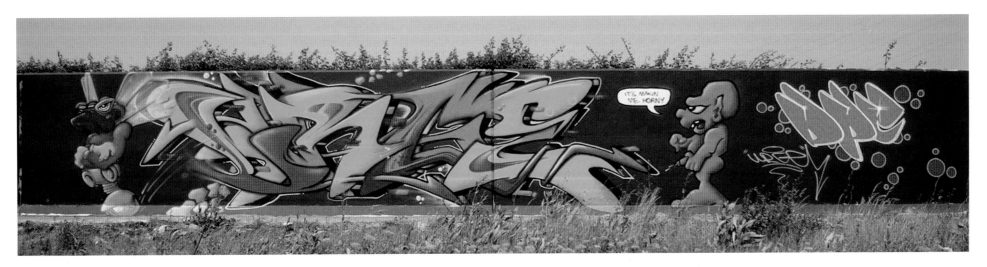

Essex 2011, photo by Urge

208

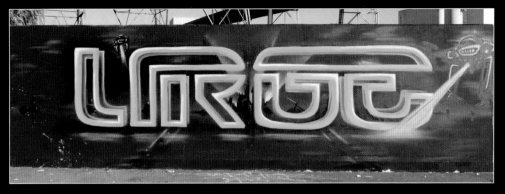

Essex 2010, photo by Urge

Urge, Essex 2010, photo by Steam156

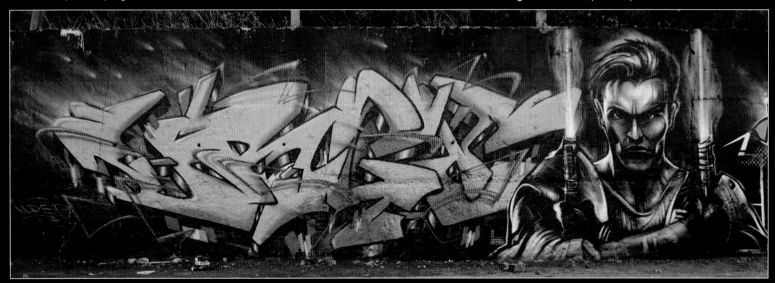

Urge/Trans1, Walsall 2011, photo by Urge

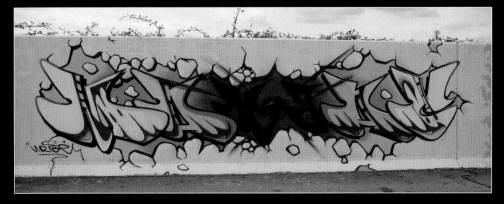

Maniac, Essex 2010, photo by Steam156

London 2011, photo by Urge

Vibes

Artist = Vibes
Location = London
Painting since = 1997
Crews = RT (Represent)
Quote = I don't like to sum up my style of painting. It's difficult to sum it up. I like the freedom of painting whatever, whenever; well-balanced letters with movement is a priority to me.

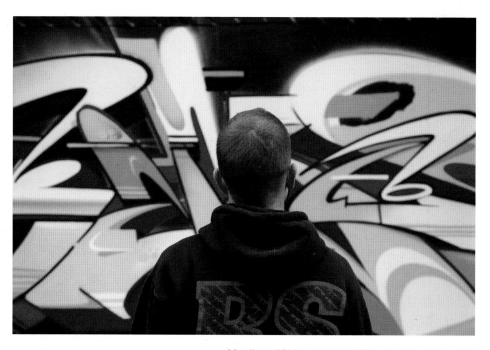

Meeting of Styles: London 2011, photo by Steam156

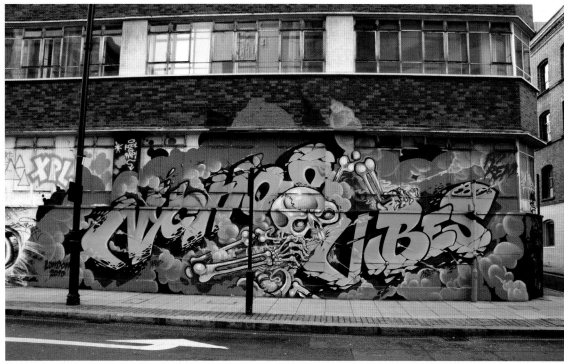

Vibes/Nychos, London 2011,
photo by Steam156

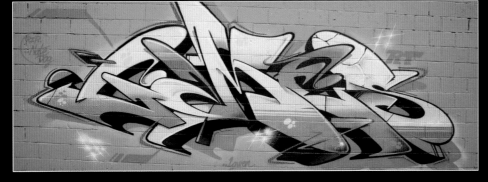

London 2011, photo by Steam156

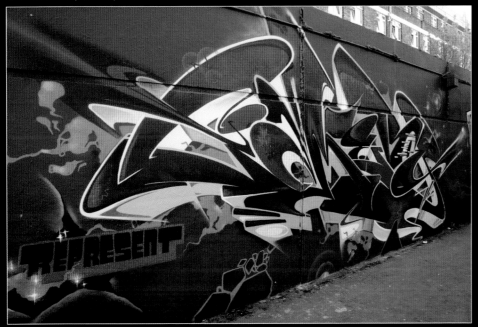

London 2011, photo by Steam156

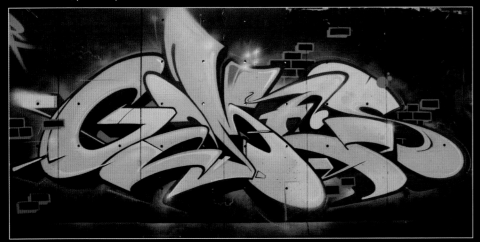

London 2011, photo by Steam156

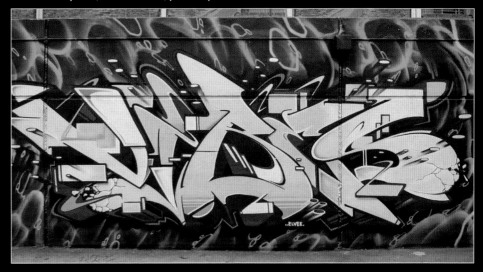

Character by Tizer, London 2011, photo by Steam156

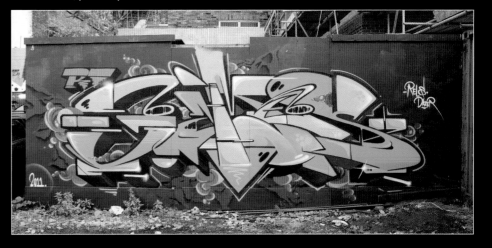

London 2010, photo by Steam156

London 2011, photo by Steam156

211

Vodker

Artist = Vodker
Location = Brighton
Painting since = 2005
Crews = none
Quote = Personally, style is very important and it's what I look for in graff. This does not necessarily mean it is or should be important to everyone. Either way, I think the more you do it the more you will find your feet and develop a unique style.
Website = www.flickr.com/vodker

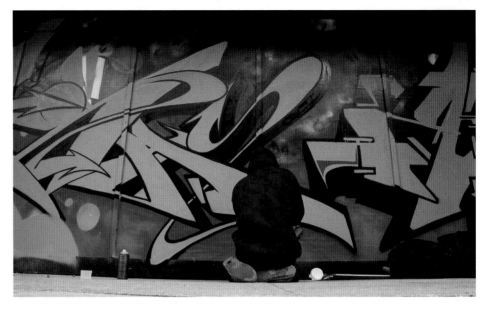

Portsmouth 2011, photo by Steam156

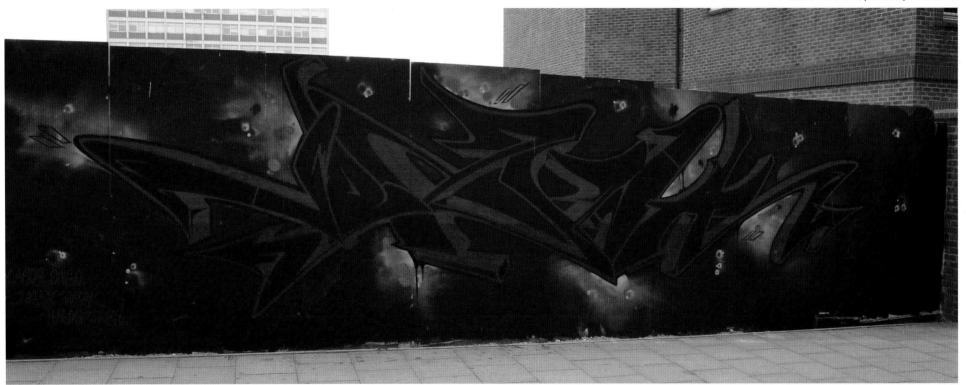

Brighton 2011, photo by Steam156

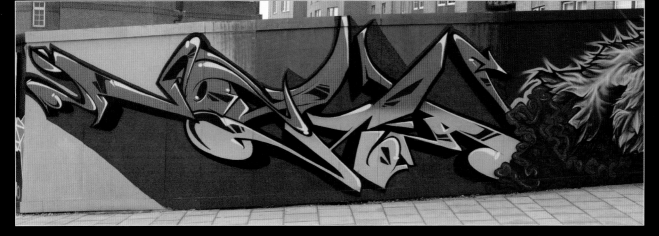

Brighton 2011,
photo by Steam156

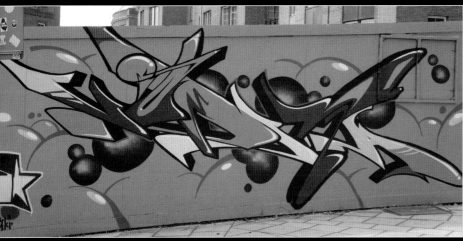

Brighton 2011, photo by Steam156

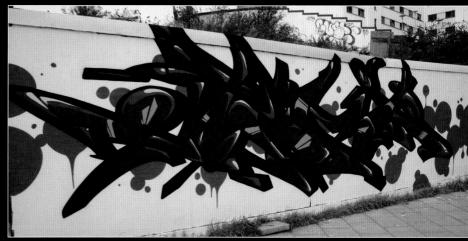

Brighton 2011, photo by Steam156

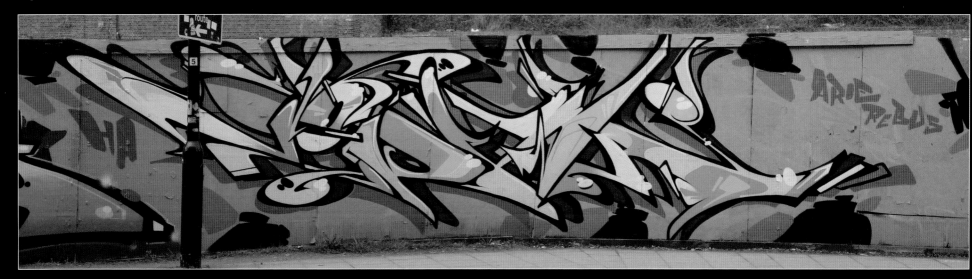

Brighton 2011, photo by Steam156

Wisher

Artist = Wisher
Location = South London badlands
Painting since = 1985
Crews = ID (Ivory Dukes), NHS (Nasty Habits), KC (Krush Clique), TBF (The Buff Fails), SSM (South Side Mob)
Quote = Graffiti—I have a love/hate relationship with graffiti. It's got me in a lot of trouble, it's gained me friends and enemies. I don't need or want any financial gain from it. It's made me steal, it's made me give. I've had graffiti highs, lows, travels, fame...one girlfriend said it gave me delusions of grandeur!!!! I left graffiti for over ten years and then I fell back in love with it. Whatever graffiti is, it's addictive and I realise now it's with me for life.

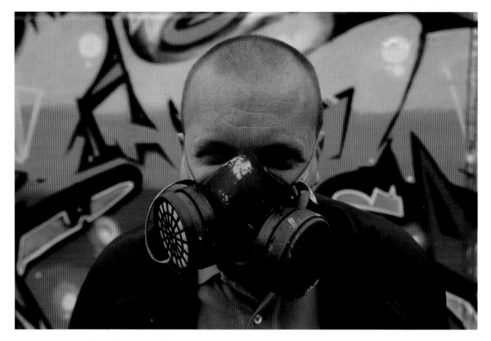

London 2011, photo by Steam156

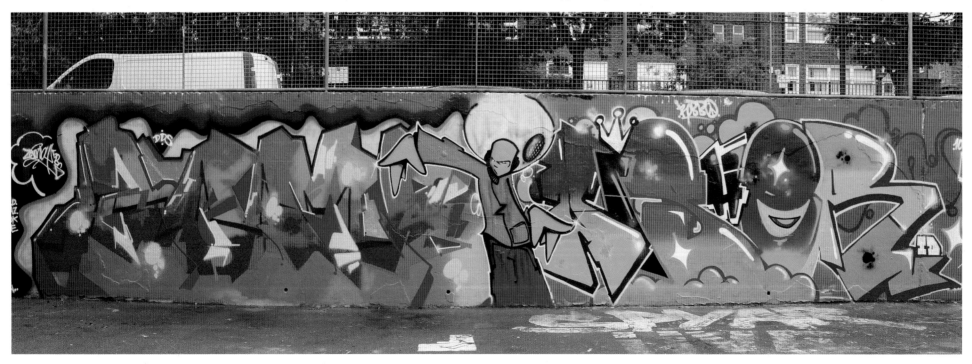

Wisher/Zomby, London 2010, photo Steam156

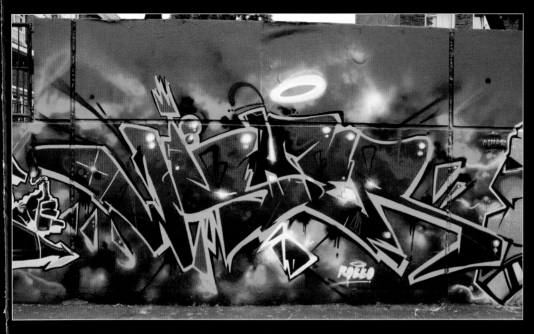

London 2011, photo by Steam156

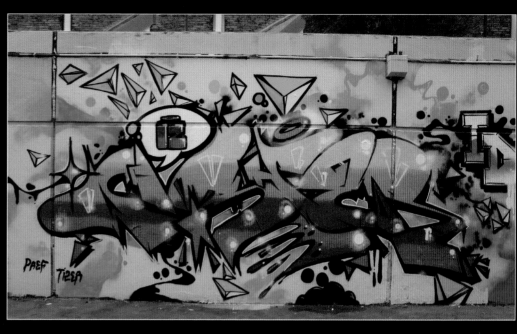

London 2011, photo by Steam156

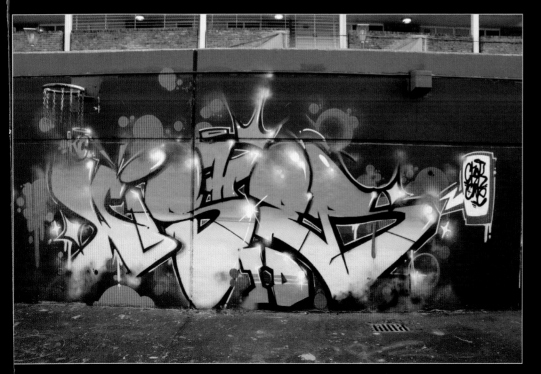

London 2011, photo by Steam156

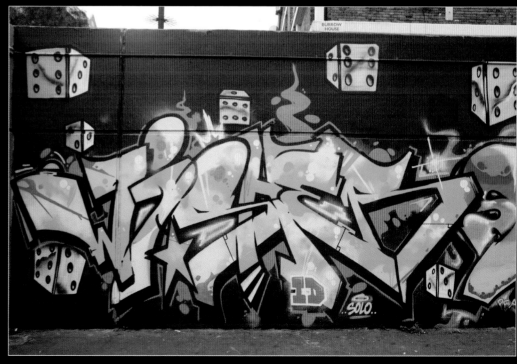

London 2011, photo by Steam156

Xenz

Artist = Xenz
Location = Bristol
Painting since = 1990
Crews = TCF (Twentieth Century Frescos)
Quote = Style comes from the heart, not the brain. The style is your natural flow, the way you move. I believe if you try to imitate others, you will never fully love what you do.
Website = www.xenz.org

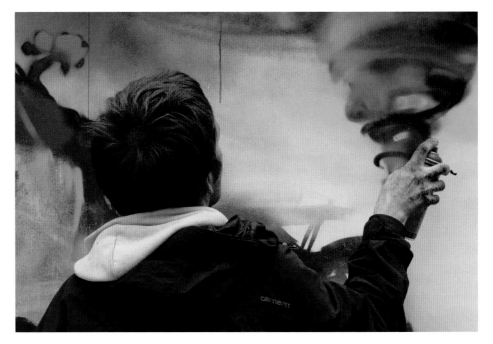

Meeting of Styles: London 2009, photo Steam156

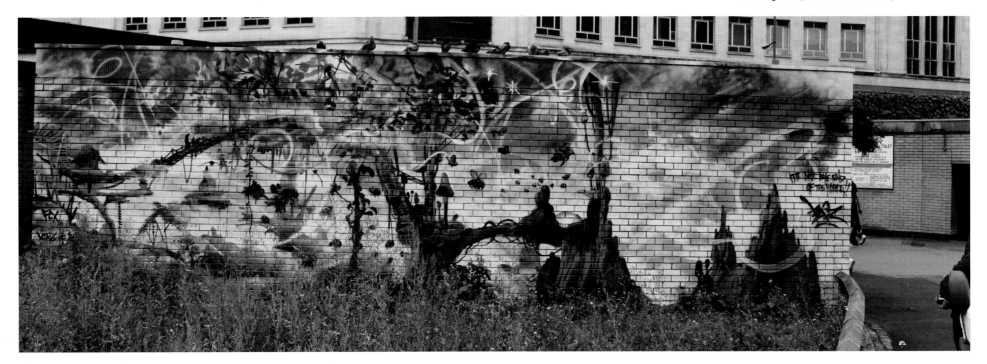

Bristol 2011, photo by Steam156

216

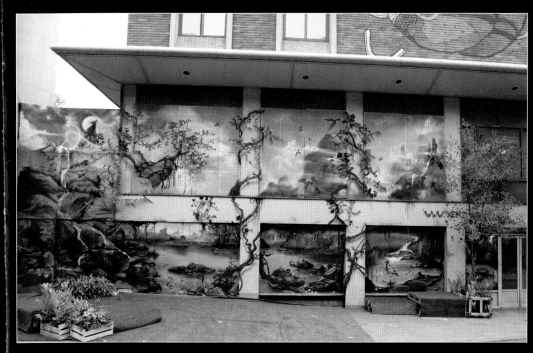

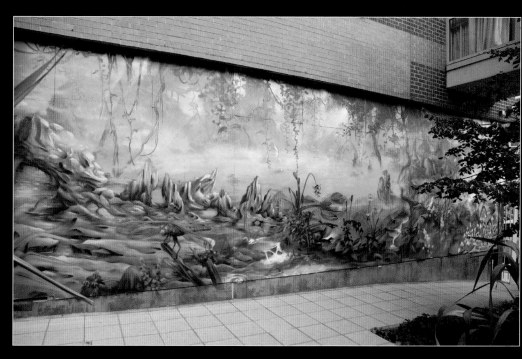

See No Evil Event: Bristol 2011, photo by Steam156 Xenz/Busk, Meeting of Styles: London 2011, photo by Steam156

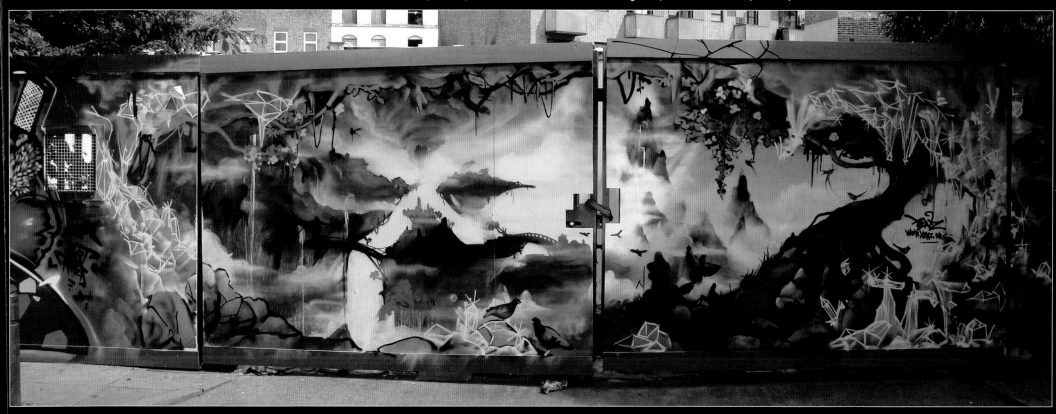

Meeting of Styles: London 2009, photo by Steam156

YesB

Artist = YesB
Location = Essex
Painting since = 1999
Crews = DL (Die Looted)
Quote = Graffiti is always in the back of my mind, it will never go away; it's a great escape from everyday life. It's great socially and I enjoy painting with my good friends and Die Looted affiliates, Izer and Are1.

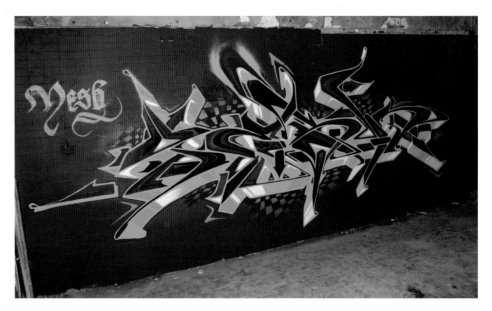

Essex 2011, photo by YesB

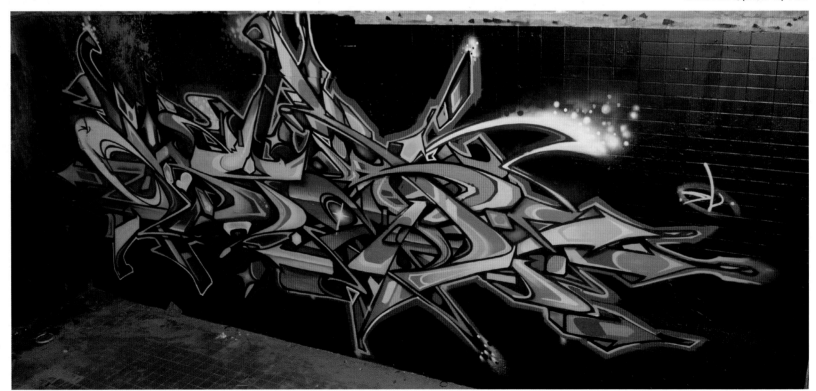

Essex 2011,
photo by YesB

218

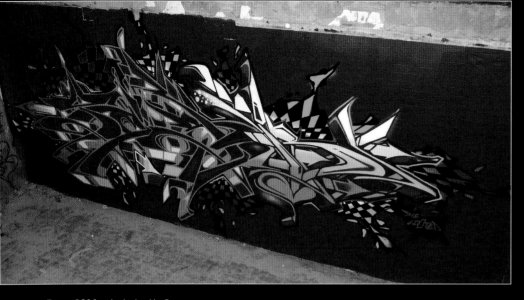

Essex 2011, photo by YesB

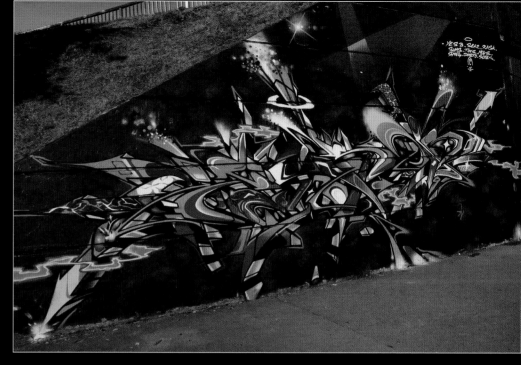

Ireland 2011, photo by YesB

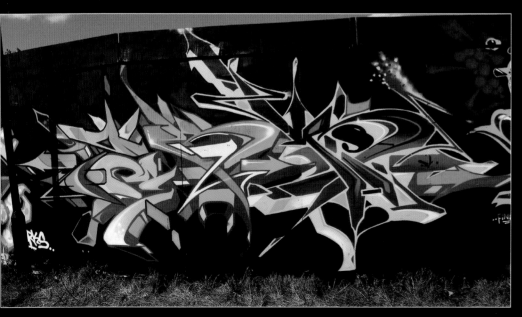

Kent 2011, photo by YesB

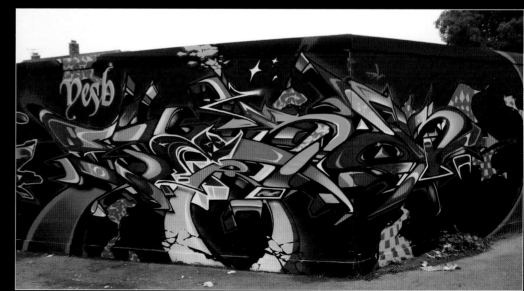

Zadok

Artist = Zadok
Location = London
Painting since = 2000
Crews = Dead Leg
Quote = Graffiti means "to deface a surface." I like to reface surfaces.
Website = www.deadleg.org

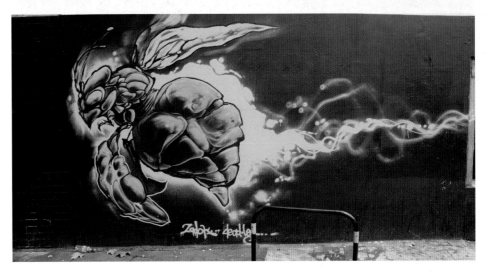

Biomeck Insects, London 2011, photo by Steam156

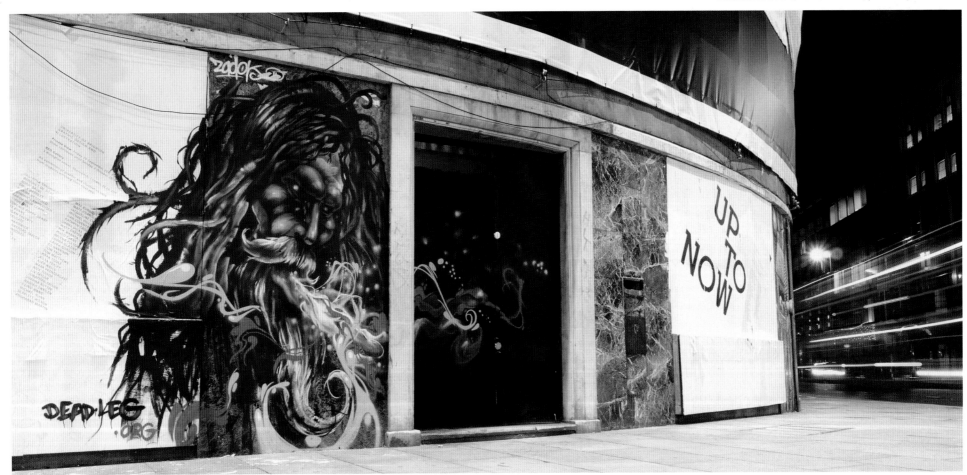

The Narrator Spaketh, London 2011, photo by mj magnetic

London 2011, photo by Toby Summerskills

Tormented Stool, 2011, photo by Steam156

Wee Wee Bunny, London 2011, photo by Toby Summerskills

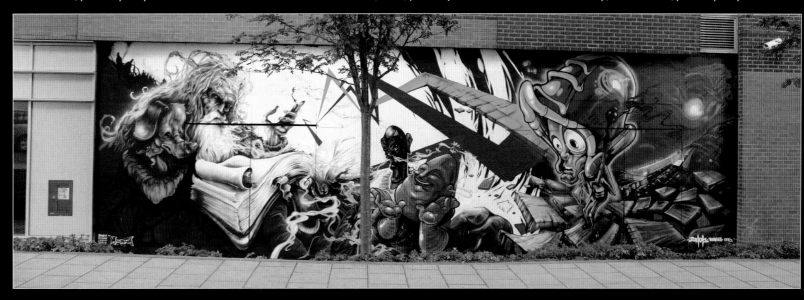

Unto the Void, Meeting of Styles: London 2011, photo by Steam156

Zaki Dee 163

Artist = Zaki Dee 163
Location = London
Painting since = 1983
Crews = TBS (The Trailblazers), TCA (The Chrome Angelz), TO (The Others)
Quote = Graffiti has been an integral part of me since the early 1980s when I saw my first burners from the legendary New York writers. Although I stopped painting seriously in the late 80s, (it) the bug was laying semi-dormant within me all that time. Having recently picked up the cans again after 20 years, graffiti continues to give me immense pleasure, and I'm having just as much fun as I did back then. At 47, I don't think I'll find a cure…not that I want to.
Website = www.flickr.com/photos/zaki163tca

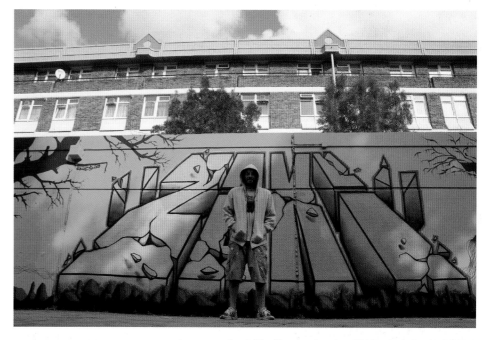

Rock Blockbuster, London 2010, photo by Steam156

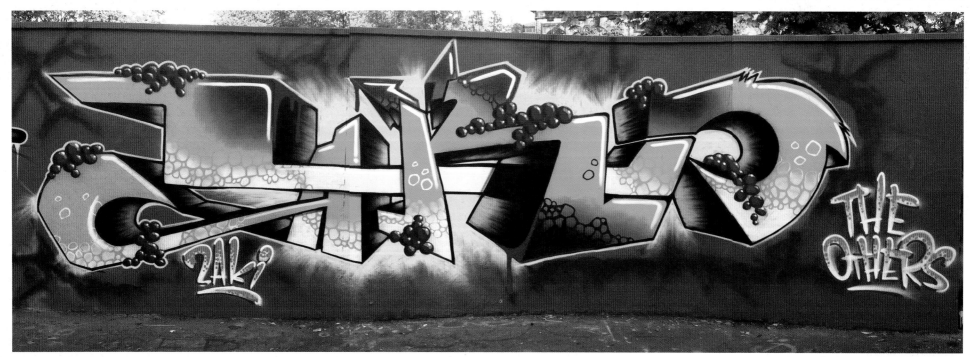

Cranberry Surprise, London 2011, photo by Zaki Dee 163

222

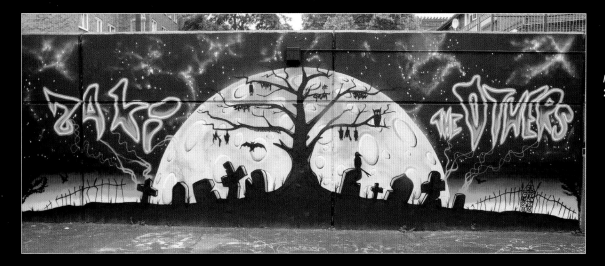

Rise from the Grave, London 2011, photo by Steam156

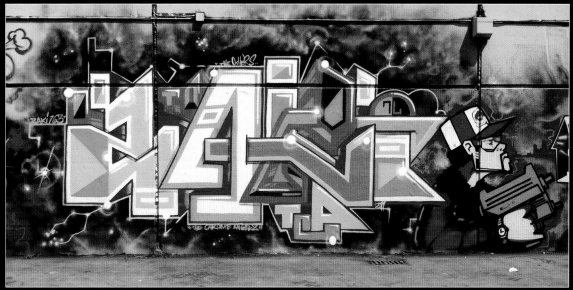

Emerald City, character by Aroe, London 2011, photo by Zaki Dee 163

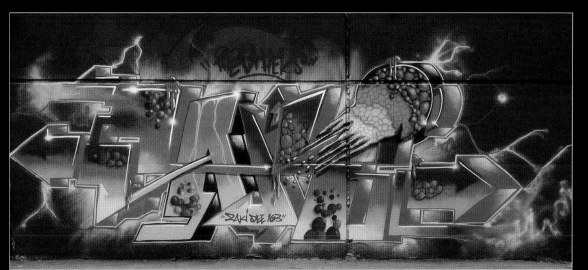

From the Volcano Came Jelly Fish and Scary Clown Balls, London 2011, photo by Zaki Dee 163